ART NATURE DIALOGUES

ART NATURE DIALOGUES

INTERVIEWS WITH ENVIRONMENTAL ARTISTS

JOHN K. GRANDE
Foreword by Edward Lucie-Smith

STATE UNIVERSITY OF NEW YORK PRESS

Published by
State University of New York Press, Albany

© 2004 State University of New York

All rights reserved

Printed in the United States of America

For information, address State University of New York Press, 90 State Street,
Suite 700, Albany, NY 12207

Production by Dana Foote
Marketing by Fran Keneston

Library of Congress Cataloging-in-Publication Data

Grande, John K.
 Art nature dialogues : interviews with environmental artists / John K.
Grande.
 p. cm.
 Includes bibliographical references and index.
 ISBN 0–7914–6193–9 (alk. paper) — ISBN 0–7914–6194–7 (pbk. : alk.
paper)
 1. Environment (Art) 2. Earthworks (Art) 3. Artists—Interviews. I. Title.

 N6494.E6G73 2004
 709'.04'076—dc22

 2004045271

10 9 8 7 6 5 4 3 2 1

Contents

Contents

ILLUSTRATIONS

Front cover: Alfio Bonanno. *West Coast Relics,* 1995. Peace Sculp-
ture Project, Island of Rømø, Denmark. Courtesy of the
artist. From top to bottom: work in process, receding
tide (detail), *West Coast Relics,* incoming tide.

Illustrations

FOREWORD
Eco-Art, Then and Now

Edward Lucie-Smith

No significant movement in art remains independent of social and historical forces. Nor can it remain independent of surrounding, related artistic impulses, which may not be pursuing the same ends. These are things that emerge clearly from John Grande's fascinating series of interviews with artists working in this field.

In a broad sense, ecological art and land art have a much longer history than most experts on contemporary culture are willing to suppose. One might in fact cite certain Roman Imperial projects, notably Hadrian's *Villa* at Tivoli, as the remote ancestors of the kind of art presented in this book. Much closer in time, and much more obviously relevant, are the creations of the great English landscape gardeners of the eighteenth century, such as Capability Brown.

Other parallels can be found in the historical record of non-European cultures, especially in China and Japan, where landscape occupies the central position in art that Europe, since the Greeks, has accorded to the human figure. A similar but more formal kind of reshaping can be discovered in the gardens created by the Mogul emperors in northern India.

There are certain points that are worth making when one considers these long historical perspectives. One is that, despite the claims to practicality made by a number of ecological and land artists, the kind of art chronicled here is essentially a manifestation of the romantic impulse. Michael Heizer's celebrated *Double Negative* precisely fits Edmund Burke's definition of the Sublime as "an outrage on the imagination."

Another, and perhaps more unexpected point, is that there are links to an antiquarian tradition that preceded the Romantic movement and that, to some extent at least, fed into it. The attempts of eighteenth-century scholars to decipher the mysteries of Stonehenge, and especially those made by

William Stukeley (1687–1765) in his *Itinerarium Curiosum Centuria I: An Account of the Antiquitys and Remarkable Curiositys in Nature or Art Observed in Travels through Great Brittan* (1724), can be seen as one of the sources, and perhaps not the least important, for the most celebrated of all land art creations—Robert Smithson's *Spiral Jetty*. *Spiral Jetty* is a pseudo-prehistoric monument, a mysterious structure that suggests great age without in fact possessing it.

In terms of the emotions *Spiral Jetty* arouses, in common with other major works of land art, it is worth quoting Stukeley's own reaction to the prehistoric monuments he examined:

> The strolling for relaxed minds upon these downs (in Wiltshire) is the most agreeable exercise and amusement in the world especially when you are every minute struck with some piece of wonder in antiquity. The neat turn of the huge barrows wraps you up into a contemplation of the flux of life and passage from one state to another and you meditate with yourself on the fate and fortune of the famous personages who thus took care of their ashes that have rested so many ages.

The one difference is that his barrows are prehistoric facts, while Smithson has produced an elaborate fiction that evokes an imaginary past.

Double Negative and *Spiral Jetty* are extremely solid constructions. There is, however, also a related kind of art that makes a virtue of its own ephemerality. Examples would be many of the creations of Andy Goldsworthy. These creations—leaves in a stream that are given a particular configuration—last only for a moment. The only enduring aspect of them is the photographic record made by the artist. The links between works of this sort and oriental philosophy, notably Zen, are obvious.

What is less obvious is their dependence on technology. This is something that raises a much larger issue. When we consider the history of art—all art, the Western tradition included—we discover that it comprises both long-enduring and ephemeral elements. In a certain sense, all art is vulnerable to the effects of time. Very few of the great masterpieces of the past have come down to us in the precise condition in which they left their authors' hands. It is not simply that almost all the masterpieces of Greek sculpture known to us are fragments—and, very often, fragments not of originals but of copies. It is also that a large number of the prized masterpieces of Renaissance and post-Renaissance painting have suffered the effects of overzealous restoration. No-one can guarantee that Michelangelo's Sistine ceiling is in a condition that approaches its original state. Even where paintings have not been restored, they have suffered from the artists' own injudicious use of materials. Géricault's *Raft of the Brig Medusa* has been all but ruined by the painter's use of bitumen.

There were also, however, a large number of art works that were never intended to endure. In the Middle Ages, and later in the Renaissance and Baroque periods, great emphasis was placed on public celebrations, for which designs were made by the most celebrated artists of the day. Sometimes these celebrations were religious, like the medieval Mystery Plays. Sometimes they were political, like the public entry of a monarch into a city, or the masques and tournaments staged on the occasion of a royal marriage.

Texts from the same period, such as Vasari's *Lives* of the great Italian artists, place great emphasis on the importance and interest of events of this kind, but the only surviving visual record of them is to be found either in the artists' own preliminary sketches, which have survived only by chance, or in books of engravings. Clearly neither of these sources can give an adequate idea of what so much impressed the fortunate spectators of the time.

In our own day we have seen an extremely rapid advance in imaging techniques, and this advance seems to be accelerating rather than slowing down. Yet, when compared with the art of the past, contemporary art actually seems to have increased its emphasis on what is ephemeral. Much eco-art and land art forms part of this development. It also forms part of an increasing tendency to define works of art as patterns of thought, rather than as visual events.

Paradoxically, that throws the emphasis on books such as this one, just as it throws the emphasis on visual records, such as video, that are dependent on modern technology. In other words, kinds of art that often seem to be products of a romantic, antitechnological impulse are intimately linked, in terms both of their propagation and their survival, to the most sophisticated manifestations of technology.

This is not an entirely new situation. It even manifested itself, in a suitably different form, in epochs that we now think of as pretechnological. Some of Capability Brown's interventions in the English landscape were funded by fortunes made in the earliest years of the Industrial Revolution—it must be remembered that this began as early as the mid-eighteenth century. These interventions can plausibly be seen as a reaction to the effects of industrialism.

The actual forms of Brown's constructed landscapes derived very largely from the paintings of Claude. Claude's paintings found their largest group of patrons among a wealthy intelligentsia both in Rome and in France—an intelligentsia of administrators employed by the papacy and by the French monarchy. They expressed a nostalgia for a mythical Arcadia or golden age of rural simplicity.

However, the actual materials from which Claude constructed his Arcadian compositions were views found in the Roman Campagna. And the Campagna itself, far from being a genuine Arcadia, was in fact a ruined landscape,

haunted by bandits and rendered almost uninhabitable by malaria, which was the product of years of misuse of what had once been ideally fertile soil in the distant days of the Roman Empire.

The reader should be alert for paradoxes of this type in this highly enjoyable and informative book.

INTRODUCTION
True to Nature

The artists whose works I have selected for inclusion in this book come from a variety of countries in Europe and North America. Each has a particular way of working with nature, of expressing their art in tandem with nature. Each brings their own specific experience to bear on this new paradigm. I discovered them one by one. And each brought a new awareness of the incredible versatility and variety of responses artists can have to place. Indeed many of the ideas initiated by these artists are seized on by professionals in others fields—landscapers, designers, architects, horticulturists, educators, and craftspeople. This gives a sense of how relevant an art that deals with the experience of nature really can be, even more so in a world where new technological innovations are increasingly pulling us away from direct experience—the tactile world—into a parallel experience indulged on, and produced by, the micro-screen technology. As Marshall McLuhan has stated: "What may emerge as the most important insight of the twenty-first century is that man was not designed to live at the speed of light. Without the countervailing balance of natural and physical laws, the new video-related media will make man implode upon himself. As he sits in the informational control room, whether at home or at work, receiving data at enormous speeds—imagistic, sound, or tactile—from all areas of the world, the results could be dangerously inflating and schizophrenic. His body will remain in one place but his mind will float out into the electronic void, being everywhere at once on the data bank."[1]

Less is more. And if we recognize the incredible variety of forms, materials, and combinations of matter that exist in nature, we can only say that we learn from nature. A walk in the woods or in a park produces innumerable stimuli, and our senses capture all of this, whether consciously or unconsciously. The variation in the real world has not yet been equaled in the world of technology. Over half a century ago, the writer and novelist E. B. White, in his essay "Removal," wrote that our future technologies, "Will insist that we forget the primary in favour of the secondary and remote . . . digesting ideas,

sounds, images—distant and concocted, seen in a panel of light—these will emerge as the real and the true; and when we bang the door of our own cell or look into another's face, the impression will be of mere artifice."

In the future, a time would come "when all is reversed and we shall be like the insane to whom the antics of the sane seem (like) the crazy twistings of a grig."[2] And more recently art critic Robert Hughes, writing in *Time* magazine, addressed the high-tech revolution's promised new territory for art: "All Human Knowledge Will Be There. With a roll and click of the mouse we will summon Titian's *Assumption* from the Friari in Venice onto our home screen, faithful in every respect—except that it isn't, being much smaller, with different (electronic) colour, no texture, no surface and no physical reality, and in no way superior (except for the opportunity to zoom in on detail) to an ink reproduction in a book . . . but how many people will realize the only way to know Titian is to study the actual, unedited physical works of his hands, in real space, not cyberspace?"[3]

These opinions are not rare or exclusive. They reflect a growing awareness that the legacy of modernism and postmodernism in art is one of environmental deprivation and segregation of arts activity from nature. Economic progress generally leads to a quantitative approach to art. Materialist history presents the evolution of art as a successive layering of movements and avant-gardisms. This ideological approach deifies individualism and promotes "ego-systems of expression" that nurture an exploitative view of culture and history.

Often, an ideological approach seems almost a required attitude to be considered active in the field of contemporary artmaking. But the public in general seems far ahead of the art world. They have seized the significance of nature in the contemporary debate on the future of our planet, its resources, and their progeny. I am not speaking of nature in the romantic sense, as a sublime spiritual source, or as an embodiment of a Judeo-Christian worldview, but more pragmatically as a real-life presence and source for sustainable resources and a vision for the future. The spate of art exhibitions now dedicated to art and nature, either directly as symposia or indirectly as gallery exhibitions, is proof positive of this new direction in artmaking, and of its broadening scope and interdisciplinary relevance.

In *Asking for the Earth*, James George writes: "We have a dominant culture that is, in an objective sense, a counter-culture, because it is, in practice (if not in theory), against the order of Nature."[4] While this may seem an obvious statement, in fact it is vastly distorted by mainstream media. We might see animals in TV ads, rephrased in sequences, made to act like humans—something that appeals to a certain nostalgia for control over things. Or wild animals might be stretched and then shrunk in animated sequences—again this sense that all things can be controlled, manipulated, that technology is the savior. Just look at films like *Jumanji* or *Larger than Life*. And the same goes for humans . . . *The Mask*. Viewers are comforted by the

ingenuity, the cleverness. Such imagery is attractive but conditions us to viewing nature (ourselves included) as manipulated, disembodied, and absolutely removed from any context. The effects of modern-day media have led us to generalize and simplify nature, as we do all things. We read experience in an informational way.

The denaturization of narrative has been with us for some time, but more recently it is presented as a positive thing. In reality it is the respect for nature and all things natural that can actually move us toward developing a responsible approach to our society, toward natural resources and eco-conscious business decision making. Paul Hawken in *The Ecology of Commerce* has written of this in depth. While using only what is required, no more, no less, may have been common sense for people several generations ago, the pure profit-taking scope of big business these days presents scale as the palliative for poverty and resource scarcity. In fact, economies of scale only further deplete resources. Economies of scale will ultimately be limited by the availability of natural resources. Quality of life must take precedence over production and consumption quotas, and we can rephrase, reenvision our needs in a way that corresponds with our real desires. Minority cultures face the same problems of scale. Their diversity, like that experienced in nature, is threatened. Cultural diversity can better maintain bioregional variation and resources when not assimilated and homogenized. The survival of minority cultures, like the survival of rare and endangered species, is essential if we are to understand where we have come from, what we really need to ensure our survival. Ensuring diversity is a responsibility. This preamble is designed to provide a context for the earth-based initiatives of the artists whose works I include in this book. Few are nostalgic for some beatific version of nature and few are deluded by the great challenge that faces us all. But their art is a response to the immediate physical environment, and challenges us to better understand that nature is resilient and can provide a source for reflection, catharsis, and regeneration in an age of stress and overproduction.

I mention all of this as a preamble to the actual artists with whom I have dialogued over the years, each of whom has their own approach. Their views on artmaking reflect a diversity of points of view, of cultural variables, and varying world visions. Their art speaks for itself. This is no longer the age of land art, of those vast earth-moving projects, a reaction to the gallery venue when Robert Smithson commented: "The earth's surface and the figments of the mind have a way of disintegrating into discrete regions of art. Various agents, both fictional and real, somehow trade places with each other—one cannot avoid muddy thinking when it comes to earth projects. One's mind and the earth are in a constant state of erosion, mental rivers wear away abstract banks, brain waves undermine cliffs of thought, ideas decompose into stones of unknowing."[5]

Land artists such as Robert Smithson and Michael Heizer were very conceptual in their approach to the land. The idea of transforming swaths of

desert, or valley, attracted them. The art remained an imposition on the landscape, and this, in an era when space exploration, the landing on the moon, was experienced abstractly, as imagery on the television set in every person's home. Landscape was real estate. For the past fifteen years, artists worldwide have been developing a completely new approach to site and environment. Ana Mendieta, whose ritual performances and artworks reflected a merging of the body with the land had a very different resonance. She almost seemed to have sensed this transformation, this move away from an art that dominated the land in her earth performances, before her untimely death in New York City at such an early age.

There were many artists who presaged today's resurgence of earth-based arts initiatives. Many are included in this book. Some are involved in large-scale projects, but with a difference. These often involve redesigning our built urban environments, parks, river basins, and highways by integrating nature as a feature. Michael Singer, an artist who began with outdoor installations and has since moved on to project planning, to the extent of designing a recycling plant for the city of Phoenix, is a remarkable example of the way talents from one field can extend and adapt into another with remarkable success. Gilles Bruni and Marc Babarit are a team from France who integrate their installations into natural settings in such a way as to reflect on human and architectural history, but always in the context of nature and with ephemeral nature-based materials.

Nils-Udo has evolved in his respective way, attracting an ever broader audience for his plantings and nature assemblages works. While Nils-Udo usually creates intimate works, more recently he has produced larger projects, mostly in response to a heightened demand for permanent commissions. Alfio Bonanno from Denmark is a primitive of sorts, establishing structures made instinctively with materials that reflect the human and natural history of a place. Doug Buis has created gadgets, mechanisms, and machines that play with our notions of nature. Ursula von Rydingsvard's sculptures seize on a mystery inherent to nature, but as something cultures can share and innovate, embroider upon. herman de vries has been a remarkable artist, pioneering earth interventions, rephrasing the meaning of art, and even working with sound in nature before the phrase *land art* had even been conceived of. Bill Vazan has worked with great integrity over the years using rocks, installations that recall the ancient monuments but are equally individual artworks, produced in an age of specialization. Bob Verschueren likewise innovated with wind and pigment, and Mario Reis with river residues all over the world.

Yet there are others, Patrick Dougherty, whose woven installations are animated with a childlike reverie and incredible application "drawing in space." Peter von Tiesenhausen began with boat, seeds, pods, and towers, in the trees and forests on his northern Alberta home and has recently broached the public by taking his burnt-wood sculpture on cross-country trips. Reinhard

Reitzenstein has embraced nature and the Amerindian connectivity to place, in a wide variety of ways in his art. Betty Beaumont has engendered a direct-action approach, notably on the Atlantic Coast off Fire Island in New York state, where she recycled coal ash, sending tons of bricks to the ocean floor to create a fish habitat, and Mike MacDonald creates gardens for butterflies whose plants have medicinal healing properties for humans. He also makes videos that deal with land claim and resource issues. Jerilea Zempel's installations recycles natural and manmade materials not only to comment on humanity's excess volatility, but equally to address historical militarism in Poznan, Poland, and in Canterbury, England. She also wryly comments on modernism in art history and its "borrowing" from more ancient sources using as ironic a material as horse dung, which she forms into bricks to then sculpt. Egil Martin Kurdøl leaves traces—small sculpted markers in nature parks and sites (recording the government bureaucracies' reactions to his interventions as part of the art)—and develops perpetual motion machines for remote locations in nature.

David Nash is a sculptor who lives in Wales and is renowned for his works that integrate living nature as part of the art. He likewise uses burning, carving, and other devices to sculpt his forms. Hamish Fulton's walks in nature, and subsequent documentation with prose and photos, are familiar to artgoing audiences. Alan Sonfist, one of the first to integrate a vision of nature in his *Time Landscape* in New York City, has consistently worked with nature as source for his installations, sculptures, and projects in Italy, Miami, California, and around the world. Chris Drury builds cairns and makes "land drawings" that go to the heart of the nature/culture relationship. . . . I have integrated all these artists/sculptors/designers/land artists in *Art Nature Dialogues* to give an idea of the breadth and scope of contemporary investigation of nature as both source and site for creative innovation. I hope you, the reader, will enjoy sharing some of their experience, knowledge, and joy in readings these interviews.

Natural history parallels human history. The two are seldom regarded, particularly in the field of art, as interrelated. The focus and worldview of one culture may differ vastly from that of another. Relativism in cultural worldviews is a constant and should be addressed in any overview of the relation between nature and human culture. Cultural narrative builds on this relativism. It is not necessary to interpret a cultural worldview—more essential to recognize that the geospecific characteristics that apply to any given culture are, in a holistic sense, being erased by an oversimplification and caricaturing of culture.

Are the definitions and words we use to label culture, nature, and art outmoded? I believe that words represent what they say they do, and are not simply labels. The roots of this opinion derive from a vernacular that is part of a narrative, or oracular culture. Why this intense distinction? Because the origins of words have a history and are rooted in experience as much as art and culture. As such, I believe that we must have a greater respect for the spoken

word and vernacular in language, just as the referencing of real living environments can reenter the language of contemporary artmaking. Environmental art has long interested me, and in the early days it was as much the environment of the gallery space as it was the site-specific outdoor artwork. Gradually the context of the art gallery space seemed arbitrary—could be anywhere—and seemed less and less relevant, even if the ideas, concepts, and approach to materials were interesting. Permaculture—that is, the culture of nature—which I believe sustains the ephemeraculture of mass consumption and production, seemed the place to begin investigating the crossover between the creative impulse and nature.

Materials—truth to materials—is an old axiom that has been around since the early days of modernism. But the parameters have shifted just as the paradigm has. Truth to materials still holds true for me. But no longer is this truth relegated simply to objects, nor does the object have to be segregated from what is around it. The two can now intertwine, and develop a dialogue on site, place, materials, and existence. The economies we have built out of the natural world, along with its correspondent tautology of progress, are still reliant on resources just as they have always been. Resources in art are no different than elsewhere; they derive from nature. In fact all materials—natural or so-called synthetic—ultimately derive from nature. The dilemmas of contemporary criticism are in part the result of a failure to identify with the holistic basis of art, not only in a visual, symbolic, or conceptual way, but more importantly, in realizing that nature is the art of which we are a part. This may seem a grand generalization. But as generalizations go—it makes perfect sense. Our bodies ingest nature as food. We breathe the air. The cars we drive are nature reconfigured. Even our unconscious thoughts and dreams and our conscious thoughts are influenced by our immediate environment and experiences.

By realizing we are a part of nature, even if we live abstracted, decontextualized lives in major cities, we can gather a holistic sense of purpose in our lives that would otherwise be relegated to distraction, delusion, and distempered life. Contemporary criticism often addresses public issues, questions of siting, and public space. Its an interesting part of the contemporary art scene. But unless public art gets beyond the production of imagery to investigate the process of life unfolding around us, it will remain decorative, an adjunct to, and not a beacon of consolidation, something that engenders a holistic sense of purpose beyond the political. There is an ethic to life. Artmaking has an ethics, even if it involves simply deciding what materials to use—leaves instead of stones, or wood in the place of earth. The installation that ingests—places itself in an environment with a sense of the place—is exciting. The drama is in this sense of place, of participating in a living history. Unseen variables play a role in outdoor nature-based art works: weather, climate, vegetation, other living species, the quality of light, and the seasons.

These dialogues will provide the reader with a variety of artists' own views on the process of their artmaking and viewpoints on the place of nature in art. With a better understanding of how the art-nature phenomenon is occurring simultaneously in many places, among a great variety of artists, in many countries, and how this synchronicity is no accident, readers will be provided with a broader worldview. It evidences the urgent need for contemporary art to embrace the nature phenomenon as an ongoing part of the dialogue on humanity's place in nature.

NOTES

1. Marshall McLuhan and Bruce Powers, "Global Robotism: The Dissatisfactions" in *The Global Village; Transformations in World Life and Media in the Twenty-first Century*. Oxford: Oxford University Press, 1989, p. 97.
2. E. B. White, "Removal," reprinted in *One Man's Meat*. New York: Harper Colophon, 1983, p. 3.
3. Robert Hughes, "Take This Revolution . . ." *Time* magazine, Spring 1995, p. 77,
4. James George, *Asking for the Earth: Waking Up to the Spiritual/ Ecological Crisis*. Rockport, Mass.: Element, 1995, p. 154.
5. "A Sedimentation of the Mind: Earth Projects," in *Artforum*, Sept. 1969, reprinted in Nancy Holt (ed.), *The Writings of Robert Smithson: Essays with Illustrations*. New York: NYU Press, 1979, p. 82.

The author would like to thank the Conseil des arts et des lettres du Quebec (CALQ) and the RLP Foundation for providing some financial support for this project.

1
REAL LIVING ART!
David Nash

Since the 1970s British sculptor David Nash has been involved with creating sculptures and living art installations the world over. He is perhaps best known for his sculptures that involve living elements, such as trees, whose growth has been redirected. The most notable of these include the *Ash Dome* (1977), a ring of twenty-two ash trees initiated near David Nash's home in Wales and still growing. Another such project, *Divided Oaks* (1985) done for the Kröller-Müller Museum in Otterlo, Holland, involves some six hundred trees. Nash has likewise created sculptures that involve interactions with animals as with *Sheep Space* (1993) for TICKON (Tranekaer International Center for Art and Nature) in Langeland, Denmark, and more recently for an organic sheep farm in Virginia. His mastery of wood carving is not purely formalist but often involves an extension or referencing of environment and history, as was the case for *Through the Trunk, Up the Branch* (1985) in Ireland or *Nine Charred Steps* (1988-89), enacted in Brussels, Belgium. Nash's work can equally be seen as an ephemeral expression of nature's ongoing processes. For *Wooden Boulder* (1978) the oak sculpture carving was left to follow its own course down a slope and then a stream. Over the years it moved hesitantly and according to the laws of nature and gravity along this river, though occasionally intervention has become necessary.

JG I first became familiar with your work because of the living circle of twenty-two ash trees called the *Ash Dome* you planted in the 1970s and which is still growing in the Ffestiniog Valley near your home in Wales. *Ash Dome* reflects an art whose language integrates nature's living processes into the art, of which we as human beings are a part. The later *Divided Oaks* project has that same breakthrough quality as *Ash Dome* for these works truly involve a crossover into horticulture, and ultimately a redefinition of the artistic process. To me these works pose a challenge to the postmodern ethos that art is somehow segregated, as are most disciplines from the flux and flow of life.

1

DN In comparison with the *Ash Dome*, the trees for *Divided Oaks*, which is in a park at the Kröller-Müller Museum in Otterlo, Holland, were already there. The soil there is very sandy and it is quite tough for plants to grow. There was a quarter acre of very scrubby oak trees that were not growing or developing. So that site was offered to me because they were going to pull all the trees out. There were probably six hundred trees. As they were so close to each other, though still alive they were not able to really grow. The annual growth was negligible. I thought that instead of pulling them all out and planting something anew, I would work with the existing trees. I made a division through them, angling one side to the east and one side to the west. They began with an open space and, at the end of this channel, the trees are crossing over. I had been invited to come and make something apt, make some sort of interaction that signalled the presence of the human being.

JG This kind of work admittedly demands some manipulation of nature. Do you prune the trees?

DN It is called fletching. The very small trees, I simply pushed over and put a stake to hold them, while for the larger ones I cut out a series of V-shapes, bent them over and then wrapped them so the cambium layer could heal over. Now this really woke these trees up. My intervention actually stimulated them, and they are obliged to grow. They are now growing and curving up.

JG The *Ash Dome* at Cae'n-y-coed in North Wales is another case of living tree art.

DN The *Ash Dome* was my first planting work. done on my own land on the coast of Wales. It is very different from the *Divided Oaks* in that I actually made a decision to plant the trees to grow in a particular form. What is also different as compared with *Divided Oaks* at the Kröller-Müller Museum, which is a long way from where I live, the *Ash Dome* is near. One of the most important aspects of the *Ash Dome* conceptually is that I had made a commitment to stay with it over time.

JG It involves a direct relationship with that land.

DN There is that, but the land art of the late 1960s and 1970s involved gestures in the land like those of Michael Heizer and Richard Long, whose work I was following and who was a sort of teacher to me. What I was uncomfortable about was the walk—that huge physical effort, and then the walk on. It stayed there, Richard knew where it was. Only the photograph was carried away.

JG Not many people really saw it.

DN Others saw it, but then what happens there? What really happens there? I just thought, for me, particularly when I am doing something that is planted, I have to be there. I have to make a commitment to stay with it. So this is a thirty- or forty-year project. Very different from a lot of the other ephemeral works. It will only work if I stay there.

JG There is a long tradition of industry that involved an intervention in the landscape in Wales where you live. Rather as with your works in nature, the landscape is never hands off, and even the residue of human intervention can be seen in the hills and valleys of Wales. You are involved in integrating the human presence in the landscape, and not in an apologetic way. There is this hands-on interaction between your sculpture and natural environment.

DN The *Ash Dome* is very hands on. It upsets quite a lot of people. When I began it in the 1970s, the environmental movement was just beginning to manifest itself and I noticed that urban dwellers of the environmental sensibility tended to believe that nature gets along better without the human being, who is largely viewed as a parasite. The message is "Don't touch! " If you actually live in a rural agricultural area you see people touching the ground all the time. Its part of their livelihood, supporting the people in the urban areas. If somebody is touching nature, in my belief, there is this dialogue in and with it. Part of the point about the *Ash Dome* was "Hands On!" It is a central irony that people love hedges but don't like people to slash and cut and bend. "Ooh! Poor trees!" Part of the point was that nature actually gets on very well when a human being is caring with it and lives with it.

JG Your living sculpture works are neither virginal postmodern nor politically correct! The tree is the living element that can be worked with, adapted, and manipulated. The emphasis is always on the crossover between nature and human culture. The two are not at odds, but symbiotic and interrelated.

DN When I first planted a ring of twenty-two ash trees for the *Ash Dome* in 1977, the Cold War was still a threat. There was serious economic gloom—very high unemployment in our country—and nuclear war was a real possibility. We were killing the planet, which we still are because of greed. In Britain our governments were changing very quickly so we had very short-term political and economic policies. To make a gesture by planting something for the twenty-first century, which was what the *Ash Dome* was really about, was like a long-term commitment, an act of faith. I did not know what I was letting myself in for.

JG And how has the *Ash Dome* matured over the years?

DN The point was that *Ash Dome* was made for the twenty-first century. It was started in 1977 when the year 2000 was a very long way to go, almost unimaginable. If I had started it in 1997, it would have been very corny. My wife and I were actually with it at the moment of the Millennium. We didn't stay all night, but were there from 11 P.M. to about 12:30 A.M. I lit it up on the inside with some submerged candles so it just flickered.

JG Do your works have anything to do with ritual or performance? I am thinking about the *Snow Stove* (1982) in Kotoku, Japan, the *Ice Stove* (1987) in north Wales, and *Sea Stove* (1981) on the shores of the Isle of Bute in Scotland, for instance.

3

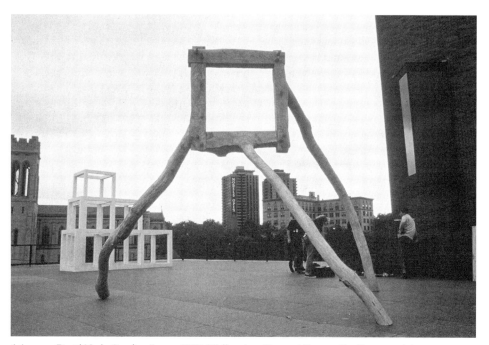

1.1 David Nash. *Standing Frame*, 1987. Walker Arts Center, Minneapolis. Courtesy of the artist.

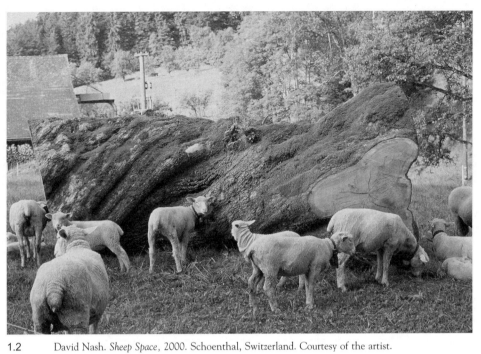

1.2 David Nash. *Sheep Space*, 2000. Schoenthal, Switzerland. Courtesy of the artist.

DN No! They have absolutely nothing to do with ritual or performance. There is no shamanism. You can bring those associations to it, but my concerns are fundamentally practical. The spiritual is absolutely dovetailed into the physical and the two are essentially linked with each other. To work the ground in a practical, basic commonsense way is a spiritual activity.

JG The act of burning wood in your sculptures such as *Black Dome* (1986) link your process with a primordial cycle of regeneration. The carbon generated by forest fires, for instance, is a natural phenomenon that brings about regeneration of the soil. *Black into Green* (1989) likewise brought together a series of tree trunks that were charred in a loose arrangement on an island at Vassivière Lake in France.

DN For *Black Dome*, I was among twelve artists invited by the forestry commission to make public works in the Forest of Dean in Gloucester, an area that has a long history of charcoal manufacture. There is a lot of iron ore there and charcoal was used to smelt the iron. In the more hilly areas there are flattened-out spaces where the charcoal burners built their fires that carry an echo of this past activity. Only certain plants will grow in these places because there is so much carbon in the soil. Knowing of the history of this place, I conceived making a mound out of charcoal, a brittle material. We went at making nine hundred charred stakes that were to be graded into a dome eight meters in diameter and one meter high in the center.

JG The charring became an action and the dome a reminder of the charcoal-burning activity, the human presence in this apparently "natural" site earlier on.

DN The whole idea was that it would rot down to a mound of humus and that only certain plants could grow on it. What I hadn't anticipated was people liked to walk on it. It got very trampled but it survived. New safety laws came in, and it was decided *Black Dome* was not safe for people. So it was prematurely covered over. It is now just a mound, which it would have become anyways.

JG There is this language or grammar in your wood pieces. The weird juxtaposition of maybe two elements, letting the materials speak for themselves within the object or form. You do not dominate or formalize them too much. The weird conjunctures of natural and carved forms and dimensionalities cause us to question our own presence in relation to this physical language of carving.

DN Making objects, making gestures that are sustained in a certain place, knowing that other people are going to see it, encourages other people to be aware of it. I think all human behavior has moral or immoral qualities. Rothko said his paintings were moral statements and I really linked to that when I was a student. Every human gesture seems to have a moral content. It does stand for a human being's behavior. If somebody knows nothing of my work and they come across a piece, I hope they will get a sense of the light touch, that there is

something here that serves as a stepping stone for the mind into the continuum of that particular place.

JG A strong relation to the land once existed in all primary cultures, and there was a basic resourcefulness associated with use of materials essential for cultural survival. A sense of infinity came with understanding those limits. Contemporary culture encourages a consumer attitude to materials and products, yet all materials ultimately derive from and have origins in nature. We are losing that physical, tactile sense of connectedness to a place that your work embodies.

DN To varying degrees we spiritualize material by our work with it. Unconsciously we are creating a language that another human being can pick up on. We connect to that spirit quality that has been put into it. This isn't done by ritual, it is simply done by "common" sense.

JG And the language of each individual artist reflects their own experience?

DN Yes. Individuality within the global reality of the physical world.

JG Your step and ladder pieces are unusual metaphors that maintain the integrity of wood, the natural undulations of tree form, while integrating manmade forms. *Through the Trunk, Up the Branch* (1985), in Ireland, demonstrates this quite dramatically, offsetting a tree's base with a series of steps. . . . In this case the tree is supporting the structure that symbolizes an ascent or descent.

DN I was presented with a huge dead elm tree in Ireland that had been dearly loved by the owner. With an Irish woodsman, instead of cutting it at the root, we decided to cut it above the first big limb. I made about ten sculptures from the top and then I was left with this huge trunk and big branch. So it remained rooted and the steps had a gesture that was upward. A neighboring farmer said he'd like to go up those steps and have a Guinness with God!

JG Do you expect to do anymore planted works? Do you have any future projects that involve living elements?

DN I am very wary to do anything that is far away from where I live. When I take on a contract to do one, it is a five-year or ten-year period. I am paid half when I do it, and I am paid in increments a fifth of the remaining on each return visit. Then I have a carrot to get me there. I know I have a budget that pays to get me there.

JG What sort of feeling do you have when you are working, when you are carving or making a piece?

DN I am usually charged up by the idea, because ideas have energy. I am invigorated by it. I love the economy of means that when you cut a shape, you have another piece of wood coming away you can use for smaller pieces. In the big projects abroad, just from the nature of how much I am trying to do, what I am trying to achieve, I have to work with other people. The social dynamic interests me very much.

JG It is an exchange process.

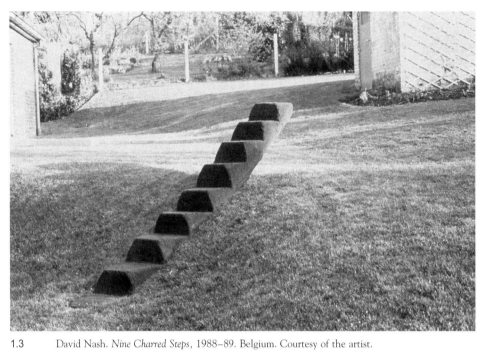

1.3 David Nash. *Nine Charred Steps*, 1988–89. Belgium. Courtesy of the artist.

1.4 David Nash. *Sod Swap*, 1983. North Wales. Courtesy of the artist.

DN It has to be for it to work. It is an absolute delight to get the right mood. Sometimes I have failed and the project has been very difficult.

JG Do you believe symbols play a role in your work? Does a work have an overtly symbolic power? Is it the viewer who brings the symbolic reading to a particular work?

DN I have found that the *Cube, Sphere, Pyramids* I have been making— triangle, circle, square—seem to have a commonality. People are very comfortable with that grouping. If I make or invent a shape such as a cross, people will ask "Why is that?" There are shapes and combinations that seem to be universally satisfying cross-culturally. I continue to make those because I am endlessly fascinated by these aspects.

JG Did Constantin Brancusi's work play a role or inspire you in the direction you have taken?

DN It was a fundamental experience for me. I saw it when I was eighteen, when it was in the old modern art museum and I was traveling with two friends from school. I had heard about it from my old art master. It was unusual from the other objects because it was sort of jammed into the one place. I really liked that. It wasn't until I went back when I was twenty-two under other circumstances, and then saw the same place again I realized how deeply this spiritualization had gone into me. I continued to revere it. Now there is a moral gesture!

JG Yes, *The Endless Column* (1937). Brancusi could integrate a sense of the universal both in a single sculpture or in a carved decorative doorway to a house. The practical and aesthetic seemed inseparable.

DN That is what made me decide I wanted to live in the space where I worked. I don't like to think of Capel Rhiw, my home in Wales, as a copy of Brancusi. If anything, it is like a magnification of that experience.

JG Do some of your works have a practical element, or build a functionality into the sculpture?

DN Yes. Various people around the world have wooden toilet roll holders built into their bathrooms and I have made handrails out of a branch for people to hold. *Black through Green* (1993), conceived for the Laumeier Sculpture Park in St. Louis, involved integrating a series of five-meter-long charred oak steps into a woodland area, the idea being that hikers would gradually erode a path down the center of the steps, while leaving the ends untouched. *Nine Charred Steps* (1988) in Brussels goes up a grassy bank, extending beyond any functional use into space.

JG The land plays a great role in these works and the siting must be central to your concerns. Usually they are modest integrations that don't seem to dominate a place.

DN Site appropriates. Site specific is not a good enough term. It is too loose. The land is absolutely fundamental and has to be in the front. I can't stand sculpture that uses the land as a background. I find it offensive!

10

JG By integrating you create a kind of questioning in the viewer. First of all we are spurred on to ask "What is this?" It has no specific function. We then question the purpose of a sculpture: "What is it trying to say?" Thus we question our own purpose in relation to it. In this way a new relation to a place in the land is achieved.

DN My most successful pieces are the ones that look like they have always been there when I put them in. I consider *Charred Forms into Charred Stumps* (1989) in northern California to be my most successful piece. A very big charred sphere rolled into a hollow charred redwood stump. When we rolled it into the charred stump, it looked like it had always been there. Looking into a charred shape is like a "something" but it is also a "nothing." It suggests an enormous space. The whole point of these pieces is the nothing.

JG When I go hiking in B.C., I see firesnags left after a forest fire that resemble your sculptures. I wonder what distinguishes these found forms in nature and your created forms?

DN It is interesting how one can sense the difference between natural occurrence and a human gesture. In Australia, the aborigines cut the bark and take it off a tree as one piece. They stitch it up and made a boat out of it. The shape that remains on the tree is like a boat. A very big scar on the tree that in fact is a boat. Seeing that, I felt I was experiencing an idea incarnating.

JG These aboriginal traces exemplify what you yourself have been engaged in—which is adapting natural forms in nature. There is no segregation of human activity from nature. Can you tell me something about how you began as an artist?

DN Well, my career parallels that of Andy Goldsworthy. Unlike Richard Long, who immediately made his mark in the art world as a very young man, exhibiting with Konrad Fischer, neither Andy nor I were picked up by commercial galleries for quite a long time. We made a living as artists in residence and "artists in the schools" programs. The arts funding in Britain is very much orientated toward making art accessible. We grew up with that. So when Andy and I were picked up by the galleries, we were like bridges. We helped a lot of people who would not be able to come to contemporary art see some more difficult work.

Take out or move! . . . I loved the minimalist philosophy, but I hated the objects. I liked the paintings, but the sculpture involved so much technology!

JG With *Standing Frame* (1994) at the Walker Arts Center in Minneapolis, you reference structural form and natural form in one piece, yet the piece echoes a Sol Lewitt already in place there.

DN It was made initially to be with the Sol Lewitt. The Walker already had that Lewitt, and Martin Freedman saw something like this of mine in Japan. He saw the relationship to the Sol Lewitt and commissioned me to come and make a piece on the same terrace. My piece is exactly the same height as the Sol Lewitt and the inside square is exactly the same size as his square.

JG Nature can be visually and experientially so much more powerful than human-built structures. When I look at the tree trunks supporting *Standing Frame*, there is a vernacular integrated in the piece—a straight pole and undulating tree branch supports. There is even a slight sense of humor to that piece. One needn't say mocking but instead mirroring the space between. *Sod Swap* (1983) is a completely different piece, rather like *The Wall* (1988–89) Andy Goldsworthy made in Dumfriesshire, where an exchange takes place. In Goldsworthy's case both parcels of land remained the same size, but the undulated wall creating a less standardized, more interesting configuration of that land. With *Sod Swap*, likewise, you are taking something out and putting something in and the result is equal.

DN *Sod Swap* came about when I was asked to take part in an outdoor group show at Kensington Gardens in London. I wanted my piece to say something of where it came from, so the most basic way to do this was to bring something of where it came from—the land itself. The land that was removed went to Cae'n-y-cod in north Wales. We swapped them over. At the end of the exhibition I wanted to swap them back, but they ran out of budget. So I still have the London turf which had five species of plant in it originally, but has lots more in it now. I keep it as if it was in London, so I mow the grass regularly. In London it was moved from the original temporary exhibition space to a permanent site. They don't cut the Welsh turf. They cut everything else, which is the opposite of what I do with the London turf.

JG It expresses an idea of mutual exchange! When we talk about economy, the roots of the word mean management of the home. In our times economy is very abstracted from daily life and nature. We think of art in the same way, rather abstracted—art object, art product. So *Sod Swap* brings it full circle. A greater economy of means can often express the same concerns more succinctly.

DN When there are limits to materials you rely on what you can make up out of yourself. You are only relying on what is available.

JG Sculpture can be more effective when it is not neutralized to become an aesthetic object of contemplation. When put in active areas, in farm fields where cows are merging and loitering with them, where some other activity is going on, it can be more endearing.

DN I have actually done a study and documented where the sheep go with a lot of drawings. I then made a *Sheep Space* at TICKON in Langeland, Denmark (1993). A big tree had blown down in another area, so I cut some very big chunks of oak and hauled them over into a shady area. In fact, at TICKON, the sheep really use these freestanding forms. Recently I made another such piece for a flock of sheep on an organic farm in Virginia.

JG And how do these forms work? Do you study the sheep's pathways?

DN Sheep always need shade and they need to be able to get away easily. They don't want to go into a hole. If anything approaches them, they need to be able

get off another way. They also need to be able to get out of the sun, out of the wind, out of the rain. So they go to different places according to what the weather is on a particular day. Over time, their continual presence wears an oval patch into the ground.

JG So *Sheep Space* is about building a relation between the art and the animals.

DN Yes, of course! I wouldn't put them there if they were not going to use them. If not, they would just be chunks of wood. Of course, where the sheep go, the lanolin of the wool leaves traces and oils the wood surface.

JG *Wooden Boulder* (1978–) is an ongoing process piece, a huge four hundred kilogram, one metre in diameter chunk of oak in north Wales. It becomes a sculptural action that takes place over the years. There are physical constraints on its movement, but the sculpture adapts and resonates with a physical energy. This journey or voyage is completely reliant on the vagaries of nature, which though seemingly accidental, have an unseen and inbuilt determinism.

DN I had for some time been working with the branches and twigs making linear sculptures, plaiting hazel into ropes and structures. I started *Wooden Boulder* in the mid-seventies. It came from a recently felled massive oak, from which a dozen or more sculptures were made. I intended to move it down the hill to a wood and then to my studio, but it got stuck half-way in a stream. While initially this seemed a problem, I decided to leave it there and it became a sculpture of a rock. It has moved nine times since then down this river. Sometimes I have had to move it on, as when it got jammed under a bridge . . . it could have caused a major flood.

JG I do believe that a distinction should be made between earth-sensitive art of this era and most land art of the 1960s and 1970s.

DN Its a generational thing. I think Andy Goldsworthy and I, and Richard Long, and most of the British artists' collectives associated with land art would have been landscape painters a hundred years ago. But we don't want to make portraits of the landscape. A landscape picture is a portrait. We don't want that. We want to be in the land.

2
YARDWORKING
Patrick Dougherty

North Carolina artist Patrick Dougherty's freeform assemblages woven to-
gether out of tree branches are visual enigmas embodied by the artist with a
fanciful, fairytale quality. Internationally recognized for the outdoor installa-
tions he has made in parks, galleries, gardens, and museum spaces in Japan,
Europe, and North America, Patrick Dougherty exploits the supple tension,
elasticity, tonal and textural qualities of the wood he works with. His art has a
"wildness aesthetic" rooted in the North American experience.

Combining craft and the physical practice of drawing in space with tree
saplings, Dougherty gathers, cuts, assembles, and weaves. *Yardwork*, (2000)
created at La Gabelle, north of Trois Rivières in Québec, is the first work
Dougherty has ever conceived and created in Canada. A gathering of seven
20-foot towers made of braided red maple saplings, *Yardwork*'s swirling wooden
shapes, drawn in space, are surrounded by a swooping braided form that acts as
an aesthetic container for this highly charged, large-scale installation. The
actual site situated next to the historic La Gabelle hydro dam built in 1924
is steeped in history. This was a place where French traders climbed the rapids
to exchange goods and contraband with the Amerindians of the Atikamekw
tribe, many of whom died in the Iroquois wars. The hydro dam was one of
the first in Canada, and still operates. Of the village that once existed
there in the 1920s, only a few traces remain. Forestry, fishing, and a range
of primary industries associated with our colonial history took place in the
region.

JG Your installations have been seen all over the world now and adapt to
the specific site, location, even the history of a place. You always keep an
aesthetic edge in the way you formulate and build your installations. They're
unique and immediately recognizable. How did you arrive at this unusual
way of working wood at the very beginning? When did you begin to weave
wood?

15

PD I hate to say spontaneous combustion working with these combustible materials. As a late bloomer I enrolled in sculpture and art history classes in the early 1980s. Eventually I returned home and wanted a way of working that I might already know. The first works were modest efforts using sticks to build objects scaled to my own height. I started making human forms with very small sticks and it was like magic! It turned out something good. Like a seamstress turned sculptor might continue to use Velcro fasteners, zippers, and cloth in her work, it was not so unusual that a woodsman like myself might see the value of the groves of small saplings along my own driveway.

In North Carolina where I live, small trees like maple, gum, elm, and willow infiltrate into any disturbed area. These saplings are plentiful and renewable. It is like having a giant warehouse of good material always at my fingertips. I realized that wood had a deeper aesthetic resonance. I grew up in the woodlands of North Carolina. My childhood home, like La Gabelle, was surrounded by undeveloped areas where kids could play in the wild. When I turned to sculpting with saplings, it seemed easy to co-opt the forces of nature and play a kind of energy flow onto the surfaces of the large forms I made. Before I could start this work, however, I had to figure out what birds, beavers, and other natural shelter builders already knew about branches and twigs. That is, they have an inherent method of joining. If you drag a small stick through the woods you will see what I mean. The top entangles with everything. As the opportunities presented themselves, I began to integrate my work with architectural situations and then to play saplings sculpture off against natural settings. For example, in Denmark in 1996, I intertwined large flying circles through the upper branches of a row of trees. The work here at La Gabelle is part of a new trend to build works that stand on their own and function as architecture.

JG How did you start this particular installation? How did the process begin and how did it evolve over time?

PD In May 2000, I visited Quebec as one of six artists participating in Cime et Racines Art and Nature symposium. I chose a site in the public park at La Gabelle near the main thoroughfare, where the work is easily seen. I imagined that viewers would be able to follow the progress of the work as it was built and enjoy it as the seasons changed. Initially, I made a list of word associations that related to the site, which included thoughts about fishing, fish, traps, Indian trading, and cargo. The park is also a place for teenage trysts, where you can ride off-the-road vehicles with full abandon. In my mind, the human activity of this rollicking outback place seems to merge with the wild natural force of water surging in the St. Maurice River nearby.

Using my initial impressions I made a series of thumbnail sketches that suggested a group of tall vertical forms resembling a school of fish standing on their heads. I envisioned these "fish tails" being looped by an energetic river of

sticks. Later in the planning process, I gave up the literal imagery in favor of seven twenty-foot-high abstract columns, surrounded by a six-foot-high sheet of undulating saplings. In completing the sculpture I developed passageways through this outer shell, so viewers could glimpse intriguing bits of the interior. Visitors can stand inside each of the inner structures and explore a kind of internal maze. My favorite view is from inside one of the tall vertical forms looking at the sky through a chimney of sticks.

JG The La Gabelle site, located as it is right near the river bank, is uncontained, not formalized. Its purpose and significance is not prescribed.

PD That's right! To me this site has a kind of wildness about it. If you drive through it onto the dam on the other side you will see it was a backwater before there was a throughway. The river itself seems to project a kind of primal magnetism. While working here, I have watched fishermen, boaters, lovers, bikeriders, running children, and the mad hatters who speed by on off-the-road vehicles go by. The one-way bridge and the railroad crossing nearby regularly result in small traffic jams. As the drivers slow down and look toward the river, they can't help but see the sculpture. From a practical point of view, I also felt that if the sculpture was in full public view, it might offer some protection from climbing. The La Gabelle site, because it is so unpretentious, is a place that removes inhibitions and frees the human spirit. It seems like a perfect spot for a kind of primitive sapling temple.

JG There is always this fantastic spirit aspect to your assemblages. They are animated and project a sense of childhood fantasy. You always work with a limited range of materials but seem to innovate endlessly. Each configuration is different. You integrate pure forms into your structures and the process is like drawing or etching with sticks in three dimensions.

PD Sticks are a common backyard material. Adults remember them from fall cleanup, and tossing one for the dog. For most kids however, sticks are absolutely essential and the cornerstone of much of children's fantasy play. Kids lay sticklines on sidewalks to describe the imagined kitchen and living room and then use the same stick as a spear, digging tool, a fighting staff, or trap. The use of sticks and the forest from which they come are part of the oldest memories of the human race and seem forever entwined with human fantasy. I have built a variety of abstract images over the years, but the response from viewers is often about a remembered personal experience with sticks, trees, and wild nature in general. Lately, I have heard a story about a tree called Big Mr. Twister and a favorite from another town called Simple Hard and Easy. Here at La Gabelle I heard a story about a recumbent Osage Orange tree that had fallen over and continued to grow on its side. It was a kind of sacred tree and provided countless hours of fun for generations of children.

Sticks are both tree branch and a line with which to draw. I can employ many of the same conventions used in drawing on paper working on the

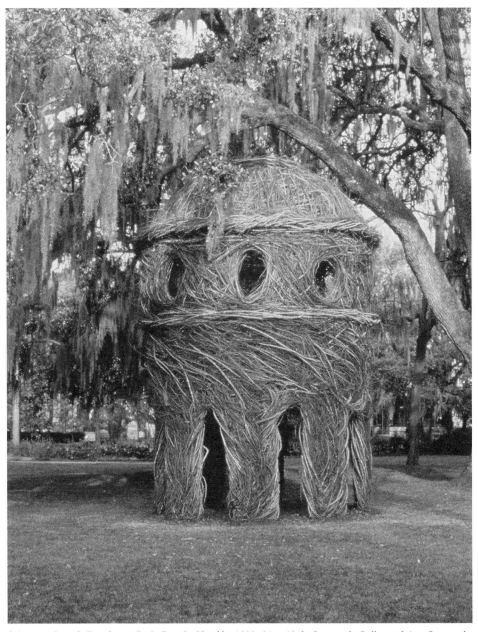

2.1 Patrick Dougherty. *Be It Ever So Humble*, 1999. 24 × 12 ft. Savannah College of Art, Savannah, Georgia. Courtesy of the artist.

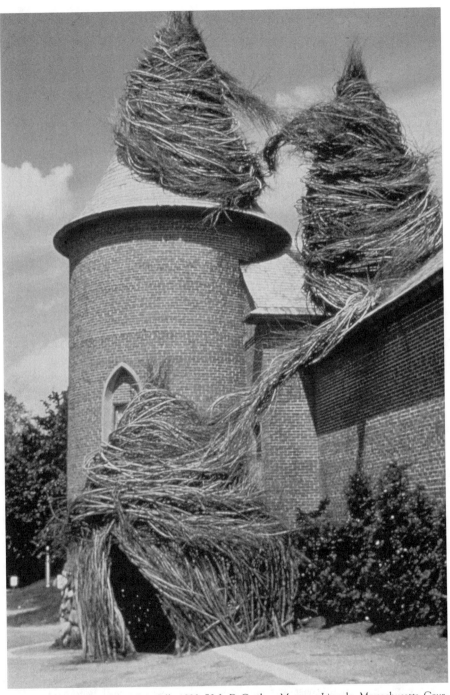

2.2 Patrick Dougherty. *Spin Offs*, 1990. 70 ft. DeCordova Museum, Lincoln, Massachusetts. Courtesy of the artist.

surfaces of these sculptures; line weight for emphasis, raking diagonals and all kinds of hatchmarks. Sticks are also tapered, and massing all the tapers in one direction builds a sense that the surface of the work is jumping and surging. The stick transforms into an animated line. As a whole image these drawn stick surfaces characterize the wild forcefulness of nature itself.

JG In *Yardwork* there is this sense of containment, enhanced by the swirling form that goes around the seven towers in the piece. This makes it somewhat unique from previous works you have done.

PD After taking full measure of the space at La Gabelle, I decided that seven twenty-foot upright forms girdled by a kind of flying fence would provide the right scale for this place. Unlike the sunny winter weather of my own home state of North Carolina, it snows here at La Gabelle in winter. And so I used the cinching action of the outer belt to help consolidate and protect the overall structure against the elements. Its a kind of racing wrap around stick sheet. The openings give a better sense that these towers are not solid, that they're hollow inside. Though I have made other temples and mazelike configurations, this river and the particularity of the place brought fish sticks and thoughts of trading tobacco and peace pipes to mind.

JG You do not usually cut down trees to make your work. I believe the tree cuttings were gathered from sites along the hydro line.

PD I say of my work that I make large-scale, temporary sculptures from materials gathered in the nearby landscape. Eddy Daveluy, a member of the local group sponsoring the symposium, helped me locate a large quantity of small red maple saplings growing under the Hydro Quebec power lines less than a mile from the park. The area was mown three years earlier and the fresh saplings that came back from the stump grew at the same rate over the entire area. This resulted in very uniform and luxurious material. Using local government trucks, a group of people gathered and transported six dump-truck loads of bundled saplings. The color and flexibility of the material is wonderful, and it is by far the best I have used to date.

JG Your work seems to play on the edge of form and chaos. Form and chaos are both present in the structures you build. You leave it all open. There is a natural and fluid flow between interior and exterior space.

PD Maybe gathering the haphazard growth from along the powercut and manhandling the saplings into a credible temporary sculpture is the real edge between form and chaos. Its a game I ultimately lose as the weather acts upon these sticks. They decay, rot, and eventually become soil again. I enjoy forming these brambles into shapes that suggest a kind of large-scale, three dimensional drawing. I try for a kind of line logic, an illusion where the lines seem to flow with a purpose and force along the surfaces of the sculpture. Lines that begin inside seem to twist and turn out of the openings and become the implied motion that scoots around the exterior. My sculptures are shelters of transition.

20

JG Working with nature and building structures in an open site involves a kind of crossover, where aspects of the built habitat and the land are both present. In other words there is a kind of cultural modification of nature in your installations. You build and elaborate with natural form, anthropomorphizing nature in a way. Working with found natural materials, you bring a human interpretation to a site. Can you elaborate on this?

PD It seems as though humans have to continuously struggle with ideas about nature and redefining our relationship with the natural world. Domesticated gardens versus the wilderness are part of a worldwide discussion and part of my (our) inner conflict. Certainly gardens are a kind of rendition of the unfettered wilds. Shrubs, trees, flowers, and grass become commodities and are forced into human geometry. I try to free the surfaces of my work using sticks as a drawing material, work them in such a way that they look like they are escaping those chains of being planted in a row. I image that the wilderness lurks inside my forms and that it is an irrepressible urge.

JG So there is humor there!

PD At the turn of the last century, people read Herman Melville and Joseph Conrad and felt a righteousness about trying to dominate and control the forces of nature, be they, beast, tangled forest, or weather. Natural resources were maidens-in-waiting for personal and industrial use. Perhaps my sculptures embody "nature" trying to creep out of the backyard and slip into the woods.

JG Unlike Japanese artists who often work with nature in a precise and highly controlled way. Tadashi Kawamata's installations are one example of this. Their conception of space is well integrated, but for them space is something you never waste when working with wood, or any material for that matter. The Japanese see nature in terms of its limitations. This contrasts the way many North American artists conceive space as a free area to work with.

PD I am sure cultural differences affect the view of space and its use. We still have an enormous amount of free space in North America and ride through it like cowboys. The fact that we haven't had these ancient traditions allows us to get away with it. The Japanese don't mind working in the tradition of the master and doing the slight incremental variation by focusing on that difference, whereas we have the gross motor skills running. The spaces I work with are generally big and require a large-scale work to have a strong visual impact. The big swath is more important than the concept or idea.

JG The other point is also that these structures return to nature. When you build them, you know they are ephemeral and will eventually return to nature. The ephemerality adds a curiosity to the artwork. People might ask, "Why would would he make this piece? What is the purpose?" The purpose is to accentuate the site in the landscape yet bring traces of the human presence into the land. Its rather like the Amerindians, for whom the land was never wilderness. In a sense this kind of art is civilizing our idea of wilderness. It's

21

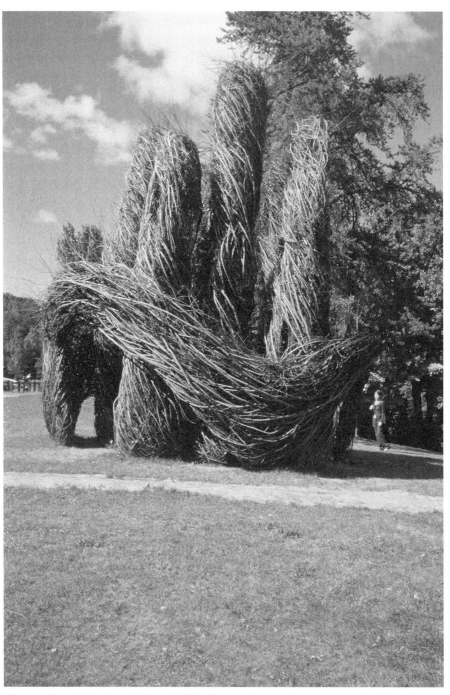

2.3 Patrick Dougherty. *Yardwork*, 2000. Cimes et Racines Symposium, north of Trois Rivières, Quebec. Courtesy of the artist.

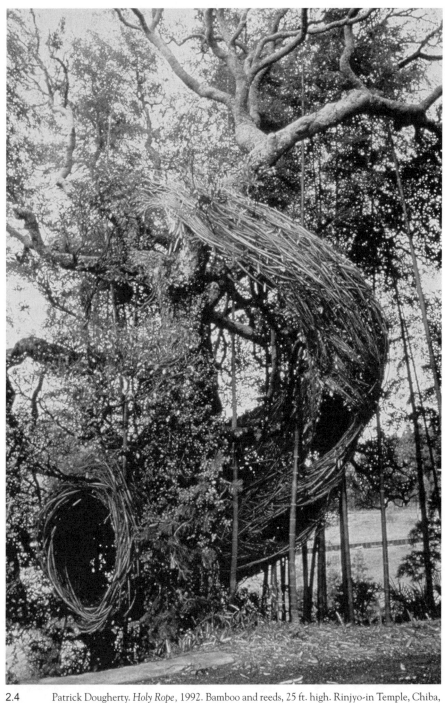

2.4 Patrick Dougherty. *Holy Rope*, 1992. Bamboo and reeds, 25 ft. high. Rinjyo-in Temple, Chiba, Japan. Photo: Tadashi Sakurai. Courtesy of the artist.

post-Cartesian, no longer rational, not a rationalization of nature more a familiarization, one could say, with the land.

PD Sometimes I worry about that. It comes back to the anthropomorphizing. You are giving vent to a human concept of nature. I make temporary work that challenges some traditional ideas about sculpture—that it should last forever, can be bought and sold, and can accrue value for those who own it. My rewards, besides being paid for the work I make, are the conversations and interactions I enjoy with the viewers during the building process. These often poignant exchanges, sometimes highly charged, allow me to participate in the larger world of ideas. It is also fair to say that I have been allowed to use many provocative spaces simply because my work is temporary and can be removed after a set period. If a work is to remain thirty years, it requires vast amounts of consideration and all kinds of permits. A temporary work often avoids many of the pitfalls of using public space.

As to this other concern about art civilizing our view of wilderness, it probably does. Artists, naturalists, politicians, actually almost everyone I meet, view nature through a manmade window. I am personally confused by many so-called environmental efforts, as it seems difficult to understand the biggest environmental picture. My own work does not really attempt an environmental mission. It is still more about *Moby Dick* than about a maelstrom that takes out a city. I like the fact that nature has a will of its own that we cannot control. It seems clear that people like gardens and grass, but they desperately desire a connection to wilderness—even if that concept is not clearly defined.

JG I find the siting of *Yardwork* by a hydro dam very interesting. The St. Maurice River waters have propelled this hydro dam for seventy-five years, the *draveurs* and loggers have long worked this river. Trading took place here. Colonials exchanged goods with the natives in early times. The site is a crossroads that captures an amazing range of cultural, natural, and historic cues. The wilderness surrounded islands of civilization in this region, in contrast to the United States where the wilds were always to the west.

PD Yes. La Gabelle has a wealth of history. The park in which *Yardwork* now stands is the site of the village where the crews who built the damn once lived. Once wilderness, it became the front yards of homes where flowers were tended in the 1920s. In the 1940s the village was leveled and only the trees from that era survived. To think that it has returned to a natural situation is kind of strange. It is now a community park and festival area for the nearby towns of St. Etienne-des-Grès and Notre-Dame-du-Mont-Carmel. In fact it is a still a yard, and hence the title *Yardwork*.

3

Gilles Bruni and Marc Babarit

Gilles Bruni and Marc Babarit are two French artists who have collaborated on projects at TICKON in Langeland, Denmark, Enghien, north of Paris, in Germany, and in Italy. After studying agriculture in the 1970s, Bruni and Babarit experimented independently with painting and sculpture. They abandoned their respective artistic practices in the 1980s to share a neutral and common field of experimentation. Since 1985, they have worked together as a team in outdoor settings, building and creating, interacting with a specific site using natural materials. Because the works they create are ephemeral and temporary, their constructions are conceived with a great sense of freedom, discovery, and innovation.

For their intervention in the Gaspe region of Quebec, for instance, Bruni and Babarit chose a forested area of private land adjacent to the outskirts of the village of Bic. Because human interventions were not as strictly controled as within Bic National Park where other artists chose sites, Bruni and Babarit considered it to be a more "natural" living ecology. Ordinary human activities were allowed, and selective cutting—a process that facilitates the growth of mature forest trees—was likewise allowed. The local ecology, space of the forest interior, time of year, climate, and vegetation, all play a role in the creation of a typical BB outdoor installation.

Conceived to gradually disintegrate with the seasons and return to their natural state, Bruni and Babarit's interventions are a natural interaction between two artists and a selected site, an ever-changing habitat of living matter. Bruni and Babarit are fully aware that art transgresses the ecological order, however "pure" or minimal the interaction. They divide their time between teaching and fieldwork in France and abroad (the United States, Germany, Canada, Denmark, Italy, and Austria), executing commissions and participating in symposia.

JG What brought the two of you to work together as environmental artists? To be two? (Two B or not to be, that is the question!)

BB The fact of working as a pair, in situ and outside brings a fundamental social dimension to our work, firstly about the "minimal ethnic unity," being two, the territorialization of landscape gets its meaning. The duality requires keeping a keener, more watchful eye on human relationships and their place in questions of appropriation and the management of space. We claim not only this work as a pair but also with the elements of the environment in which we immerse ourselves, at once climatic, geophysical, social, and technical. Being two, we develop the minimal conditions of collaboration and codependence, of synergy, of respect in the sharing, of conflict and of contract, naturally widening this situation to others in trying to work with them, take them into account, drawing them into these adventures.

JG The scale and rustic approach you have embraced seems anathema to contemporary art. What are the main interests that drive your work?

BB Our approach doesn't throw an anathema on contemporary art from the outset. Actually, contemporary art is largely made of a series of anathemas that become "academicized," one after the other. You have to be realistic. We are also part of the artistic sphere. However, the attitude we advocate, this idea that humanity is part of nature and that our position stands on "terra firma" is not in the air of arts criticism and theory. The tendency is more often toward the virtual, and is always more mind driven, and far from a "material" relation to the world judged as being too trivial. We think our human condition fundamentally depends as much on the "basic" as on having one's "head in the clouds," there is no privilege of the thinking on the making. We defend a position that is both materialistic and idealistic.

Explicitly, we share the already ancient idea of a museum without walls, that the work of art is the site, and that the site is planetary. The art is thus where it is made, with the people who are there. The work results from this physical and social inscription of the artists in a specific site. To reveal a site, to name it, to reconcile a landscape with its inhabitants, to relocate. To give back meaning to the local might seem to be a paradox when the vast movement of globalization never stopped from delocalizing, from leveling the differences. We think that, humanly, we never stop from living this dual movement.

Be it topographical, architectural, agricultural, artistic, or customary, the concept of site torments us, it is universally shared: How to inhabit the world? A game between us and others in sites where the intent is to make happen and reveal what is there via our interventions.

JG Can you tell me something about your most recent and upcoming projects?

BB In 2000, we had the opportunity to work at the same time on an impressive site, an open mine site near Bitterfeld, being converted for the Expo 2000 (between Dessau and Leipzig, in the east part of Germany), and in a little place in Brittany, something very intimate. It seems to us to be very salutary to be able to work on these two levels, the scale of the sites changes nothing to our socio-ecological relation to the site.

In Germany, the six hectares that we occupied had eight hills and forty-nine slag heaps: a transitory landscape for remembering, walking, looking, locating oneself's work toward a social and environmental project in a difficult context. (Bitterfeld, the European capital of unemployment and pollution was then the headline of an article in Le Monde.) We were torn between the fact of allowing ourselves to propose a work of mourning to a population that had been the subject of numerous aggressions for the last century and giving our approval, against our will, to a system of "redemption through art," one that enables "society" to clear itself of any responsibility far too easily. Over there, ecologically speaking, industry has crushed the environment and the people who were there at the same time. A cosmetic approach doesn't cure the wounds, it only hides them.

At the same time, in Brittany, more serenely, and with "a few pairs of hands" (including the inhabitants of the place) we have set about "the willow fence: to filter our words and temper our exchanges," a lighter project, more intimate, where we come back once in a while in order to follow the evolution of the vegetation. The two experiences are complimentary for us, a question of balance, and of cycles.

At this moment, we have proposed a work for a damaged site in the South of France, at Fos-sur-Mer, a small town ruined by a complex of petro-chemical industries and the consequences that go with them (landscape, city planning). Our visit is linked to a fire that devastated a parcel of nature on a dry hill. The project is again about an "idea of nature." In this case it is symbolic. Ecological awareness is not equally distributed: sensitive to their conditions of life, to the excesses of pollution, to the neglect of the environment, people create their own ideas of nature, fantasizing like everybody else about a space strongly "anthropized" (changed by man) since antiquity. . . . The aspect of the hill is apocalyptic, ashes from the scrubland emerged from the garbage, left over from World War II, ruins or relics from ancient and forgotten pastoral occupations, "to reconcile man with its landscape, an affair to be continued."

We will also intervene in a training center for school teachers. The site is an urban one. The loss of nature is not perceived as such. But what is at stake is important. It concerns the raising of consciousness to art, to the landscape, to the eye, of those who will educate the generations to come. To renew contact with a space often relegated to the status of scenery, of green spaces.

JG When talking about nature with you, you emphasized that nature is a place that is not distinct from human activity but a shared space. Can you explain?

BB Yes. For us nature is a space shared with other inhabitants. If we are willing to come back to the fact that nature is only a concept, which evolves into ideas of nature, we only have a fragmentary comprehension linked to a state of our knowledge, a state of our societies. It is full of paradoxes. The cultural gap that we always cultivate allows us to try to seize it. With this conscience of the world, of the part of the world that is habitable, humanity discovers more and

3.1 Bruni/Babarit. *The Lean-To: Building a Temporary Shelter for Peace and Protection in Any Season*, 1995. Wood, tree branches, twine, 23 m. long × 2–8 m. wide × 5 m. high. Art and Nature Symposium, Bic, Quebec. Photo credit: Cliches B/B. Courtesy of the artists.

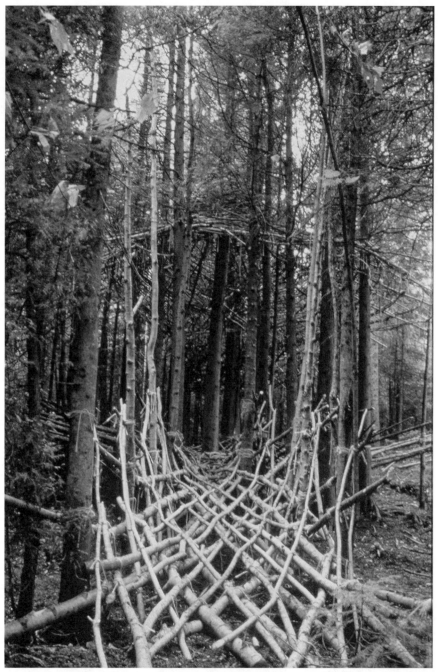

3.2 Bruni/Babarit. *The Lean-To: Building a Temporary Shelter for Peace and Protection in Any Season* (detail), 1995. Wood, tree branches, twine. 23 m. long × 2–8 m. wide × 5 m. high. Art and Nature Symposium, Bic, Quebec. Photo credit: Cliches B/B. Courtesy of the artist.

29

3.3 and 3.4 Bruni/Babarit. *The Stream Path: Clothing the Banks for Confrontation and Cohabitation of the Commonbed*, 1988. Clemson University, South Carolina Botanical Gardens. Photo credit: Ernie Denny, SCBG. Courtesy of the artists.

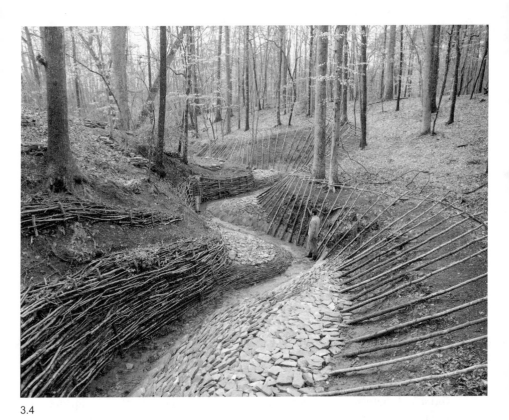

3.4

more to its own cost that the more it tries to control nature, the more it becomes dependent on it.

We are "sentenced" to share with the plant that lives there, the ladybug, the rat, the cloud that passes by, the night that falls, the cold, the rain. . . . Outside a moralistic doom watch generated by the media, we must bring this back to an intimate experience of the world where the question is, for us as artists, to get lumbered with the vagaries of vegetation and climate to remind us that we inhabit the world and to not only concentrate ourselves on the human community and our common humanity. Humanism, yes, but not at any price. The place of man in nature is thus necessarily reformulated: to dominate, to manage, to adapt, to adapt oneself—to constrain or to collaborate?

We are part of the system, a link in the chain, precautions and excesses taken together. Our long history of agriculture allows us to get some lessons. It doesn't mean either to fall into the other extreme of a blind and quite obscurantist "deep ecology" looking for we don't know what primordial environment. Man is part of the ecosystem.

The terrestrial space is an "anthropized" space. Man is a cosmopolitan animal who occupies the largest part of the terrestrial ecosystem. He has to share it with his fellow creatures and with a complex geophysical and living environment, which he finally dominates but only partially. Thus, we think that we have to find the ways toward a renegotiation of our relationships to the world, and that this renegotiation can, in particular, be done through art: we never actually work in neutral places, we have to take into account a third party with whom we must compromise.

4

EPHEMERAL PUBLIC ART
Jerilea Zempel

Renowned for her public art installations and "mock monuments" that appropriate urban and natural detritus, "transforming them into strange shadows of their former identities," New York–based Jerilea Zempel's art projects bring together feminist and ecological concerns, but do so with a wry sense of humor. Among her best known works are *Excess Volatility*, created at Battery Park in New York City in 1989, *Peace Dividend*, which involved "redefining" the look and purpose of a field artillery gun in Canterbury, England, and *Guns and Rosettes* (1995–98), a project that involved "redecorating" a Soviet tank at the military museum in the Citadella at Posnan, Poland, a site that has witnessed battles since the Napoleonic invasions. More recently Zempel has become referred to as the Princess of Manure for the ephemeral works she creates out of horse dung. These tongue-in-cheek takeoffs on formalist art history also have a serious side. They cause us to reflect on the very permanence and historicity that traditional monumental sculpture assumes. As a result, the dilemmas inherent to official public sculpture are highlighted in these works, and a sense of immediacy, relevance, and social satire become part of Zempel's public art vernacular. Instead of using traditional materials such as bronze, steel, and concrete, Zempel appropriates the detritus of militarism, or alternatively works with biodegradable manure. She has an attitude and admits to it. Her work has attracted a dedicated following of like-minded artists and public, who are often invited to participate in the making of these works. In so doing Jerilea Zempel is helping to broaden social and public discourse on the nature and role of public art.

JG Your public works have consistently built a continuity between the process of artmaking and the site. In your choice of site, the social environment likewise looms large. I was wondering when you began to orient your artmaking this way? What were your first public artworks?

JZ I started doing outdoor work as soon as I was out of school. I was more interested in formal issues then and to site a formal piece out of doors is a

33

challenge. I was always interested in how something looked outside, how the background was a field. It was like a painting issue, a concern with the object-field relationship. Then I started to think about external issues, not what a piece looked like but why I was doing it. A couple of years ago I was invited to do something at Art Omi in Hudson, New York, in a huge open field. There were at least ten artists and myself and we all had to do something in the field. We were like animals in a farm. We had to coexist in this pasture. And most of us felt compelled to do it because we wanted a showing opportunity. We needed the field but did the field need us? I decided I wanted to give something back to the nature that had to endure what a bunch of sculptors were about to do to it. I wanted to do something with the field that didn't change it in any way. Most of the other artists clawed up the field, put in concrete footings, leaving their mark on the field in some way that could never be erased. I wanted to do something silently, and my friend Naj Wikoff encouraged me to do something with the field that wouldn't change it in any way. Should I do something out of ice? How could I make an object that would just disappear? Then I came up with the idea that this field could use some fertilizer. Why not make a sculpture out of horse manure and let it dissolve? Then the issue became What form did the material deserve?

JG Was this work *The Lady Vanishes?*

JZ No. It was a very small show and I didn't have my shit technology together. Manure was just an organic material I wanted to work with and I didn't know how to build with it. Since I had been educated to revere the modern masters of sculpture, I thought *Well, maybe I could redo some masterpiece of modern art in manure.* I went back through the orthodoxy I was taught: Rodin, Brancusi, Henry Moore, Matisse. I started to look through some of their works to see which one was best suited to be executed in horse manure and given back to the earth. Most of what I found were naked bodies—female bodies—and sexual imagery. So here came the feminist side to it: How could I pay them back for the endless stream of naked girls? And I realized I would have to carve it. Technically, I was constrained because I couldn't do anything really complicated in terms of modeling. I found Brancusi's *Kiss* and it was blocky and very simple to do. I made it the size of the original, which was very small, and I planted a little garden around it. It was very very quiet while many of the other artists were struggling to make the biggest, loudest possible pieces.

JG Yes. Probably imposing works, always that idea that if you make your mark emphatically and with permanent materials that somehow it will be indelibly inscribed into the annals of Art History. Yet we have so many permanent works, literally an overpopulation of permanent materials and objects in our parks, governmental and corporate headquarters all over the world. They begin to look like baubles or decorative designer mementos rather than art.

JZ Yeah! I did this tiny little thing and situated it under a tree, planting flowers around it. It wasn't easy to find! Ironically, my first "dung work" didn't

dissolve very quickly and lasted longer than many of the other pieces that were vulnerable to wind and rain. My *Kiss* actually had to be broken apart several seasons after the show. Dung is a big building material in the developing world where it is hot and dry, but there are also sod and mud houses in our climate. **JG** Yes, In Canada we have nineteenth-century sod houses made in the Victorian style in southwest Ontario with the gabling and so on. The actual brickwork is sod. In China some homes made of earth and dung are actually hundreds of years old. And in the southwest United States there is the whole contemporary adobe housebuilding phenomenon.

JZ After creating this initial piece I thought I could work my way through the modern masters. I was invited to the art park in Casenovia, New York, and had the opportunity to make a bigger piece. I decided that Henry Moore deserved some attention because he did so many naked women. I thought it was time to make a reclining female nude out of horse manure.

JG There is quite a bit of humor in your work. And I think the humor comes from a posthistorical look at the macho nature of the twentieth century's art history and movements. For me your work is not only cause for reflection but jubilation, because live culture is so firmly embedded in the conception of your works and people can identify with it. The isolation of the artwork, the aestheticism, the refinement, can be a challenge for those who are initiated into it, but popular public art has a vernacular all its own. I think this is where your work plays an effective role in breaking the boundaries of contemporary art and leaving the discourse open. Can you tell me something more about your notion of mock monuments?

JZ Along with all this formal orthodoxy that was fed to me at school came the idea that there was High Art and then there was popular culture—everything else around us in life. It took me a long time to unlearn the hierarchy. I think a lot of what I do now is about mocking this distinction. Monuments are a class of sculpture that publically commemorate important events or grand persons, usually war or military heros. They represent some shared values of a culture. It's hard to know today what we share, so the question of a monument is a tough one. That's where I got the idea of a "mock monument."

JG When I think about the work of contemporary artists like Ashley Bicker-ton, I feel that all the cleverness they are involved in is an internal aesthetic quarrel about the niceties and history of modernism and postmodernism. Do artworks like these really have an enduring message or are they just fashion?

JZ Any artist who, like Bickerton, participates in the art market is in a sense constrained by the High Art distinction because, if the market didn't have that distinction how could it build a value to keep it going? My work has almost no value because the minute it is realized it starts to disappear.

JG There is also a wildness coefficient in your particular brand of public art. *Excess Volatility* (1989), one of the works you call mock monuments, actually looks like a bizarre animal that has forayed into New York City. The de-

35

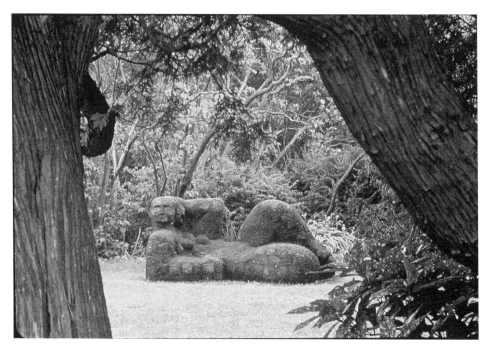

4.1 Jerilea Zempel. *The Lady Vanishes*, 2002. Dried horse manure. St. Catharines, Ontario. Courtesy of the artist.

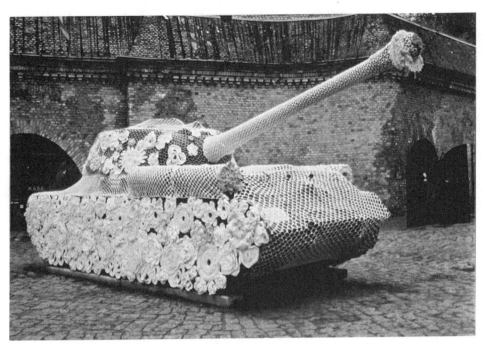

4.2 Jerilea Zempel. *Guns and Rosettes*, 1995–98. Poznan, Poland. Courtesy of the artist.

sign and haphazard conjunction of materials—an old VW, tree clippings—encourages further reflection on so-called official monuments and their supposed permanence and immortality. Recycling an abandoned burnt-out Volkswagen beetle, bringing it into Battery Park, clothing it in tree clippings and branches donated by the New York City park management, and clothing it with tree branches, you created a work that comments on the speed of modern life. The message is ever more pertinent. There is always this permacultural aspect of life we seem to miss in contemporary society due to our visual and social conditioning. I found *Excess Volatility* particularly exciting because of its siting in a fairly ordinary standard-usage public park.

JZ I thought for a long time about that piece. Basically I decided to take two forms of garbage, two materials that had been cast away and were thought to no longer have any value. And I wanted to see if I could do some magical thing with them, by putting them together, to give them a new value as art. A lot of people think that art is made of precious material, but the twentieth century told us that it is not. I wanted to put art made of garbage in a place where garbage is not a day-to-day issue. I would never have done that on the Lower East Side or uptown in Harlem. I did it two blocks from Wall Street!

JG In a way this is Naum Gabo in reverse. Modernists were always looking for the latest material, like plastic, to bring a sense of their vision of historical progress. They had so much faith in progress. The segregation of humanity from nature was implicit in their specialized vision of artmaking. Now we seem to be working in reverse, trying to find forms of art that are like biomimicry, or that emulate nature's design. The integration of economy into ecology, not only in the art field but in all fields, has become a hot topic. Your work builds a kind of social repartee into it, and a discourse develops between the people who live around the places you work. With *Guns and Rosettes* (1995–98), for instance, done in the Citadella of Posnan, an industrial town in Poland where military battles took place in the past, you organized a volunteer team of architecture and textile students and locals to crochet a tea cosy for a Russian Tank using fishnet and rosettes. Emblazoning feminine motifs onto macho war implements, a way of bringing into artistic focus the whole post-Soviet experience in Poland.

JZ *Guns and Rosettes* was really specific to the history of its site and to its moment in time. The Poles were just feeling their freedom from Soviet influence. There was not an army to be offended. Everyone was amused that this American would come and poke fun at their former oppressors. I'm not sure I could do that work now because the social, cultural, and economic atmosphere there has changed. I think if I went back and asked for permission to do it I might not get it. It was serendipitous. I was just lucky to be at the right place at the right time. I went into the project with a lot of naive enthusiasm and the help of a wonderful Polish sculptor Joanna Przybyla, who somehow understood the situation better than even I did and helped me figure it all out.

JG Didn't the citizens of Poznan flock in droves to the military museum to see the work? It became a kind of beautiful ghost of Soviet militarism. Children offered flowers and asked for autographs, and grannies inspected the knitting and pronounced it "fantastic," while men, of course, discussed the relative merits of the actual tank model. The event itself is fascinating as much as the finished work.

JZ Yes. Polish TV was there almost every day. I think it had as much to do with Polish media wanting to be as American as possible, practicing what they thought were Western media tactics, fighting to get the first scoop. They didn't want me to talk with anyone but them and didn't care if I finished the work. They just wanted to cover it every night in the news. I thought maybe it would attract attention in Germany, but it didn't. It was a real Polish phenomenon. A lot of New York artists thought I was wasting my time because they consider New York the only forum for art.

JG Art from the margins seems to be important in feeding the center. One thinks of the expressionist Edvard Munch coming from Norway to Paris in the nineteenth century, or Brancusi from Romania, for instance. As things become increasingly regionalized and the world is linking beyond borders, I think that our perception of the role of art is changing too, just as the art market is. I feel that the devaluation of the artmaking process by the art market is a dilemma for many young artists that they can't quite figure out. Your art projects show how artmaking can be fun, as well as a social and educational activity that involves the public. This idea of ephemeral public art that you build into your new works is catching on. Even the Poznan tank piece is a rather ephemeral work—like clothing. Taking this war implement, this dinosaur of militaristic nationalism, and clothing it in pink, highlights the ridiculous nature of war. War is one of the greatest polluters and money wasters, even when its so-called purpose is prevention. Even now, when the third world or the poor need our help, President George Bush has proposed a preventive strategy for nuclear threat to the United States. It seems like a kid's game!

JZ When the Soviet Union collapsed in 1989–90 and there appeared to be no military superpower except the United States, the American government announced that we wouldn't have to spend so much on our army, that there would be a peace dividend. So I started to think it would be great to use all that left-over military stuff as art material. Landscapes all over the world are littered with trashed tanks and wrecked planes. I understand the desert in Saudi Arabia and Iraq is just covered with spent war materials.

JG I have heard that in some parts of North Africa they use tanks as architecture instead of weapons and build them into walls because they do not know how to use them—don't have the fuel and don't know how to repair them.

JZ When I was in art school no one really thought about how much material we were wasting and throwing away. Why not use cast-off materials as art supplies?

JG In a way, limits to materials increase resourcefulness and creativity in people. One teacher I recently talked to said he is going to have his students work on a patch of ground and use just what is there. You came up with *Peace Dividend* in Canterbury, England, didn't you? The timing of the work again was excellent. What was the reaction of the officials to this piece?

JZ A lot of my projects with military mateials were done in other countries. The U.S. Army is a lot more protective of its image and its used military hardware. I once got permisson to recycle materials from a base in Pennsylvania, but when I started selecting things from the scrap pile, like exploded schrapnel from munitions tests, I was told I couldn't have them because they could be analyzed for military secrets. On the other hand, in Canterbury the head of the garrison, who lent me a field cannon to thatch, came to the opening launch for *Peace Dividend.* He was somewhat surprised to see what I had done. I explained to him that I had made it with a pair of scissors and some string and boxes of pine needles and that I had Margaret Thatcher in mind when I made the work because she obviously came from a family of thatchers. She was then prime minister and her government was having lots of crises at the time. In typical British fashion, he was very polite, but I could tell he was disapproving. But he didn't try to stop me or censor me in any way. Nor did he speak out against the project.

JG I was wondering what projects you have in mind for the future. You mentioned you hope to work on a piece in the United States that involves a disused war plane in upstate New York, at Plattsburgh.

JZ In Plattsburgh, New York, there is an abandoned SAC (Strategic Air Command) base. They used to have bombers scrambling in the air all the time, fighting off the threat of a nuclear launch against the United States. Some years ago it was closed down and the missle silos covered over. It looks like a deserted suburban ghost town. The grass is cut, the bushes are clipped, the windows are clean, the signs for the base stores and theaters are freshly painted, but it is empty of people, as though everyone left a few minutes ago. It is eerie, like an empty stage set. There's a very sleek bomber sitting at the entrance on a pedestal. It has no scale at all and looks like a toy, a model. It doesn't look as big as it really is when you see it, more like one of the toys you buy in a store. I would like to work with a team of north country fiber artists, because they are not given enough attention, and they are usually women. (It would be an estrogen alliance.) Together we would make a cover for the bomber and it could become a tourist attraction.

JG A neat idea. What sort of material would you use for the cover?

JZ We would have to use acrylic because it doesn't shrink and maintains its color. It also won't rot. It will basically be a big sweater, a huge sweater, probably colored pink. I am sure that the estrogen alliance will support us! Maybe Hillary Clinton will help out. It would be really fun to make a public call and invite everyone who is willing and knows how to crochet to do a flower for it.

JG It seems that even now many contemporary female artists do not get enough airplay in the art world. And one of the problems I find is that those who do get airplay tend to have one agenda, one ax to grind, and fail to broaden the issues. When the statement or commitment is more universal, as was the case for Ana Mendieta, the art seems to draw a larger and less academic audience from the start. I feel it unfortunate that agenda-driven art is given more attention than the incredible range of work being done by women now. One just has to remember Barbara Hepworth, who made the first pierced stone sculptures before Henry Moore, and never received much recognition for that. Moore appropriated Hepworth's stylistic innovation and was thought to be the originator. In fact Henry Moore is almost like a pastoral artist—a twentieth-century Turner of sculpture—particularly when you think of a sculptor like Jacob Epstein whose *Rock Drill*, actually a pneumatic sculpture, was very critical of industrialism, of man and machine, as was a lot of women artists' work from the early part of the twentieth century. The art world was as male dominated then as it is now. Hepworth, of course, was married to Ben Nicholson. There is a strange symbiosis that goes on between artistic couples. The same goes for Ana Mendieta and Carl André. The men tend to be the mainstream formalist "originals" and the women more open minded, organic, and future oriented, especially when you look at it in hindsight.

JZ I think there is a way to think about the differences between male and female artists. Men do command a greater economic share of the art world for sure, but on the other hand they have more expectations of conventional success to live up to. I feel there is a greater freedom in being a female artist. I don't have to worry about my work reselling at auction because it will never get there! I am not trying to be a Pollyanna about that, but there are some advantages to being a woman artist.

JG Well there is another irony that I saw in *The Lady Vanishes* a full-scale replica of Henry Moore's reclining woman, made out of manure, in that Henry Moore appropriated this pre-Columbian piece to integrate a spiritual quality in his work. The colonial cultures from which artists like Henry Moore come—Britain, America, wherever—are precisely the cultures who wiped out so-called primitive cultures (including natives on the West Coast for instance). And then these "modernist" artists come along a century or two later wanting to reappropriate the spiritualism from the objects of the cultures they wiped out. It is like a double whammy!

JZ I did a copy of Henry Moore, who cribbed the Mayans. It was great. When I discovered where he got the image—from a Mayan temple sculpture—it seemed a perfect choice. Last summer I was asked to do a manure sculpture for the twenty-fifth anniversary of Sculpture Space in Utica, New York. I looked for an iconic female image from Western art and I settled on the caryatid, those mythological women holding up temples on their heads. It just so happened that the area of the Mohawk Valley is filled with Greek revival

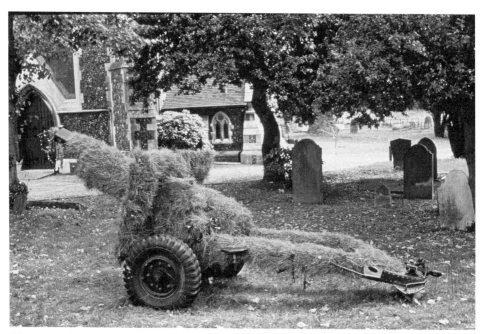

4.3 Jerilea Zempel. *Peace Dividend,* 1990. Army cannon, pine needles. Canterbury, England. Courtesy of the artist.

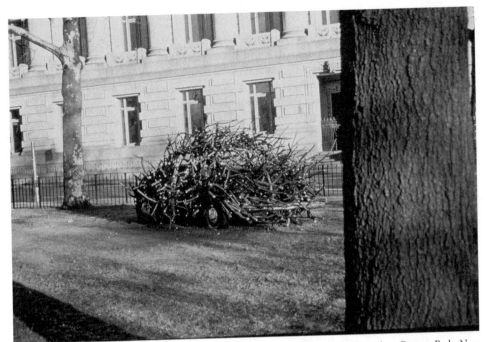

4.4 Jerilea Zempel. *Excess Volatility*, 1989. Abandoned Volkswagen, tree branches. Battery Park, New York City. Courtesy of the artist.

architecture from the early nineteenth century. So it fit perfectly and gave everyone a basis for discussing the project. There were lots of gardeners around so the idea of making something out of manure was completely natural to them. Some even admired the quality of my art material! Masons working on a bypass nearby came to see how I was building the figure out of mud bricks held together with mud mortar, a process similar to building a brick wall. One even confessed to me that his daughter was an artist and how he worries about her life. Working in public can be a sociological event.

5

IN NATURE'S EYES
Alfio Bonanno

A pioneer of the site-specific nature installation, Alfio Bonanno uses nature's materials, cutting, lifting, carrying, bending, and placing them to build artworks that have a rough feel to them. Ephemeral and earth bound they establish links with nature, a reminder that nature is both a spiritual source and practical provider for humanity's needs. When he arrived in Denmark from Italy in the 1970s, with roots in the Arte Povera, nonconformist use of materials, Bonanno set to work in Denmark, where he was one of the first to involve himself with art actions that involved creating art with and within nature's sphere. The founder and leader of TICKON—Tranekaer International Center for Art and Nature in Langeland, Denmark—a venue that has attracted many of the world's leading artists who work on site in natural settings, including Andy Goldsworthy, David Nash, Karen McCoy, Chris Drury, Alan Sonfist, Lance Bélanger, and Lars Vilks, Bonanno has extended the language of outdoor installation through his activities with TICKON and as an independent artist. His concerns are as much social as environmental. As Bonanno states: "The 'other landscape' exists at a closer look—here—where we have always been. Where we least expect to find it—there it is. Where earth meets air, and water meets the sun, we see myriad vital life cycles. And life arises, where it is given a chance to exist: on the cracked boards of a train wagon in movement, in the midst of a concrete footpath, on rooftops."

Alfio Bonanno has exhibited his works extensively in European and international exhibitions and symposia. Among these can be included Naturligvis at the Kunsthallen Brandts Klaedefabrik in Odense (1994) and Peace Sculpture '95 (for which the video Bunker Art was realized), both in Denmark. In Barcelona, Bonanno's breakthrough multimedia installation for the Miro Museum (1985) brought him international recognition. Near Allihies in Ireland, Bonanno produced The Mountain Shelter project (1995) for the Wilderness Sanctuary on a remote cliff in collaboration with Chris Drury, a shelter structure intended to be frequented by poets and visitors. Among his commis-

45

sions can be counted an upturned oak tree installed inside the AMU school in Svendborg (1995) that provides a central focal point around the stairway and seems to carry the roof, and *Snail Tunnel* (1998) created for the Louisiana Museum of Modern Art in Humlebaek where, participating alongside Mario Merz, Richard Serra, and Suzanne Ussing, Bonanno made an outdoor passage that used the variability of tree limbs to add a quality of mystery and imagination to the event. For the Arte Sella Nature Biennial in Valsugana, Italy, Bonanno responded by building *Where Trees Grow on Stone* (1996), an elongated curving bodily form out of branches, twined together and filled with tiny stones in a forest interior—a nature offering. An ingeniously curved and intertwined branch weave around a dead tree for the European Art Nature Triennial in the Dragsholm Castle Forest (1998) reaffirmed Bonanno's view that "A fallen tree is not necessarily a dead tree—it lives on through its memory and continues to participate in the very cycle of nature that once gave it life—if we listen, it will tell us stories of our own existence within that same cycle." A simpler basket of woven branches built around bright green moss growth in Vrangfoss, Norway (1999), and an exquisite curling podlike sculpture made of bamboo (*Where Lizards Lose Their Tail,* 1999) in Tosa Town, Japan, seems to defy gravity in a surreal way—a mimicry of bioform in art. In Scotland, Bonanno's *Fossil Fragment* (1990) sculpture out of a carved tree with sandstone elements became an interesting kind of instant archaeology, a refabrication, natural history in the art mode. For the *East Sea Ring* in north Germany (2000), Bonanno set the whole project alight in a ritualistic act of identification with the complexity of the site.

Bonanno documented nature's resilience with a series of photos published as a book titled *Linguaggio della Terra* in 1995, and at the Charlottenberg Exhibition Palace in Copenhagen (1997) he exhibited 1,620 photo portraits documenting all the leaves from a small elm tree in his backyard. The language of Bonanno's nature assemblage, often enacted with boulders, logs, and tree branches, extends our awareness of nature's resource. At the International Sculpture Conference in Houston, Texas, Bonanno gave a memorable and impassioned speech called "Art, Nature or Silent Revolution" (2000). He created a site-specific assemblage commission at the Cedarhurst Sculpture Park in Mount Vernon, Illinois (summer of 2001), and a bamboo snail sculpture titled *Keong* (2002) for the Art of Bamboo Symposium in Nitiprayan, Central Java in Indonesia. A 45 minute documentary film titled *Fragments of a Life* on Alfio Bonanno's art and life, produced by Lars Reinholt Jensen and Torben Kjaersgaard Madsen, is now available.

JG After World War II you returned at the age of nineteen to Sicily from Australia, later to be joined by your parents. The place was called Contrada D'Urne—the area of the terracotta vessel. In antique times people walked through here to fill their amphoras with water. In the spring of 1966, a landslide enveloped a section of road near the hills where your family lived. Visiting the

slide site, you discovered a beautiful amphora upturned by this natural disaster. When you tried to remove it, pull it out of the soil, it crumbled back into earth, just a stain in the mud. It must have left a lasting impression—this trace of ancient history—first seen, then returned to nature—the very essence of emphemeral. It is something one finds in the conception and process of your sculpture, and has followed you throughout your career.

AB I have always been fascinated by traces in the landscape, something that tells a story you can build on. It gives meaning to our existence. That particular instance must have left something with me. It was full of so much symbology, and to experience it in that way was the real thing. When I helped my father build stone walls to keep the earth from eroding in that area we often found pieces of ancient pottery. Though I am not an archaeologist I could see they were old. It fit into the idea that this place was one where water was collected way back in time and there was no other water in this area. When my father bought the property it was all covered with thorn bushes. There was no water. It was very hard. We finally found this little cave in the earth. I would go down into the earth and crawl on all fours. We dug it up and went in and found these very old tiny lamps lying there. It was very dark in there. Then all of a sudden there was a tiny trickle of water—so small—not even the size of the head of a pin—but that was enough. My father dug a little more, and he made a container outside. With time it filled up and we were able to plant. We relied on that tiny source of water to irrigate the farm.

JG When you began your career as an artist in Italy you must have absorbed the Arte Povera artist's innovations with found, cast-away materials. Do you feel you transferred some of this social initiative to the nature art you began to make in Denmark?

AB Oh yeah. Already at fourteen, I told my parents I did not want to go to school, that I wanted to be an artist. I had odd jobs and went to art school in Australia. By the time I was living in Italy, Arte Povera was quite strong. I was quite aware of people using natural and discarded materials. Most of them were using natural materials, even if they were working conceptually. Jannis Kounellis, for instance, was using horses in his installations.

JG Your project at the Miro Museum in 1985 was a breakthrough exhibition and brought much-needed attention at a time when environmental art was less recognized than it is today.

AB In any profession you need someone to believe in what you are doing. The Miro Museum gave me the opportunity to make an installation in their museum. This was my international debut, and I was struggling with nature work in the 1980s so it was very important. I got the opportunity to do a three-week installation at Espace 10 at the Miro Museum. I invited my friend the Danish composer Gunner Moller Petersen to create a composition called *A Sound Year*. This six-hour composition tells the story of the changing seasons over the year with electronic sound. It's very beautiful, very realistic, but also

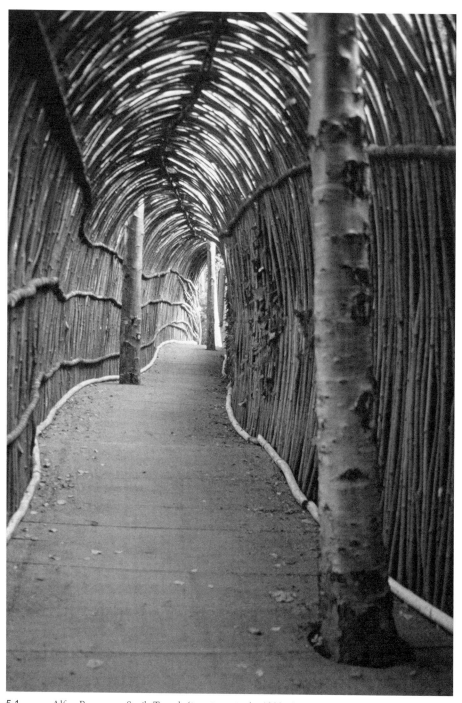

5.1 Alfio Bonanno. *Snail Tunnel* (interior view), 1998. Louisiana Museum of Modern Art, Humlebaek, Denmark. Courtesy of the artist.

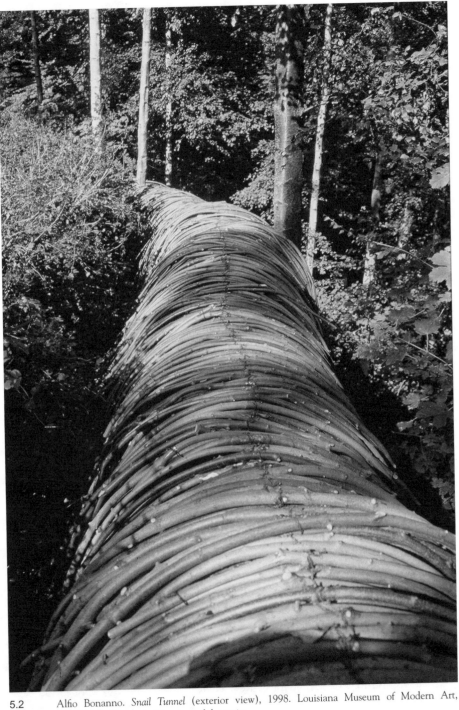

5.2 Alfio Bonanno. *Snail Tunnel* (exterior view), 1998. Louisiana Museum of Modern Art, Humlebaek, Denmark. Courtesy of the artist.

artificially created. It was an ongoing installation that moved from the summer months through to the autumn, winter, and spring. We used animals, birds, fruit, plants, everything related to nature. I did line drawings with branches. When you are into this type of material you find out it has a lot more to say then you thought. A branch put on a wall becomes an expression and tells me something. These natural objects are signs and symbols that inspire me to imagine that they have been a basis for our language.

JG The language and process of your sculpture, your use of trees, branches, stones, moss, vine branches, all manner of natural materials, carries with it traces of human involvement, of individual expression. You do not separate or segregate nature from human activity. Does the object-based cult of the gallery or museum exhibition hinder or help? It seems diametrically opposed to your integration of expression with the land. Even if it's installation work, the siting is artificial.

AB The real thing is the real thing. Here I am saying, "Look at this stone, look at this tree." I use all my strength to tell people this. For me it's just as important as all the other stuff. Of course there is confusion about what is real and what is unreal. I like to touch things, to smell things. I like to be in the middle of things. That is why I am working out there and usually not in galleries. A museum or gallery can have the possibility of clarifying certain aspects of the expression. For me the strongest form of expression is out there where the work is born, where it belongs, in real life. That is where it collects its strength, even more so because it is vulnerable. In a gallery, works are protected and don't really live. With site-specific work outdoors, they have a life and participate.

JG One of the two main trends in art of the future has to be art and nature, along with art and technology. Maybe people will tire of all the video and screen imagery that invades our inner space. The pendulum could swing back, if only for reasons of health and well-being. Tactile experience always surpasses the recreation of image and effect. Having worked thirty years with environmental art you must have quite a perspective on the whole art and nature movement. How it has evolved over the years?

AB I got into art and nature working in the natural environment because I couldn't do without it. I needed it, my body needed it, my mind needed it. I was curious. I didn't do it because of the art, and that's crucial. A lot of the art today is being done for the exhibition. Though I am not free of that, going out and working in an open environment is a powerful and demanding experience, but not only in "natural" landscape. When I was in Houston I got really kicked off by the skyscrapers. I would love to have the opportunity and challenge to work with that particular "landscape." I'm sure that I could integrate some of my ideas and experience, adapt a site-specific language for this venue, and bring a touch of human warmth to these cold, powerful forms. Sometimes we need to set things off to get a perspective.

JG Nature is not isolated from human activity. A fax machine is reconstituted oil and mineral. A house combines a range of natural and nature-derived elements. Nature is the house out of which all civilizations arise. It's an endless source that nourishes us spiritually and practically. Even Leo Tolstoy knew this when he commented: "One of the first conditions of happiness is that the link between Man and Nature shall not be broken." Our own bodies are nature. What do you think?

AB You cannot separate one from the other. I am very comfortable working with natural materials in the natural landscape but am very aware of the other side of the coin, our city environment. The best would be to join both tendencies or contrast one with the other. Then it's a dialogue. Otherwise it gets too aesthetic, too picturesque. As a friend of mine once said, "We have to watch out that we don't become 'nature fascists'." I agree.

JG If we take the extreme of social activists Hans Haacke or Joseph Beuys, and compare their work with the land artists Robert Smithson or Michael Heizer, the intentions are different, but all of these are conceptual from the start. They have this notion of imposing an idea or message onto the landscape. The site becomes a place to drop a concept into place. There is absolutely no link between the art and the setting. By contrast, your environmental projects are involved with the integration of art and nature, an interconnectivity between site and art.

AB I have a lot of respect for my surroundings and everything that's in it, ourselves included. That doesn't mean I hold back. I do intervene but it has to fit in. Even if it stands out, it's got to have a feeling of belonging to that place in some way. If I can get that to work, that gives me a reason to do it. Far too much sculpture and installation work imposes itself on a site, or is just pushed and placed there. Siting is very important because site is my collaborating partner. When I am successful I accentuate the feeling of a place. The work needs the site to breathe and function.

JG What do you mean when you talk of art in nature being a silent revolution?

AB I gave a lecture in Copenhagen to some art students and younger artists a few years back. They were interested and asked, "Do you really mean that you create sculpture because you respect nature and your environment. Is that it? Is that all?" And I said "Well, isn't that enough?" So much of the art being done seeks to be sensational, has to be big, imposing, monumental. Working with and within a natural environment you learn to look and listen, to respect and appreciate simple moments of truth and participation. My sculptures don't carry or display signage, the artist's name or title. I am against that. They're almost anonymous, just there like everything else. I don't want to manipulate things—just show what they are. It is a form of expression that reaches out to a very broad and growing public audience, many of whom have never set foot in a gallery or museum. Here we have a basis for a true and much needed natural dialogue. I feel it is a silent but determined revolution.

JG ART!—oh ART! Why is the art establishment so reluctant to embrace nature art? In science our understanding of nature's endemic place and relation to human health and well-being are recognized. Why is the art world incapable of recognizing the profound changes humanity is wreaking on ourselves and this planet, and the sacred importance of nature to our own survival?

AB That is a very good question. I feel there is a lot of misunderstanding and it gets me very upset. Do we really need the art world? We can use other forms for our dialogue and will do it anyway. Maybe the wrong measurements are being used, established ways of judging and accepting trends. Trying to make nature into an art may not be the most important point.

JG Contemporary art is incredibly estranged from everyday life and nature. But there is a counterforce involved in bringing the art back to the people both in cities and country. Could we talk about some of your specific projects? Your *East Sea Ring* project near the German-Danish border is truly a freeform work, originally conceived as a series of structures connecting the sea and land, like the marks sand worms might leave. You eventually came up with a twenty-meter ring, built out of two-meter sections of pine. Setting them alight introduced the element of air, along with the earth and water that were part of the site, a fitting symbol of the unity of elements. Nature, the sea in particular, has reclaimed some of it.

AB Yes. It was hit by a storm and I expected that, because there were some pretty heavy winter storms in that region. If nature wants it, it's going to reclaim it and stop the process. The process before and while it happens is interesting. There again you have the participation and inherent vulnerability of the work. They are very fragile in that sense. Even if they are strong and look resilient, nature is more forceful.

JG Public participation plays a part in so many of your projects.

AB The public is part of the process, whether it be in the planning phase, during, or after completion. It can involve politicians, organizers, helpers, assistants, the art world, and the local population. It's an important aspect of site-specific environmental art, this involvement of a broad range of people.

JG Your actions and performances are less well known to the public. A video you made in Denmark had white-clothed figures running around in an empty field. There was a surreal sense to the event.

AB We did it in a burnt-off field and when the white-clothed people moved they became like a blue blurr. It became a surreal moonlike landscape. Playing with images, the people and landscape complemented each other, became one. Organic identities or microorganic beings.

JG At the Botanical Gardens in Copenhagen, Denmark, you built a series of islands, and made earth structures out of fresh willow and sycamore branches in the car park for the animals and birds that frequent the place. (You used the plant remains being thrown out by park authorities). Your concern was less with the aesthetic look of your construction than its apparent functionality.

Terrapins and birds don't care about the aesthetics of something—just that it works! The earth on the islands was sown by the wind. As seeds blown there landed on the surface, the roots of the willow also grew and provided an attractive biosphere for the fish, frogs, and insects of the lake. It seems to relate, in its approach to nature as endemic and not segregated from us, to various artists work. Your artmaking shares something in common with the work of Bruni/Babarit from France, Lars Vilks from Sweden, or Alan Sonfist from New York. You like to leave traces, accept nature's imperfection and changability. You are not into pure aesthetics, design. The language is more vernacular, like a dialect spoken in materials. Are you something of a primitive in your approach?

AB That is a very good question. I do feel a little bit like I am a primitive. Sometimes I am accused of being naive. The art world seems to want another type of expression. With the floating island project I felt it very strongly because it was totally ignored by the art world. The most important thing in that project was that the terrapin turtles did climb up and sunbathe on the islands, and birds built their nests on the islands. The islands were constructed in a simple and practical way for use and growth—that was the point—not to create an aesthetic and artificial form so we (not the turtles) have the excuse to call it Art.

JG I think of the *Snail Tunnel* you built as well for the Louisiana Museum of Modern Art, a long processional walkway made of branches that proceeds through a forest; or the bridge over a creek you made from an oak tree at Hummlebaekken and the intricate *Eel Box House Labyrinth*. All of these works reaffirm the action of discovering something of ourselves in nature. Is the *Eel Box House Labyrinth* a structure, a conceptual work, or a a way of bringing life back to a cultural remnant?

AB The *Eel Box House Labyrinth* is one of the most important works I have done. The eel boxes were once used to keep eels and fish alive underwater after they were caught, and are a piece of Danish fishing history people are not aware of. The red boxes from my island were in the water for forty years! Bringing the eel boxes into a museum like Louisiana and building this labyrinth structure, keeping their identity while making them into passages, houses, and a village is, for me, a powerful idiom. You can add to things and still keep their identity. The identity of the oak I used to make the bridge at Louisiana is still integral to the piece. I cut the tree down the middle and opened it up but it remains an oak tree after my intervention. It still tells the oak tree's proud and beautiful 350-year-old story.

JG While hiking the forests of British Columbia, I saw fire snags, tree remnants naturally sculpted by air and fire. As sculptures they surpass anything we can create as art. We can imitate this effect. *Where Lizards Lose Their Tail* (1999), the sculpture you made in Japan, is fascinating because it does a kind of biomimicry in creating a kind of curling leaf pod form out of

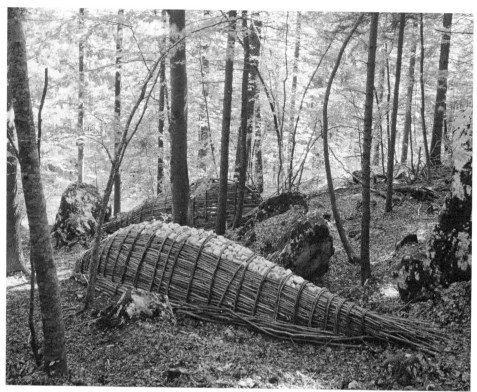

5.3 Alfio Bonanno. *Where Trees Grow on Stone*, 1996. Arte Sella, Italy. Photo: Carlotta Brunetti. Courtesy of the artist.

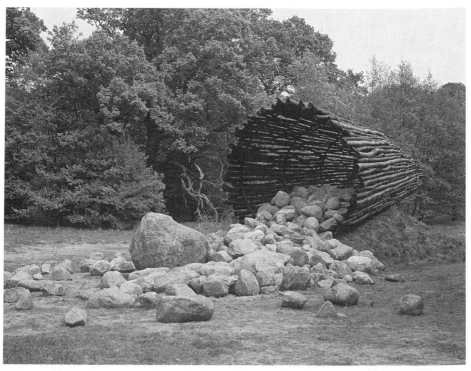

5.4 Alfio Bonanno. *Between Copper Beech and Oak,* 2001. Tranekaer International Center for Art and Nature (TICKON), Langeland, Denmark. Photo: Lief Christensen. Courtesy of the artist.

bamboo. Did you decide on the form after going to Japan and seeing the site?

AB Yes. Over the years, I have found that seeing a site before deciding is important. Each site has its own story to tell. If I am patient, something happens. After a day or two, or an hour or two, I never know how long, I connect with the site and it tells me what to do. The key to what I have to do is there, I just have to find it.

JG Art is a gift that we bring to the world. It is part of the economy of love. You do a lot of art projects in schools with children and that is a gift an artist can pass on to future generations. Children gain confidence working with materials firsthand. Its a tactile activity and, in expressing themselves, they grow experientially.

AB I've worked the last twenty years or so very much with youth and school children and consider this a very important aspect of my work. That is a chapter of my life that doesn't come out so much in the art world. In Denmark, that part of my work is ignored as if it were unimportant. It is important, and I have done some big projects even in major Danish museums with school children because I believe in it. This is the most important investment we can make—in our children. Its wonderful! We dialogue in such a great way and I have learned a lot from children. The child inside me awakens when I am with them. I need it as much as they do.

JG The writer Hugh MacLennan once wrote: "The land is far more important than we are. To know this is to be young and ancient all at once." This incredible little structure, the *Mountain Shelter* you built out of stone on cliffs on the coast of Ireland, together with Chris Drury, embodies that spirit of wonder. Its a beautiful piece in a beautiful place. There's a feeling of eternity to it that truly stimulates the imagination.

AB The *Mountain Shelter* is very anonymous. You can only see it when you get close to it. From a distance, it's almost invisible. You can't see it because it is made with the local materials and seems to disappear. It is so beautiful that way.

JG How do people perceive nature differently in the present as compared to the 1970s, the 1980s, the 1990s?

AB Nature art was a trend that has now become an explosion. Everyone is playing around with nature elements. People are doing nature sculpture as they would go into a studio and paint. But one has to understand the processes involved—feel the necessity—most of all because it's a living space. Nature demands more attention and respect! Some younger artists are doing interesting work that reflects the technological world—but nature as they conceive it is more like a virtual reality. I feel this work has a nostalgic touch—almost the feeling of something lost—that is cold and clinical, reflects a distance from the nature they represent. A growing global awareness about our environment brings a focus on ecological balance. Bells are ringing, warning us about our

existence and survival. It is fascinating that we can simultaneously discuss the serious problem of the ozone hole and its consequences while preparing to send tourists for a week's recreation in space in orbiting hotels at a cost of $50,000 to $100,000 per person. We humans are, and always will be, the most complex, destructive, and unpredictable species.

JG We are not invincible. Nature is so much stronger than we are. You shot a series of photos of every leaf from an elm tree in the backyard of your home and exhibited the photos in Charlottenberg. It is a modest yet powerful expression of nature's versatility and omnipresence.

AB The photo installation covered a two- by twenty-meter area that ran across four walls. The imagery was very strong. The walls were literally filled with photo portraits of the elm tree's leaves. It told a story of the biology of the tree. I had seen the tree grow in my backyard for fifteen years. It doesn't exist anymore!

JG The *West Coast Relics* piece on the west coast of Jutland has a certain symbolism to it. What was the idea behind this work?

AB The exhibition was to commemorate the fiftieth anniversary of World War II. Twenty or more artists were invited from all over the world. The actual location was where the Germans with the help of the Danes built over five thousand bunkers. They were never used. It is a fantastic sculptural landscape, with glacial boulders and weather-worn cliffs, that tells a story. Some of these bunkers for fifty years have been bashed by the waves, pushed backward and forward on the beach, and moved into the water, like strange obsolete sculptural objects. The local people living on the island identified with the burnt-out forms of my relics on the beach, associated them with shipwrecks and whale skeletons—part of their past history—so much so that they wrote to the ministry of the environment requesting that the sculpture remain on the beach. Another parallel project is the hay pieces I put in front of the parliament buildings in Copenhagen in 1992. It spurred the same kind of discussion. A few bales of hay can produce the same amount of energy as two hundred liters of heating oil. I was very proud to initiate a dialogue on energy with that art work.

JG At Odense in 1995, with the Center for Landscape, Environment, and Culture in the Twenty-first Century, you proposed a pilot project involving a huge abandoned garbage dump that serves 200,000 citizens of Odense, the most populous community on the island of Funen. It is still ongoing. The goal of the project is to emphasize recycling, redevelopment, and professional and interdisciplinary cooperation, with art as the catalyst. From the air, the dump and sculpted landscape is intended to have distinct visual components created out of garbage. Local citizens are to be involved throughout. You want to make a huge archaeological cut into the waste mound, create an amphitheater with the waste. Other fragments of industrial waste are to become freeform sculptural elements embroidering on the conception of the work. Barges will be

used to transport people to the site. In fact garbage becomes the spectacle, the focus for public participation, involvement, and tourism. It sounds fascinating. How is the project progressing?

AB The Odense project is huge! I have been involved with it for the last six years. We came up with the concept where, instead of hiding the garbage, we would make it the most precious thing, something to discuss, to dialogue on—the problematics of garbage. This is why we are hoping to make this huge cut like an entrance to an amphitheater in the dump. We want to bring in huge elements, huge pieces of machinery, pieces of airplanes, and cranes, to enhance the visual aspect of the landscape so it tells a story. This will make it a very visual landscape, and accentuate the identity of this rubbish dump. To build a continuity the whole area will be covered with an earth membrane. People have to be reminded that we are a waste society, that we consume a lot and have serious problems getting rid of it. There is always the danger the dump might become a superficial cultural landscape where people will jog, have art, and sculpture exhibitions.

JG In a way the vernacular language of your art is closer to the native Amerindian arts expression of North America. It's inclusive, less aesthetic than an expression of the contemporaneity of nature in today's world.

AB I am proud of that, if you say it. It's a privilege and an honor. A lot of art critics do not understand that. It has to do with the respect for things. One of the most important things I have learned over the years is to rely on my instincts. They will pull me through, and that is human and universal.

6

MECHANICAL BOTANICAL
Doug Buis

As early as 1958, Marshall McLuhan was already addressing the effects of electronic technology on North American culture when he wrote: "The effects of the sheer aesthetics of print on art and science were both extensive and subliminal or unconscious. And today the effects of the electronic revolution are quite as pervasive in every sphere of human perception and association. . . . The young . . . respond with their entire unified sensibilities to these forms of codifying and packaging information."[1] McLuhan understood very early on the way our perceptions were being channeled by packaging of information. The situation is more pervasive than ever now, with virtual reality, the internet, and computers influencing many aspects of contemporary life. Yet environmental concerns remain foremost in peoples' minds and many artists are addressing our relation to nature in interesting ways.

Long Beach–based artist Doug Buis teaches at California State University and has been exploring the meeting of technology and environment in his sculpture for well over a decade. Buis's early works, such as *Grass Machine* (1989) and *Seed Chairs* (1991), were somewhat naive, homespun, in their use of machines. Over the past fifteen years Doug Buis has rapidly evolved and developed his own language of sculpture building inventive and topical contraptions that seize on social, environmental, and technological issues in a subtle way, as if to emancipate sculpture from a purely esoteric and aesthetic paradigm. In so doing, Buis highlights the very real cultural concerns North Americans are dealing with as our culture experiences rapid technological and environmental change. Doug Buis's works have been exhibited at the Open Haven Museum in Amsterdam, Holland, at De Fabriek in Eindhoven, Holland, and in solo shows across the United States and Canada. Sculpture/installations by Buis have recently been exhibited in Happy Trails at the University of Santa Barbara, California (Autumn 1999), and the Estevan Art Center in Saskatchewan, Canada, in 2000.

JG There is always this dichotomy between your microworks and the large-scale axiomatic contraptions like *The Heart of the Matter* (1992), that canoe with two heads at one end and mechanical "arms" that swung tree branches full circle; *Walking Lightly* (Amsterdam and Pianofabriek, Brussels); and *Sowin' Machine*, included in The Power Plant's *Digital Gardens* show in Toronto in 1996. Whether macro- or microscale, your works address the relation between human culture and nature. The large-scale works are self-created machines, imaginative and inventive flights of fancy. The spirit in which they were created recalls the sculpture of Panamarenko or Tinguely. Yet your microworks such as the *Lap-Top Garden* or *Biosquare* (1993), or your recent piece called *The River*, are as effective, if not more so, in calling the viewer's attention to the difference between perceived reality and real perception. They play on the virtuality of so-called virtual reality.

DB *Sowin' Machine* has to do with definitions. In the *Digital Gardens* show I wanted to take idea of digital, as in computer, rehabilitate it, and take it back into digital, as in the digits on our fingers. That is why that planting machine looked like an arm that was going out and dropping seeds. The video interactions with it had a random effect, rather than performing the function of planting seeds of the viewer's choice.

JG It's a kind of dummy machine then.

DB With a lot of these landscapes that I have been fabricating, what I am dealing with is the whole idea of virtual reality—the way we have been replacing reality with the image. A number of years ago I saw an image—a MacIntosh ad that had pictures of a computer with images of leaves on it. The add stated, "This morning Johnny went to the Amazon twice and then went to the Louvre." I thought, *That is bullshit*. Johnny did not go to the Amazon. We all know there is a difference between the experience of being in the jungle and seeing a pixilated version of the jungle. To reach the point where you no longer go to the jungle and you see only a pixilated image . . . we are starting to replace experience with a simulacrum, an image.

JG No question about that! In those simulated hybrid forms we see on TV or in advertising, where a nature form—animals and humans—are stretched, manipulated, transformed in a brief sequence as if made of plastic, the visual language is quite brutal. The message we read between the images is clear: reality is not what it is and image culture can transform reality in any way we want, in fact more than reality transforms itself. We have become the gods of our own consumption and we are now devouring ourselves!

DB In a sense the message is that we no longer need the real as long as we have the image of it. We don't need the jungle, we don't need museums or even art galleries because we've got them on file.

JG Your digital gardens, microgardens, hit the nail on the head in this respect when they poke fun at the way the image is replacing the real. So absurd!

DB I like to turn it all on its head. In one of my pieces simply called *River* (1996), a small contained diorama, there is a distorting screen on it that makes the interior resemble a video or video still. It looks like an image of virtual reality, an object reassembling an image of itself. Yet the river scene within actually is real. It is only by the cue of the title that people think of it as virtual reality. They somehow assume and think, *That's really neat, how did the artist get that water effect?* In fact it is what it looks like, it has real water flowing in it, an assemblage of microelements. People look into them and explore what is inside because they look so real.

JG What I find interesting about an early piece of yours, the *Machine with Grass* (1989), is the idea that nature is on the surface but underneath there is this machine, another force working on it. Was this your intention?

DB The *Machine with Grass* comes from a completely different approach yet there is something that links it to my miniature landscapes. It has to do with our perception. I am really concerned with our ability to perceive. The *Machine with Grass* worked with very elemental phenomenology and perception. That was back at the time I was thinking of ritual and rhythm, the effect that rhythm has on our consciousness and how it can bring it into nonverbal states. The whole idea of the machine was to create a state where, with the moving grass, it would soften up your perception of what grass is. You might look at other grass differently. It was sort of a Romantic notion of consciousness, almost New Age.

JG Sort of surreal.

DB Of course it has that absurd element, but the absurdity, that collision of absurd elements, is what takes it out of that framework. It cannot be defined in any specific way, and once you can't define it, you perceive it differently.

JG I think of Maya Lin's *Wave Field* (1995)—those geometric patternings on the surface of the land. To me it is horrific—sort of a metaphor for our control of nature yet ironically created with natural elements out of doors. Your approach always has a human side to it, plays on nostalgia, or romantic perception and conception. It's got a home-built feel to it.

DB A lot of environmental or political art simply strives to give an opinion on something. I always feel there is something problematic with that. Everybody has access to the same information. It is not a lack of information that is the real problem, it is our inability to perceive. We are locked into rigid frameworks of perception. For example if you are a logger you define a tree very differently than if you are a tree hugger.

JG One thing I wanted to ask you as a writer. Do you feel that the language of the objects you use limit your expression to a narrow set of definitions? Is the narrative we see in your work—the fact that you are using object elements to tell a story (as in your recent *Short River* (1999) piece with its landscape on canvas atop a wheelchair) is this a plus or a minus?

DB Do you mean limit or directed?

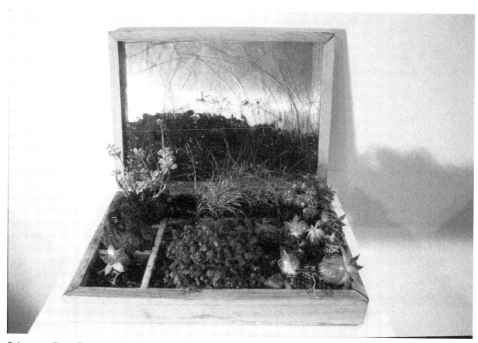

6.1 Doug Buis. *Lap-Top Garden*, 1994. Or Gallery, Vancouver. Courtesy of the artist.

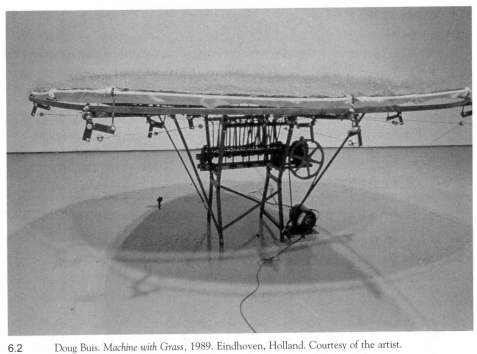

6.2 Doug Buis. *Machine with Grass*, 1989. Eindhoven, Holland. Courtesy of the artist.

JG . . . edited to the point where the story is oversimplified. The strange synthetic or denaturized landscapes we now see in advertising are highly simplified appropriations used by designers to present an ideal of what we look for in a landscape. The real landscape is much more complicated. There are many more details that can never be codified. We are used to eliminating, editing this out of our perception.

DB Belief systems are the same thing. We eliminate all the awkward things, experiences that do not fit our belief structures. Even artists do that.

JG Doesn't the exhibition space present a similar problem? In a world of video and internet culture bringing these sculpture objects/installations to a place that is somewhat anesthetized, how can one compete, how can you impact?

DB I actually prefer bringing the objects to a place. They are still real. You build a whole scenario. It is like planting trees in a park, the setup may be fake, but the trees are real and they do what trees do. Nature parks are fake forests but still more real than virtual reality. They are different forms of seduction.

JG You mean the scenarios you build are part of a language of today's culture, of our times?

DB Well in some way. In the recent works *Landscape with Short River* (1998), *Brief River* (1999), and *Mountain in the Box* (1999) there is a potential problem, not the language of the objects, but the potential baggage we carry with them. In *Landscape with Short River*, when you recognize that the powdery landscape on top has a wheelchair supporting it, you make all kinds of associations, say with poor or sick people. That is not necessarily true at all. It is a prejudice one has. The wheelchair is just a vehicle, a way of getting around. There is this obvious pun going on. The wheelchair is actually under the landscape, so it is not on the surface of it. I guess that's why there is a sense that the earth itself is kind of sick, but instead if you look at the thing it's very much just the surface. I am not trying to talk about the state of the earth, just renegotiating our relation to the surface of it.

JG It is ironic because the landscape is canvas. It makes one think of the tradition of painting, art history, to see this canvas with a river on it supported by a wheelchair. The suggestion is that the Romantic landscape painting vision is itself crippled because it presents nature as from a window, and so defers the real world environment to a recreation thereof, that is the landscape painting.

DB I find the surface form in *Landscape with Short River* does not actually resemble canvas at all. When you look at this you do not know it is canvas. You don't know what the surface is.

JG And *Brief River*, exhibited at Evergreen State College in Olympia, Washington, in 1998, almost looks like a return to minimalism. Makes me think of some of Robert Smithson's gallery installations.

DB It is just this little river construction that fits in perfectly with the California landscape conception. The U.S. Army Corps of Engineers created all these canalized rivers you see on the West Coast . . . minimalist rivers!

JG How do you relate your latest pieces to an earlier work like *Chaotic Encounters*, exhibited at the Toronto Sculpture Garden, which used wind and played with notions of chaos theory. The *Chaotic Encounters* piece had these random objects—machinery parts, fragments of mechanisms—inside a thirty-foot-long plexiglass and aluminum wind tunnel. Wind patterns were generated that moved the sand so it would build up around, over, and onto these fragments.

DB *Chaotic Encounters* was all about how the forms, like the sand dunes created by chaotic systems, resembled mechanical objects, like transmission or motor parts. They are either formed by laws of physics or made to conform to physical laws.

JG Sculpted by nature.

DB Yes, but not only—human intervention is there. With *Mountain* (1999), I let the natural forces create it. In an obvious way, I would at the very top pour sand on it, and fix it with a gel medium. I didn't form it or sculpt it by hand, I just let it go.

JG It plays on irony a lot, this kind of work, the idea that a landscape is considered a permanent presence, something that is always there, and yet these landscapes are rather folky, can be moved around, just as earth movers reshape and reconfigure a landscape. There is this uneasy feeling of artificiality in your work. You find this obsession with structure—domination and control of natural forms and environments—throughout twentieth-century modernist art, from Cézanne's landscapes through to outdoor land art of the 1960s and 1970s: Michael Heizer, Robert Smithson, Walter De Maria. The early land art aesthetic emphasized domination or transformation of the landscape and was largely ideational. Your works are more whimsical and can actually be seen as an aside to this, because the forms are built naturally into them. They are actually containers . . . the landscape becomes a kind of memento.

DB They are actually like little sketches. They are not only ironic, because all these landscapes are totally artificial. The landscape in the bathtub or on the wheelchair is a totally artificial one.

In a similar vein, my view boxes were an example of fabricated alien landscapes, volcanoes, desert scenes. What I am doing is creating natural landscapes and photographing them in stereoscopic photography. It actually looks more real than landscape itself. When people view them, they think they are photos of real desert landscapes, but they aren't.

JG It reminds one of the origins of film making, when they made sets in miniature and filmed scenes of boats sinking, volcanoes erupting. When the public first saw these fabricated scenes in movie theaters, they seemed to be real.

DB The intention of these films is that you believe that space. In my workspace is a mediating place. I want people to look at the installations and look into the boxes and have that moment of ambiguity that makes one question whether one is looking at the real thing or an image of it.

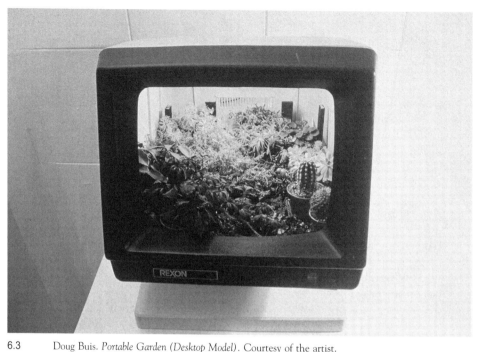

6.3 Doug Buis. *Portable Garden (Desktop Model)*. Courtesy of the artist.

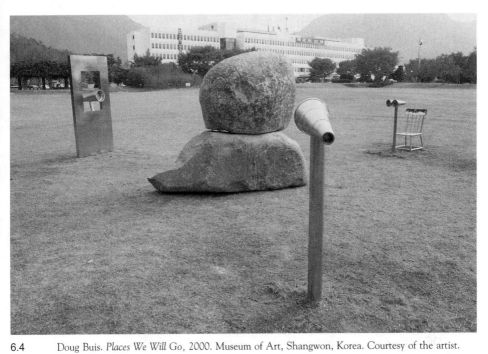

6.4 Doug Buis. *Places We Will Go*, 2000. Museum of Art, Shangwon, Korea. Courtesy of the artist.

JG Are you battling with habits and perceptions in the culture, trying to reawaken a natural language or impulse of creation? In media culture the language used is plastic, *pro forma,* and constructed in such a way the response is mediated, even before the person has a feeling.

DB A sort of intellectual dialogue is going on, a set-up. There is all that groundwork of theory and intellectualism in advertising and the media. Much contemporary art is the same.

JG How does an artist break out of an artspeak language and create an art with vitality that speaks to people?

DB The very finest work does that. It reaches the dumbest and the smartest.

JG *Earth with Protective Cover,* exhibited at A Space, Toronto—this miniature planet surrounded by an armadillolike covering of metal—was a succinct comment on ecoconsumerism, the double-bind notion that one can consume more and yet nature will not be harmed.

DB It was an absurdist piece.

JG Eco-friendly this and user-friendly that. Replacing one kind of consumerism with another and never getting to the heart of the matter. The mutability of everything, including ourselves. What a state of affairs!

DB I think we are going to reach a crisis point. We are all complicit in it. We do not have to own the land, we can simply appreciate it!

JG Recently you created a permanent sculpture titled *Places We Will Go* (2000) for the new Museum of Art in Changwon, Korea. It has three viewing gadgets: two big telescopes and a pair of binoculars placed at various distances from a huge centrally placed stone. The stone looks like it has rivers, and general topographies carved into it. Are you trying to comment on the direction our society is taking, in manipulating and directing nature, or is it pure fantasy, sci-fi?

DB The answer to that question is: both really—partly in the sense that the content of sci-fi is often very much related to how we direct nature and form our world. The piece was set up in an area where children play, so I set up a situation where they may start to think about the nature of a planet and how it gets made. In some ways I am creating little myths, or perhaps creating a mental space for people to form their own. In part, the work was influenced by a sci-fi novel about a character who was responsible for building the fiords in Norway, and justifiably proud of them. In some ways I am considering how little we really think historically (in geographic and geological terms rather than human history) about the formation of the planet, particularly about the scale of time. I am amazed often how we are so willing to alter, so quickly, something that took so long to form. We have absolutely no sense of perspective as to our own importance in the order of things. I was just reading (in *Harpers* magazine) that, in terms of the biological importance to the ecology, we rank below certain funguses. The ecology would collapse with the absence

of ants, but not humans. In having the viewer peer through the telescopes, I am raising that question of scale.

JG *Suburban Legend* (2001), exhibited in the Cyborg Manifesto show at the Laguna Art Museum, presents a window the viewer looks into to see your installation. The scene inside has some of the tables and chairs that look like they have been knocked over, as if some event had recently taken place. The landscape visible through the window can also be "looked into" from the side, and one immediately senses the artificiality of this "nature scene." Computer disks with nylon strings attached whir, thus causing the tree to move. The tree is on an artificial platform. The whole "set up" is rife with a sense of irony about truth to nature, the illusion behind the reality, and the way we over-simplify certain myths. Can you tell me more?

DB This piece, in part, is also about fantasy in a sense, in that it was influenced by the children's story *Jack and the Beanstalk*. As a child, I often daydreamed about that story, as I so much wanted to climb that beanstalk, to have some of those magic beans. The fact that the tree is of an indeterminate scale hints that it may be a bonsai or two miles high. It is my beanstalk in a way. The volcano in the background gives some hint as to the possibilities. The viewer is given the option as to what size the tree is, very much like our option to believe stories. For many stories, such as urban myths, morality tales, and such, it really doesn't matter as to the veracity of the tale. It is the nature of the story that counts. I don't really think of the piece as an ironic work, although it may be tucked away in there somewhere. It is more of an investigation into the strategies we use to contextualize narratives, without there really being one in the piece. In some ways we have these internal frameworks that inform all of the narratives we see, or impose on what we perceive.

NOTE

1. Marshall McLuhan, "The Electronic Revolution in North America" in *The International Literary Annual*, No. 1. London: John Calder, 1958, p. 166.

7

DESIGNING WITH NATURE

Michael Singer

A graduate of Cornell in Fine Arts, Michael Singer has, since 1971, received prizes and grants, notably from the National Endowment for the Arts and the Guggenheim Foundation. His art can be found in the collections of the Albright-Knox Art Gallery, Buffalo; Australian National Gallery, Canberra; Louisiana Museum of Modern Art, Humlebaek, Denmark; the Solomon R. Guggenheim Museum, New York; the Museum of Modern Art, New York; and the Yale University Art Gallery. His sculptural works from the 1970s and 1980s opened up new dialogues in art having to do with approaches to site specificity and the development of public spaces. His more recent works have been recognized for their original solutions to the integration of aesthetic and social preoccupations in the context of public works and infrastructures. In 1993 *The New York Times* declared the design of the Recycling Depot in Phoenix, coproduced by Michael Singer and Linnea Glatt, to be one of the ten most significant architectural projects in America that year.

Among Singer's recent outdoor environmental projects, one finds the two-acre Woodland Gardens for Wellesley College in Massachusetts and the one-mile Waterfront Park restoration masterplan project in New Haven, Connecticut, which he directed. In Stuttgart, Germany, he created *Retellings/For Those Who Survived*, a one-acre commemorative sculpture garden. At the Denver, Colorado, airport he designed a large-scale indoor garden that transformed the site dramatically, and at the Isabella Stewart Gardner Museum in Boston, Singer has revolutionized the notion of exterior museum garden design. He is presently working on a multidisciplinary revitalization project for the Troja River basin in Prague, Czechoslovakia, an interpretive center for the Lower East Side Tenement Museum in New York, a restoration policy for the Eldridge St. Synagogue in downtown New York, and a universally designed artists' environment for the Millay Colony for the Arts in Austerlitz, New York.

JG In the 1970s you were an artist, working predominantly but not exclusively in outdoor sites. In the *Glade Ritual Series*, the *Lily Pond Ritual Series* (1975), and the *First Gate Ritual Series* (1976, 1979/80) there's a gradual evolution in your approach to outdoor sculptural composition. Your works from the 1970s go from drawing with trees, bamboo, and phragmites in natural sites to juxtapositions of cut wood and natural wood, cut stone and natural stone, and then they start merging. You began working on constructions for indoor environments in the mid-1970s. *The 7 Moon Ritual Series*, the *Ritual Gates*, and so on. Writers commented at the time on how these works introduced a human element into environmental sculpture. They were not just about nature, but habitation, integration, even as fictional history of habitation. It's interesting you did not distance your work from ritual as so many artists did at the time, and saw this as a compliment to your artistic process of working in nature.

MS Yes, because I saw my everyday work in these environments and my studio as the daily rituals—resulting, eventually, in a work of art. At the time I felt I could keep making outdoor installations in beautiful environments forever. It's seductive. In the *Lily Pond Series*, I sought to build a structure that captured light in different ways at different times: late afternoon, early morning, and so on. I wanted to create works where the human activity wouldn't be destructive and yet interface with the natural environment. Eventually the question became What happens with a site that doesn't have reflection, illusion, changing atmospheres of light and space? This led me to a site in an old hemlock forest, a dark place in the woods with some topography. I took the limbs off old hemlocks and first built a mat to create a level place. I felt that this might be the intervention a human being would undertake in such an environment. It became a starting point for other ideas. I then built the parameter walls and the work became a container for other ideas.

JG I find your *Ritual Series* (1980–81) in the Guggenheim fascinating. Here is a sculpture that begins where the outdoor series such as the *Lily Pond* left off. The piece is really conceived for space rather than a specific indoor or outdoor setting. Yet because your art was as much about the way humans interact with nature as it was about nature itself, the work becomes almost mythopoetic. You put together a structure from the wood of an old barn and built a base. It's like art as archaeology—recovering the history of a site and reinvesting it with a new meaning through reconfiguration. And there are these storage shelves in the structures with stones. This makes one reflect on our fixation with object meaning in art, as much as the space this installation is in. The subject seems to be the way we perceive structures materially and material structurally.

MS It's a question of what happens when you take an idea from a natural environment and work inside architecture. The base of the piece (*Ritual Series*) is the wooden floor of a barn that has been taken apart and reconfigured. I made walls similar to the hemlock forest piece and built the structure

within it. It's a kind of intervention that builds its meaning into an architectural setting.

JG The early pieces are like fragile structures—everything hangs on everything else. Language of forms and natural forms and precut wood and stone. This interrelation of many forms—both manmade and natural—cast you as a neoprimitive back in the 1970s, yet, as with the vast indoor garden at Denver Airport, which adds mystery to an otherwise dull functional building, or your first permanent work in a building in 1986, the meaning of the place is located by your work. You don't play off the structure, but you center it by adding another layer of meaning to design architecture. It is less decorative or additive than geocentric in approach.

MS Yes. Well, in the case of my first permanent project I really respected the architect Michael McKinnell and he asked me to design two large atrium spaces in the building. These are spaces that you look into. When it was completed, the architect actually siad to me, "We designed the space and you transformed it into a place." At Denver Airport the garden is visible from the level above, where there's a McDonalds restaurant and all the airport junk stores. It's covered with vines, ferns, all manner of growth—a living ecology and a complete contradiction to its surroundings.

JG Yes. You transform the whole meaning of architectural siting, bringing a kind of mystery to the place that would otherwise be lacking. Yet in your works, it is as much this aspect of play, where nonlinear growth elements intersperse with linear puzzles and syntaxes that are not absolutely resolved. It's a puzzle with clues about the way nature designs holistically and the way we design rationally. The language you use is one that informs, even educates the viewer to the way we actually look, perceive nature and the built environment in different contexts.

MS I am involved in investigations, as for instance the intersection of the built environment and the natural environment. Then the issues of geology, time, and of layers enter more strongly into the subtext. Slate, granite, and natural stones become materials that inform us in relation to the built realm as well as the nonbuilt. Architecturally I am interested in how people move through a space and how architecture choreographs our movement through space, as well as the power architecture has in bringing meaning to a site.

JG Your work references history—both human and natural. It builds links both in the materials you use and the alliterative forms you create. Sometimes I feel they are akin to Shinto ritual sculpture, as in an intervention titled *Sangam Ritual Series* (a Hindu word describing the place where two rivers join) in Aspen, Colorado (1986). There is a miniature element of the piece within the walls and gates you built. Its like a microcomment on the macroscale of our landscape perception. Its a shrine to nature, and the material allusions, with the series of steps and layers, also allude to the underlying geology.

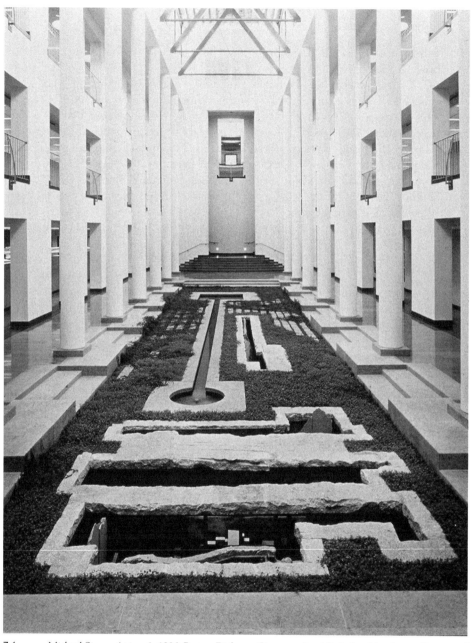

7.1 Michael Singer. *Atrium 1*, 1986. Becton Dickeson Company, Franklin Lakes, New Jersey. Courtesy of the artist.

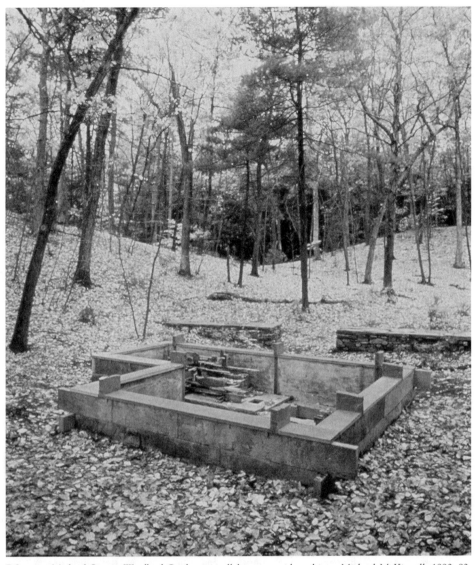

7.2 Michael Singer, *Woodland Garden*, in collaboration with architect Michael McKinnell, 1990–92. Wellesley College. Courtesy of the artist.

MS Aspen was the first time I worked in a site that I felt needed alteration. The river winds around at almost a right angle where I began. After working for fifteen years in outdoor sites where I didn't touch anything, *Sangham Ritual* was the first time I actually manipulated the site itself. It began to be about building a garden. I felt the need to establish a portal and boundary for the site. As you enter through the portal, the sounds of the river become magnified. The small, sunken element within is like a table of contents. And that archae- ological thing you are talking about with the layering of stone is the element that becomes a reflection of the layering of the land.

JG There's a similar sense of the lived-in history of the land in the *Tomol Ritual Series* (1987) created for the redwood section of the Santa Barbara Botanical Garden in Mission Canyon Creek, California.

MS You first see it from the top of a canyon looking down into this structure built right on the stones of the stream. There are storage areas in it that describe another area of human activity—the need to create places to keep special things. The title comes from the Chumash Indians, the native culture that lived there. They were the only native people to make planked boats that were not carved out of tree trunks. So they actually had a technology of making planks and using tar from the beaches to seal the planks. They used a rope that they made from vines to tie the planks. They also had a ritualized secret society of the boat called the Tomol. I found some of the minutes from the last meetings in the 1880s that were translated by a man who learned their language. It was very poignant and I tried to make connections to that culture and relate it to issues of our time.

JG Your work at the *Phoenix Recycling Plant* (1993) is truly exceptional for an artist. I mean who would believe artists created that building, the site, the layout, the daily patterns for movement of goods and vehicles, the visitors locations. Yet apparently it draws crowds of school kids, tourists, and Phoenix citizens to see what's going on, as well as to recycle materials.

MS I worked on this project with Linnea Glatt from Dallas. An engineering firm had done a preliminary plan that really defined this as a place no one would ever want to come to. It was a building that was a box—enclosed on itself—twenty-five acres of pavement with a traffic situation that would create a nightmare, mixing five hundred tractor-trailer-sized trucks, coming in every day, with the other users. People were supposed to bring their recycled mate- rials into the back of the site, which was hidden out of sight and therefore out of mind, not even related to the building.

Basically I think the planners thought that the invited artist would do what most artists would do in a public art project. They would choose a color and paint a stripe around the building and make a little something that would be there. We just said, "There's no way." There was a lot of money involved here in a percentage of 18 million. There was no way that anything they would

do here, if they maintained this plan, could humanize this place. It would be like every other off-the-shelf waste facility that is built around the world.

Phoenix had a very special public works official, Ron Jensen, who listened when we started to point out some of the real problems of the site—like, for example, that all the visitors and administration of this building are on the east side of a two-acre-sized structure filled with garbage and the wind was west to east. So, right off, it took an artist to tell them if they just moved visitors and administrators to the west side, upwind, they would be way ahead of the game. In the engineers' defense they never even went to the site. They just pushed a button on the computer and out came the design.

There were many problems we were able to point out. So Ron Jensen said "Okay. We have a facility to build. Its on a schedule. We can give you two months to come back with a new site plan and lets see what you artists can come up with." As artists we put together and led a team of professionals who worked with us to question the design and then redesign the site of this facility. It all happened in that brief time. We told them: "The site plan is one thing, but we should really design the building; we should design every aspect of this sight to give it meaning. If you really want people to understand this place and be open to it, it needs the approach to every element in the site." And Jensen said "Go for it!" We also increased their program here, adding all kinds of community spaces. The project ended up costing 20 percent less than its original $18 million budget—$13 million.

JG So there was some kind of switch from environmental artist to environmental designer in this whole process that took place.

MS Not a switch but an inclusion, an addition. After twenty years of work in natural environments, and questioning my role in a natural environment and what humans do there, I began to wonder how I could use that knowledge to address community issues, look at problems in communities from an artist's point of view. And I began to develop a sense that the creative process of artists is very special, and different from any of the other professionals. Its not that we will have the solutions (sometimes we will) but we will have observations, questions, and ideas, and we should be invited to the table to talk about the problems and help with the problem solving. That is what is happening in addition to what I was doing before.

JG Being a professional, 1 percent artist, is something of a dilemma. You have to respond to designs that are decided for you. There is seldom much communication between the landscaper, the architect, the artist, and public works. Isn't crossover the real need we have now?

MS One percent tends to become decorative and tacked on rather than worked on in consultation with landscapers or architects. People come to the Phoenix project and say "Well where is the art?" It's really not there. It's within the design, it's within the questioning, its raising new issues.

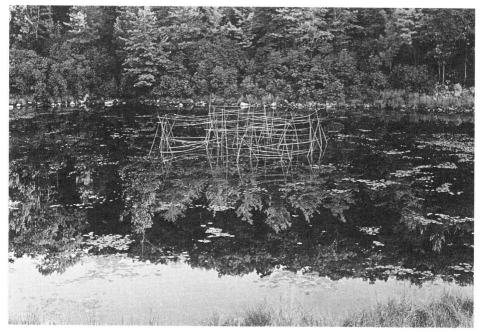

7.3 Michael Singer. *Lily Pond Ritual Series*, 1975. Harriman State Park, Harriman, New York. Courtesy of the artist.

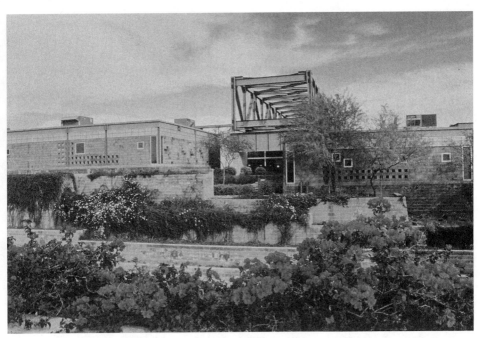

7.4 Michael Singer. 1993. 27th Avenue Recycling Depot, Phoenix, Arizona. Courtesy of the artist.

JG Isn't one weakness of art as process—even if it deals with architectural structures and space as Gordon Matta-Clark did—that it's final goal is to demonstrate an idea? That was part of the problem with land art—minimalism. A lot of it was extremely wasteful. It could simply be done by drawing on a photo. Whereas your own works build from a context outward. Finally the aesthetic becomes less a purist notion, even if the forms and materials have pure relations. So for me in a sense it becomes more permanent.

MS It isn't just "of the moment," and that is what I was responding to in your book *Balance: Art and Nature*. Your book eloquently explains and drives a point of view I have really had in my own work. It is one of the reasons I haven't had a show in New York since the mid-80s.

JG When you look at Kawamata, the large-scale works, with the wood coming out of buildings and so on. It maintains the mystique of art that has a relation to public life, but a dysfunctional one. It integrates into an environment, but finally it becomes a display that emphasizes the disconnectedness of things. It is eventually deconstructed. So it describes the symptoms without alleviating the problems.

MS These kinds of pieces are display, but it's also a piece of dialogue within an exclusive conversation. Artists can respond back and forth in those dialogues. They're a lot of fun. But I'm really interested in more than that.

JG It perpetuates a myth of art that doesn't include society or the public directly, as participant.

MS It happens in every profession.

JG It codifies, in the same way professional medicine is codified, mystified, put into a language that is inaccessible and complex. Where is the simple holistic vision? We are fed so much encoded professional jargon that we often cannot see the forest for the trees.

MS It's a symptom of a whole culture that encourages specialization. It interests me when a gallery or an artist really wants to go beyond the specialization and develop a cross-disciplinary approach. Its much more fun. Its really stimulating and fun for me, to, within the same day, be looking at issues that deal with planning in Prague, or an interpretive center for the Lower East Side Tenement Museum in New York, or a restoration policy for the Eldridge St. Synagogue in downtown New York, or to ask questions about that sculpture that has been sitting in my studio slowly evolving and being informed by all this other input. This is much more important for me than where is my next show, who is publishing my work, all of those kinds of things. This is what really excites and enriches me.

JG Part of the challenge really is to build some kind of holistic culture where people consider themselves part of a community, put their energies together rather than being divided by professionalism.

MS Its very important for me to acknowledge that, working on so many projects, it isn't me alone in my studio. I'm working in the community, putting

together people in projects, some of whom have never worked on projects. I'm interested in a cultural historian's perspective on something, or an anthropologist's, an architect's, or an engineer's.

JG In a sense everything is inversed. There are limitations to object-based analysis in criticism, to theoretical discourse—there are limits to everything—but if you can establish some linkages that haven't existed before, then things are moving forward, which I think your work does quite well. Prototypes are always good in art, but its the transferal from prototype to real life that is the challenge I think you're meeting.

MS Phoenix is a good example. Remember that in 1989 no architect would consider designing a waste facility. It took artists to change this. I think this is an example of what artists do—an artist being given a problem will come up with new ideas and questions. Some of them will be ridiculous and some of them will offer previously unthought-of possibilities. In 1989 it probably could also have been thought of as ridiculous that a waste facility is a design opportunity, a place for the public, but this has now changed.

8
THE VEGETAL (AND MINERAL) WORLD(S)
OF BOB VERSCHUEREN

Belgian artist Bob Verschueren is not only a veteran of vegetal art; his works are likewise daring in their use of mineral matter. Nature silently and surreptitiously invades the meaning of art in his art. His ephemeral artworks do not seek to conquer or possess a space, but in creating scenarios that are site-, light-, and earth sensitive heighten our awareness of the actuality of a place. . . . Among his most ground-breaking works are the *Wind Paintings* from the 1970s and 1980s, which involved "painting the landscape" of empty and desolate places with crushed charcoal, iron oxide, chalk, terra verte, flour, yellow ochre, terre de Cassel, and burnt and natural umber. Each time, after a specific material was laid out in a linear motif on the land, Verschueren would wait for the wind, "a hand that sublimates the art to the materials" to distribute the variously colored pigments and materials over the land. The resulting works usually last only a few hours, whereupon the wind that created them likewise blows them away.

Verschueren's experiments in "painting" landscapes and landforms with light in the early 1980s at night have yielded results as unpredictable and beautiful as the *Wind Paintings*. He has said that the monumental and colossal aspect of land art is lost in photographs that bear witness to such art projects. Verschueren's vegetal installations play on and with ephemeral materials such as nettle and water lily leaves, sand, tree branches, moss, lettuce, twigs, stones, fire, even potato peels, and the list goes on. . . . Bob Verschueren has explored the sounds of plants at the Banff Center for the Arts and has exhibited his installations and color photographs extensively in Europe, as well as in North America and Japan. Verschueren's vegetal aesthetic invokes a phenomenological approach to artmaking. Each design applies natural elements to establish a relation to the specific architecture and landscape of a site—be it indoors, out in the land, or in the city—but the process remains accidental.

JG When people talk about art and nature, they often avoid the question of our strong dependence on nature, the fact that everything comes from nature.

BV This dependence demands a certain kind of modesty, and this is what seems to irritate a lot of people. Moreover, in the West there is also a somewhat tense relation based on Judeo-Christian values that suggest nature has been created to serve man, that man can do anything he wants. This sets up a kind of barrier in our understanding. The division between man and nature still persists, and from many perspectives seems absurd.

JG In Japan, the notion of the garden is strongly rooted in their tradition. It embodies a kind of harmony between man and nature, which is a source of wisdom. In looking at your work, we see a constant preoccupation with the integration of environmental elements—light, matter, and so on. When you began creating your first environmental works, in the eighties, the integration of these nature-based elements was definitely quite revolutionary, even shocking for a lot of people.

BV People must first be receptive and, initially, some were probably not ready to accept this kind of proposition. One has to admit that ways of thinking evolve very slowly and that there is some resistance to new ideas, as, for example, the notion that "vegetable" art can only exist in the outdoors. Another important aspect to consider is that most people still maintain a quite romantic relationship to nature. And yet, nature is not only "marvelous." There exist other realities, like AIDS, a disease that was not created by man but comes from nature. It is this romantic and somewhat absurd perspective that continually repeats the Judeo-Christian problematic whereby nature exists uniquely so humanity can dominate it. This point of view completely avoids the fact that nature can also be very harmful, that it doesn't just generate things that are beneficial.

JG When we look at a billboard in a city or in the country, what spontaneously comes to mind is the romantic landscapes of Turner or Constable. These billboards always suggest one single message and avoid the more complex notion that the image, in fact, surpasses reality, and is never as simple as initially seems. What is incredible in a system based on overproduction is that people don't realize that the integration of elements of nature in art, architecture, environment, and so on, makes life a lot easier, certainly less tough than if we continuously oppose ourselves to nature.

BV I came to the idea of using nature as a starting point in the creative process somewhat by accident. At first I was a painter, but over time the medium began to bore me. Feeling the need to explore other paths, I went outside, and I there met nature. It left a strong impression on me. After completing my *Wind Paintings,* I then used leaves because they seemed to be the most obvious material. It is a primary material we spontaneously think of: leaves are easy to carry, in autumn they change color and create a large carpet on the ground. What fascinated me with this material was its constant transformation, both in color and form. When one brings this leafy material into an interior space, we see it anew. Installed out of their natural context, leaves are free from any of

the usual associations we have with them. We stand in front of a green rectangle, for example, and then a few days later, we notice that the color and surface have changed. The work changes and moves, just like a living being. This was an important discovery for me: that matter can transform itself without any intervention. You begin to notice that this material goes beyond the formal level, that it directly references life and provides us with a kind of mirror to ourselves.

The next experience that influenced my direction was that while peeling an orange I noticed the peel that I was about to throw in the garbage suddenly reminded me of squamous, those tiny epidermal flakes that fall from our skin. I then realized that without knowing it we are all . . . sowers who spread tiny particles of skin here and there along our path. And the orange peel looks like skin, particularly because it is covered with pores. This skin element immediately fascinated me. I then made an installation with orange and grapefruit peels at Atelier 340 in Jette, north Brussels. What I was exhibiting was in fact waste, which in a way is an allegory for death. Death is an inherent part of the human condition. It is impossible to evade this question of death that we all carry within us, that we try to resolve and handle as best we can. From then on, I continually tried to integrate waste elements—mostly food—in my work.

JG Your approach is less concerned with any specific ecological message than with the links between man and nature's process.

BV I don't consider myself to be an ecological artist. Ecological consciousness, I think, has to do with something else . . . a life ethic. To have a real impact on ecological questions, it is probably better to hold a demonstration or symposium than to create a work of art whose effect is lesser. By creating art that has a philosophical reflection you can deliver a message with multiple resonances.

JG The fact that you use found objects to create works of art brings us automatically back to Duchamp. . . . When a work has been completed—either in an exhibition space or out of doors—do you define it as an "object of contemplation" or just an integral part of an environment that goes beyond the work of art you have created?

BV I am always careful to make a direct allusion to the space in which a piece is being exhibited, as was the case with my first installation at Atelier 340, in Jette, north Brussels in 1985.

JG In this work, the color of the leaves extends an image of the light from the window into the environment immediately outside the gallery.

BV Yes, and this creates a relation with the specific site. This is a parameter that became an essential element in my work.

JG You have made *Wind Paintings*, since 1978 with sand, which I find spectacular for their integration of nature as an active element in the work.

BV These are lines of natural pigment that I sow with the wind, thus creating tonal gradations in the landscape. What fascinated me with this kind of work

85

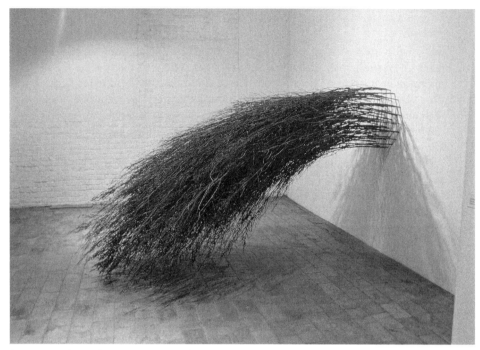

8.1 Bob Verschueren. *Installation II/97*, 1997. Atelier 340 Museum, Brussels, Belgium. Courtesy of the artist.

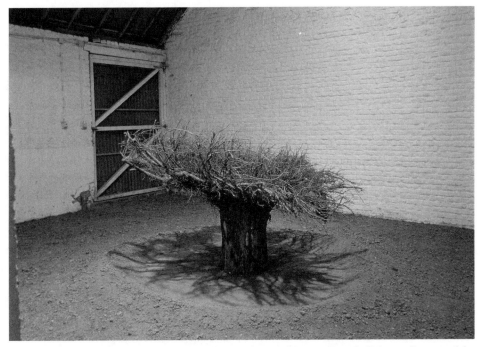

8.2 Bob Verschueren. *Installation II/97*, 1997. Atelier 340 Museum, Brussels, Belgium. Courtesy of the artist.

was the boundless aspect: it is impossible to measure the work, to know which is the last grain of pigment, where it went. . . . The experience was even richer for me as I had just stopped painting, because I was always confronted with the limits of this "horrible" rectangle, and persisted by trying to suggest that the subject was going beyond the frame. A lost fight from the start, it goes without saying! Since then, even if it doesn't come back in all my work, I try to work the space throughout, in its "vastness," as with the installation I made at the Maison de la culture Mercier in Montreal, where a ring of pine needles seemingly vanished under the wall. It was an illusion, of course, but I thought it was interesting to suggest that what we saw was only part of the work, that the rest had to be mentally reconstructed. In this way we project our vision beyond the "frame" of the artwork or the exhibition site.

JG If we return to the original land art of the 1960s and 1970s, to the first installations being inscribed in the landscape, we notice that the artists of the time had no consciousness about the site they were altering. Their gesture could simply have been drawn on a photograph instead of actually disrupting and destroying a mountain, for instance. . . . Your process takes another path, surely because of this notion of the ephemeral, acknowledging the site by leaving a humble trace of the human persona. Nature always plays a decisive and active role in your work.

BV I always have to fight against preconceived ideas, and one of them has to do with the kind of work I do, which, like Nils-Udo's or Andy Goldsworthy's, has nothing to do with land art. My works are the opposite of land art because they don't try to "take possession" of the space . . . or win over the landscape.

JG In order to create photographic images.

BV As was often the case, yes.

JG Contrary to what we might think, the early land art interventions didn't really have a social nature. Visitors could only project a (formal) image or rational "idea"—often too geometrical—of the work. Any other possible dimension was excluded.

BV I am not an art historian, but I am sure that the land art artists worked without any interest in nature, with the exception of Richard Long, who was the link between yesterday and today, a bridge between where this differentiation began and where it now is.

JG You have created a public artwork for the Musée d'Erasme, that will last the length of its slow decomposition and is quite different from most of your projects.

BV The work is an extension of my process, from a tree stump this time, taken here as an inscription site for life. It is recut, keeping in mind that a tree stump always has an unequal form—and does not remind us of a circle, for example. This form more closely resembles the area immediately surrounding a volcano, with its lava flows and gullies. For the Musée d'Erasme I have proposed the idea of a "crater" on top of the stump, out of which water seeps. It is not about

fire or fountain but instead about . . . sweat, if I may say. Algae and moss should grow there.

JG A force generates the creative energy of a human being. It brings him or her to transform things, and this power does not exist on a conscious plane only. When you create forms or assemblages of elements, these are less "patterns" than games of perception that relate to light, texture, and the contrast between nature and so-called sculpture.

BV In fact, most of the time I work in a very empirical and intuitive way.

JG In 1998, you held an exhibition at Erfurt, located between Berlin and Frankfurt in Germany. How did the local people perceive your work?

BV It was a fantastic experience! Very moving. People were very enthusiastic, as if I had brought them an incredible gift. In this region, there are interesting links—almost visceral—with nature. You find there, for example, the Turing blue, created from leaves and used to dye fabrics. This pigment made the area rich at one time. Today, the process has been revived by some idealists who began to cultivate these plants in order to use their pigments again. I was asked to exhibit at the Erfurt train station, which was then still in use but no longer is. The work I did had many aspects, the most noticeable being related to pure mathematics. There was an immediate echo effect with the building. I used mushrooms that grow on dead trees, and I placed them on a bed of sandstone powder, whose color resembles that of the stones in front of the station. The form of these polypores also recalled the form of the building's pediment. There was thus a direct reference to the architecture of the building and to its eventual destruction. While we were setting up the exhibition, travelers were waiting for the train on the platform and could see me working through the windows.

JG We talk a lot about ecology these days, and artists reinforce this dialogue with the public and the media. It is as if nature is becoming a metalanguage.

BV When I go somewhere to create an installation, I am confronted with an initial problem. I walk and discover the nature around a place. This is when I have to make a choice. It is not always easy. Which material, for example, would be most suitable for this particular circumstance? Sometimes, I simply fall in love with a material, but most often I favor a material simply because there is a lot of it. I always have an ecological concern—on the ethical level, not in my creation—and take care in using a material that it does not affect the landscape. I then proceed to collect, in a blind manner one could say, as I don't know yet, at that point, how I am going to use the material. . . . Then I slowly discover some possible directions, often determined by the material itself. Each experience is thus unique, and always different.

An example of my process can be given. During one intervention I made in Hungary, I noticed a shrub with long needles and thought it would be a big challenge to work with a plant that looked so threatening. I would see how I could tame it. Some people, who had helped me cutting the branches asked

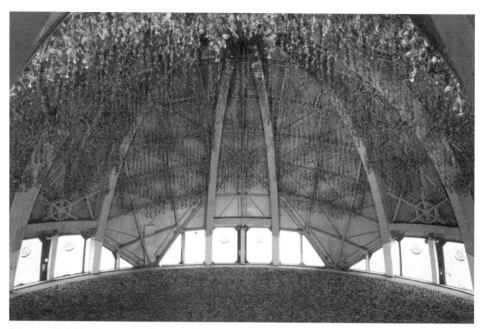

8.3 Bob Verschueren. *Installation XVI/02*, 2002. Roses (petals on the ground) flax, dolomite. Atomium, Brussels, Belgium. Courtesy of the artist.

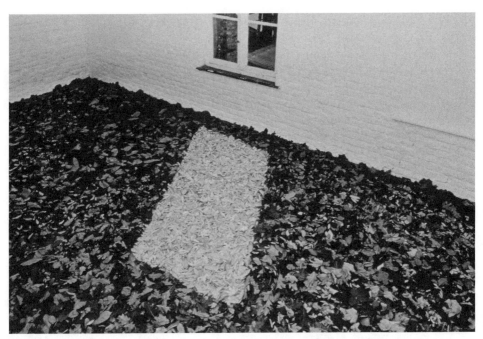

8.4 Bob Verschueren. *Leaves*, 1985. Atelier 340 Museum, Brussels, Belgium. Courtesy of the artist.

how they should cut them. I said to do it simply, as if they were the hairdressers of these shrubs. I did not want them to think about the length. Instead I hoped that they would respect the form of the shrub.

While collecting this unusual material, I kept wondering, skeptically, what I was going to do with it. I was afraid I would not find a use, that I would face an eventual failure. When we got to the exhibition site, we piled all these elements, and then I saw how they interacted with each other, how they built a kind of framework in space. I was surprised by this spontaneous framework and I worked from it. So when the material was brought to the site I discovered what I had to do.

The process is always implicitly hazardous, even dangerous. But this aspect is always very important to me. I even think that I am looking for this confrontation, this danger. Things always get resolved. In another project, at Matane in Quebec, the challenge was to use rushes. After having cut and piled them in the exhibition site like a kind of haystack, I noticed that it looked like nothing, that it was not very expressive. I then looked for another direction that would be more interesting as the piling itself gave nothing. I thought that I could sort them out according to the curve and the length of the elements. As it was a very complex task, I asked for help and at one point eight people were doing this sorting. As for myself, I was doing the sorting of the sorting! Then, I started to align the most curved stems, from the smallest to the longest, then those that were a little less curved, always in an increasing order of length. The result made me think of a wave, and this was not planned. In fact, what I was trying to do was to find a logic that would allow me to express what this plant embodied, and it was a great gift to reach a configuration that conformed to the life of the plant itself, which ultimately has a waterlike aspect.

JG The method of creation you describe is similar to that of the writer who, after he has the words, organizes them as the writing progresses, eventually giving them an original form that coincides with the subject, and the idea he wishes to develop.

BV I think that an important factor in the act of creation is to give oneself the opportunity to be surprised. If not, we are just artisans, craftsmen. I often say to my students that they shouldn't try to manage everything, but instead try to generate something. The artist is a generator, unlike the engineer or artisan who are happy to simply manage a work or project.

JG Which explains that in art, one must go on, sometimes blindly, trusting that one will get a result. When an artist has an idea for a project, he or she must set the process in motion, convinced that the elements will eventually fall into place.

BV For sure one must be open to things. I often have been confronted with students who took a direction to finally reach a completely unforeseen avenue. They often see it as a problem because they think that it is not them who have

created the work, that it created itself! This is an absurd point of view, because if they hadn't make this attempt they would never have reached this point, and the work wouldn't exist. Even if the result is quite different from what was initially planned, it is something that belongs to them, that is completely theirs. But most of them have great difficulty accepting what eludes them, what they didn't decide on their own.

JG On the other side, some people think it is naïve to think that art is linked to society.

BV It is evident that this universe is not open to everybody.

JG As with the art nouveau movement, the art-nature movement involves many people who have a direct concern and interest in this process of reidentifying the presence of nature as a creative source and presence in art. This is certainly one good way to integrate art with the environment, architecture, and the landscape.

BV I think that any art movement, except those that are a bit superficially constructed, always happens as a reaction to something. There are certainly similarities between the end of the last century and today, and these similarities give hope for what is to come. It is true, however, that at a certain time in the twentieth century one had the impression we were evading the question, which caused many artist/creators to follow Duchamp and exhaustively repeat the same exercises with found objects, as if we had come full circle from the urinal . . . back to the toilet!

9
NATURE VISION
Nils-Udo

Active in the field of environmental art since the 1960s, Nils-Udo builds structures, elaborates on the landscape in a scale that fits, montaging natural materials on site. Thus links are established between horticulture and art, but with a basic sensitivity to the history of the landscape and land. Nils-Udo's approach is tactile and often extemporaneous, creates a visual counterpoint between the various organic and inorganic elements. Site specific and with an integrative approach Nils-Udo's plantings were a major breakthrough in the field of contemporary art. The trees, plants, and materials he has used in works such as *To Gustav Mahler* (1973), *Birch Tree Planting* (1975), and *Spruce Tree Planting* (1976) embroider on nature using living natural elements in situ. Structures—both hidden and visible—likewise play a role. *Romantic Landscape* (1992) a permanent installation on the grounds of Ludwig Forum for International Art in Aachen, Germany, an entire "natural landscape," is raised onto an artificial platform, and is used by children who frequent the grounds. In New Delhi, India, Nils-Udo presented garlands of marigold flowers that flow in long lines like curtains to cover an ancient arch structure evoking a sense of the sacred. *The Blue Flower: Landscape for Heinrich von Ofterdingen* (1993–1996), a craterlike earth mound near Munich has a closed gate that contains a pond and plantings of about ten thousand blue wildflowers in a newly generated ecosystem. Thus Nils-Udo's interest in plantings merges with a built-up earth structure. In 1994 at the Chateau de Làas near Pau in France, he created a living spiral comprising various corn species to celebrate the five hundredth anniversary of the introduction of corn to Europe from the Americas. In the center, an octagonal tower was built, with original nonhydrid species of Mayan corn growing on top. At the Jardin des Plantes in Paris, France, he recently created a fairy tale-like piece that merges his interest in earth structures and planted elements, and near Mont Tremblant in Quebec, a major boulder and cave work titled *Pre-Cambrian Sanctuary* (2003).

 Nature's process of endless reproduction and recreation usually goes unrecognized by most of us as we go about our daily lives. Nils-Udo breaks

through this dream state of contemporary culture to make explicit the many ways we perceive, define, and reflect on reality. *Nils-Udo: Art in Nature* was recently published by Flammarion (2002), as well as a book on Nils-Udo's *Nests* by Editions Cercle d'art in France (2003).

JG You have worked in environmental art since the 1960s. Were others working in the field at the time?

N-U I did not know any artist whose subject was living nature in such a comprehensive, fundamental sense—including all the natural phenomena humans are receptive to. Nor did the minimalist work of Richard Long have this approach. Even less so, the works by American land artists who were often fairly indifferent to the vitality inherent in nature.

JG You live in Europe, where peoples' perspectives on nature and the environ-ment are quite different from those in North America, or Asia for that matter. How did your art evolve into environmental in the early years? Can you remember a specific point when you said, *I want to make environmental art?* Was the original impulse a romantic one, ideological, ecological, or did it evolve out of an interest in the aesthetic of the landscape itself?

N-U The works I created in Paris in the 1960s using living plants and natural materials marked my first step toward moving away from panel painting and studio work. Moving from Paris to rural Bavaria, perceiving the endangerment of nature, its growing destruction, I lived through a profound change of aware-ness. Being a part of nature, being embedded in it and living on it, it appeared to me that acting in compliance with the laws of nature was something self-evident and necessary for survival. To preserve the original character of na-ture, its unscathed condition, because like preserving the air I breathed, the basis of my existence. Any human interference could bring about nothing but destruction and extinction. Every newly detected piece of destroyed nature brought me to the verge of despair.

Since the very beginning of my work with and in nature in 1972, plantings have been my central focus. I started out by leasing land from the farmers in my region, the Chiemgau, in upper Bavaria. In the early 1970s, I created a variety of works on these lots with earth modelings and, in part, some extensive plantings of trees, bushes, lawns, and flowers.

The idea of planting my work literally into nature—of making it a part of nature, of submitting it to nature—its cycles and rhythms, filled me on the one hand with a deep inner peace and on the other with seemingly inexhaust-ible new possibilities and fields of action, putting me into an almost euphoric state of readiness for new departures. As a part of nature, I lived and worked day after day in its rhythms, by its conditions. Life and work became a unity. I was at peace with myself. The decade-long abstract struggle in front of the canvas with the subject of my life—nature—was now past. Nature's room itself was to be my art space.

I acquired new knowledge with every new piece of work I performed. I

advanced further and further, penetrating deeper and deeper—it was as if I was following a call, when, for instance, I was crawling along the course of a brook, endlessly, on and on, further and further. Where to? Longing.

The aspect of art now completely faded into the background. What I wanted was to live, act, and work in symbiosis with nature in the closest possible way. The living nature itself, all the phenomena that are characteristic of it, were all of a sudden potential issues. The sphere of nature simultaneously became the sphere of art, in which I inscribed myself.

By elevating the natural space to a work of art, I had opened myself to reality, to the liveliness of nature—I had overcome the gap between art and life. The roundabout way of two-dimensional abstraction in painting had been overcome. Henceforth my pictures were no longer painted, but planted, watered, mowed, or fenced. Through my plantations, I associated my existence with the cycles of nature, with the circulation of life. Henceforth my life and work proceeded under the guidance and in keeping with the rhythms of nature.

JG One of your works that I personally find most exciting is *Landscape with Waterfall* (1992), created at Atelier 340 in Jette, north Brussels, a town in which the surrealist Magritte once lived. Not only is this work a nature piece in an urban setting, but the nature literally was planted over a balcony and had water flowing out of a room onto the balcony and down onto the street. The tree, slabs of rock, and plants projected an idea of nature that so remarkably contrasted the actual place that indeed this replacement of urbanity with nature looks surreal yet is somewhat cathartic. How did this piece and its conception come into being?

N-U My work is divided into two main divisions—the pieces of work created in and with nature, using exclusively natural materials, and the projects designed for urban spaces. These are fundamentally different from the projects I perform in nature. In order to put them into practice, I use any technical materials necessary. If need be, they can also be nonnatural materials, such as reinforced concrete. They are, as a rule, laid out in urban spaces deriving their tension from the confrontations of austere architecture with natural plantations. The working process is rather like that of an architect. I take measurements, prepare plans, and shape models, and in general I entrust building contractors or landscape gardening companies with the performance.

JG Is the artificiality seen in *Landscape with Waterfall*, which parallels the *Romantic Landscape* you built for the grounds of Ludwig Forum in Aachen, Germany (1992), or *The Flying Forest* in Lyon (1994) intentional? Underlying manmade structures hold up the nature settings in these works. The *Romantic Landscape* in Aachen is truly ingenious. You can see right away that the hill, stones, and trees were intentionally placed there and that we are looking at a constructed landscape. It has also become a place that children can play on. It has a purpose in this place. . . . Did you intend to make this artificiality of the

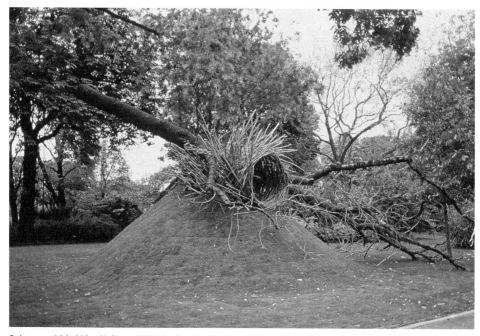

9.1 Nils-Udo. *Habitat*, 2000. Jardin des Champs Elysées, Paris. Courtesy of the artist.

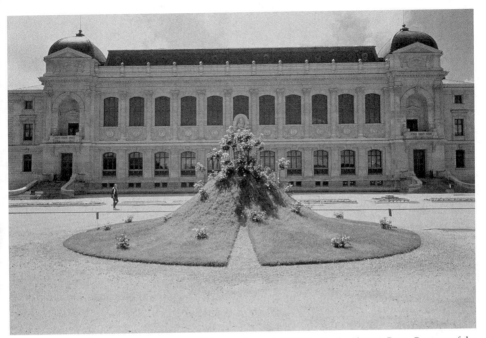

9.2 Nils-Udo. *La Belle au bois dormant* (Sleeping Beauty), 1999. Jardin des Plantes, Paris. Courtesy of the artist.

landscape a feature of the piece? Or was it a way of making the viewer realize that in a world where we are continuously transforming spaces and sites, we inevitably make them less natural? *Romantic Landscape* does make us aware that we can beautify places with planning as much as uglify them through neglect.

N-U In my project called *Romantic Landscape*, I tried to reproduce a specific type of landscape from German romantic (and Biedermeier) periods, a "grove," that is to say a "romantic" place in nature inviting one to tarry. Typical components of a grove can include a shady place under a tree on a knoll, with an erratic boulder, surrounded by flowers and blooming shrubs; a footbridge leading over a brook; a millstone. . . . The landscape lays on a pedestal. Nature has been set on a pedestal and declared a work of art. *The Flying Forest* is a precisely modeled and planted reproduction of a fictional natural landscape. It has a sloping mountain with spruces and meadows. The landscape lays on a platform placed on high stem columns. A precisely shaped copy of a piece of natural landscape has been set on a pedestal, displayed, and declared a work of art. (We destroy the original natural landscapes and build ourselves new ones, artificial ones.)

JG The crossover into plantings art—making a living landscape of trees, ferns, or flowers—must have received mixed reactions from the public in the early days. I feel this facet of your work has largely been overlooked in critical discourse, yet its relevance is increasing as landscapers and planners increasingly look to artists for new conceptions of urban, suburban and rural space. Your more recent *Shells Flowers* planting in Martinique (1994) is predated by your V-shaped section of trees planted in a hillside (titled *To Gustav Mahler* [1976]), and other plantings that are extremely romantic and hopeful. The early works embroider on nature in a highly personal way. The more recent works seek to reintegrate notions of nature as living elements into art, as did your tree walkway in Turin, Italy (1989), a platform that literally allowed participants to experience upper tree growth first hand.

N-U It is certainly true that those of my works that I have designed for urban areas have so far been considerably less noticed and appreciated than the works I have performed in the sphere of nature. This is certainly due to the fact that there are considerably fewer of these works in natural areas and that these works are just simply more difficult to convey in exhibitions. And also, people are always first impressed by the ephemeral character of the works performed in the sphere of nature.

JG You have written: "Nature is still complete and inexhaustible in her most remote refuges, her magic still real. At any time, meaning any season, in all weathers, in things great and small. Always. Potential Utopias are under every stone, on every leaf and behind every tree, in the clouds and in the wind. Pitting poetry against the inhuman river of time."[1]

Do you believe that art can change society, or at least help people to believe in visions other than the commercial, consumer myths that are thrust

upon us daily in great volume? Does the change come with recognizing the small things, the details, an awareness of our physical environment in an era where high-tech emphasizes the contrary, a displacement of the individual from their historical, physical, and natural environment?

N-U We must realize our responsibility for what is happening, for society. Art always deals with reality. Those who shut their eyes to reality are liars and deprive themselves of any meaningful possibility of acting in society and (in the history of) art. What are we working for, if not for man, for society? Despite clear-sighted pessimism—we must hope in order to live—what counts for me is that my actions, Utopialike, fuse life and art into each other.

JG When you worked with corn, a tribute to the Aztecs perhaps, you actually transformed a landscape in France—planting corn over a large land area, building a huge spiral design and walkways that led to a tower in the center—I felt you were turning a corner, almost, into agriculture as a ritualistic kind of artmaking process. How did the public react to the piece—as art or agriculture? Did you receive any comments?

N-U The *Maize Project* was a piece of work that I performed to order in France on the occasion of the five hundredth anniversary of the bringing of the first maize harvest in Europe—in a way, "applied art," as it were. A challenge, however. A kind of time-lapse spiral through the history of that cultivated plant. A plantation comprising fifteen varieties of maize including the original maize stemming from Mexico. The audience, which had of course been informed of the intention of the project, reacted in a very positive and interested way. They enjoyed the comparison of the different varieties of maize. Of course the ecologically questionable side of maize cultivation was omnipresent: enormous amounts of artificial fertilizer and pesticides.

JG Can you tell me something of the work you made for the Jardin des Plantes in Paris?

N-U This project responds to the spirit, to the poetry, to the language of shapes and the flora present in a typical park laid out "a la francaise." Placed right in the center of the ample square laid out in front of the Musee d'histoire naturelle, there rises a Sleeping Beauty's enchanted castle of roses. Four avenues lead steeply upward, ending in front of a thick wood of standard roses. At the end of each avenue, a little white cloud issues from the lawn, continuously sending out the scent of a perfume that was mostly composed out of the rose essence "Paris" by Yves Saint Laurent. Even from a distance, the Sleeping Beauty betrays herself by the bewitching perfume of roses.

JG What projects are you currently working on? What future areas of expression in nature are you exploring?

N-U Activities planned include outdoor projects for a horticultural show in Germany, a large-scale project in front of the Chateau Versailles, a project in the Neanderthal near Dusseldorf, a series of works on Lanzarote, the Canary Islands, La Reunion, the Indian Ocean, and in southern France. Large-scale

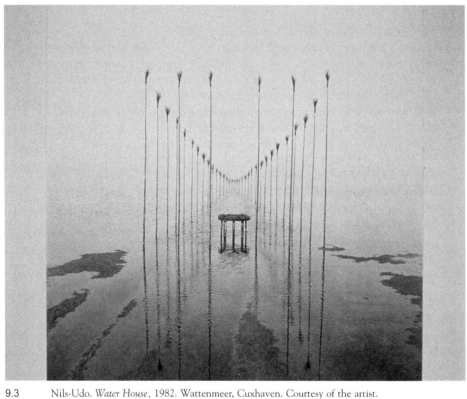

9.3 Nils-Udo. *Water House*, 1982. Wattenmeer, Cuxhaven. Courtesy of the artist.

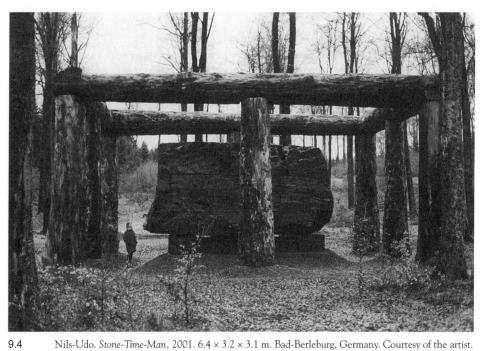

9.4 Nils-Udo. *Stone-Time-Man*, 2001. 6.4 × 3.2 × 3.1 m. Bad-Berleburg, Germany. Courtesy of the artist.

installations will be made for three museums in Japan. A special kind of challenge is a work designed for a large existing barrage in southern France "Le barrage des olivettes." The draft has already been made. I am further planning to cooperate with architects to perform projects in urban areas in Germany. As a rule, my projects evolve without any preconceived conceptual ideas. I respond to the natural spheres or urban situations I encounter, so that I am not able to know in advance what projects will evolve in the various spheres of nature, landscapes, and countries.

JG Can you tell me something about this major work titled *Stone-Time-Man* (2001) you recently created in Germany? This permanent outdoor installation features a massive stone as its centrepiece, surrounded by huge fir tree trunks, which serve as vertical and horizontal supports that are interconnected.

N-U *Stone-Time-Man* (2001) has been created for Waldskulpturenweg Wittgenstein-Sauerland at Bad Berleburg near Cologne, in a forested part of central Germany. This project is about vulnerability and the temporality of human existence. I discovered this large 150-ton rock in a quarry, where ages ago it had broken out of the face, waiting to be blasted apart. In the face of thoughts and sensations that arise inevitably at the sight of such a monumental block of rock, I wanted to take myself back as far as possible. The rock remained unworked. In the sparse beech-tree forest, I created a space that both protects and displays it. There it sits, on top of and surrounded by mighty pillars of tree trunk wood whose dimensions react to the monumentality of this mass of stone. I didn't cut one tree down. I chose every one of those mighty fir tree trunks after they had been knocked over by a storm in the Black Forest.

JG Is this some kind of representation of the history of the earth?

N-U The main thing is that it has to do with *la condition humaine*.

JG And do you feel the response to your nature-based brand of art has improved in recent years?

N-U Yes most definitely. Recently there is increasing interest in nature work all over the world.

JG And yet environmental art remains marginalized, set apart from the mainstream of contemporary art. No major museum in North America or Europe has yet held a significant show of environmental art.

N-U Why should museum people be in a different position than society in general? Knowledge, and thus interest and affinity with nature, have become lost. That which no longer plays a role in the reality of life cannot find expression in art or museums.

NOTE

1. *Art & Design Magazine* (Art & Design Profile No. 36), "Art and the Natural Environment," 1994, p. 59.

RIVERWORK
Mario Reis

Nature and art are less critically segregated and life takes precedence over art when German artist Mario Reis makes "nature watercolors." He does so by placing cloth framed by wood into a river and allowing mineral and vegetal sediment and color to accumulate on its surface. Water is the paintbrush that moves and displaces the sediment and color on these works of art. Reis draws these configurations of silt, sand, and sediment from rivers all over North America, in places as varied as the Yukon, Idaho, Ohio, New Hampshire, Nevada, Michigan, British Columbia, Alaska, Wyoming, and Kansas. Reis also creates such works in Mexico, Europe, Africa, and Japan and exhibits them extensively. He finds each artwork to be as original and confounding in its variety of hues, shades, and textures as any old-fashioned artwork. It is also much more challenging. In Colorado, sluice mine tailings carried along a mountain creek give the canvas a rusty iron ore hue, while the clay basin in Oklahoma's Red River produces a reddish tan color. As a collectivity, Reis's artworks are a powerful reflection of natural diversity.

JG Your way of working with nature is very particular, almost scientific. Traveling in Europe, North America, Africa, and elsewhere, you select specific river sites along a projected route. The method is simple. Once there, you put stretchers with cotton cloth in the water and nature does the rest of the work. The results are infinitely variable, revealing the patterns, colors, textures, and residue of each site in microcosm. The nature watercolors give a sense of the specific microecology of a place. Brought together as an ensemble of works, from numerous sites, they become a microcosmic study of the world's waterways, yet each is very specific. What impact do these works have when exhibited in galleries? What is the response?

MR Before answering your question, I need to explain my working method in more detail. I don't simply place a stretcher in a stream and let nature do the rest of the work. Before placing the stretcher, I have to carefully select a site that provides the working conditions I need. For instance, the water level and

the speed of the current have to be right. The installation of the stretcher is the most demanding part of the work. It is truly an interaction between myself and the river. I actually use the floating water as my paintbrush. By placing stones on the stretcher, I influence the flow of the water, and can control the painting's result to a certain degree. That means I decide where the natural pigments, transported by the river, will settle down, or where there will later on be lighter parts in the painting.

So from the beginning I compose a painting. That is particularly important when bringing together several paintings from the same river into large format grids. Of course, the degree to which I can control the outcome of a painting is limited. Having installed the piece, I leave it on its own, and the river then works on it. It is thus influenced by any natural changes that might occur. There might be rain or snow, the water level could rise or fall, and animals might come along and leave their imprint. Whatever happens, it's an expression of nature in its own voice. Each stream has a specific character. Some paint in a really hard-edge manner, others paint more softly. In this way, each painting, influenced by the interaction between myself and the river, is a kind of a self-portrait of that specific river.

To answer your question, I must say that when my works are exhibited in galleries, people are initially drawn to the works because of their colors and patterns. The texture of the works is very earthlike, and the colors awaken memories that, at first sight, cannot be clearly specified. As their curiosity is aroused, they get closer and closer, visually exploring the tactile sense of the work. It is only after reading the inscription at the bottom of the piece (the date, location, state, and river's name), that they realize they are actually looking to a river painting. For most, no holds are then barred. They begin to ask questions about how the work is made, and why, and what the starting point was. They want to see river paintings from their homeland, and think of rivers they know, and so on. Most are fascinated with the concept behind the nature watercolors. They find it almost unbelievable how different each piece is, and how many colors can be found in the rivers. They are puzzled by the beauty of the waterways and by their individuality. The works change the spectators' way of looking at nature and rivers. They become more sensitized and begin to appreciate the diversity and beauty of rivers. The works have a deep impact on the viewer. Once on the walls, these works change the whole gallery environment into something totally different. It creates a dense atmosphere, a purity and clarity that is unusual. The works transform the space and there is an eloquent calm. Even when shown in a massive quantity, they never overwhelm you, and are like windows into the world.

JG Jackson Pollock used to talk of how he could control the way he dripped paint on canvas. Your *Nature Watercolors* seem to be a statement against the modernist artists' willingness to control the process of their creativity. They

106

are not segregated from nature's processes the way much postmodern work is. You once commented that you are neither a traditional landscape painter nor a postmodernist. What do you mean by this?

MR What distinguishes me from traditional painters is the medium I use. It is a direct approach. The rivers in my paintings are both the object and subject of my work. I am not creating an illusion of rivers, but catching some of the real essence of the rivers in my painting. They leave their imprint on the cotton and show us how they are. That is partly what separates me from the post-modernists. As you correctly stated, my work is not detached from nature's processes.

JG In a strange way, your *Nature Watercolors* remind me of American color field paintings, of Rothko, for instance. Yet the effect seems all the more mysterious and fascinating because flowing water is part author of these works.

MR Mark Rothko was one of the greatest artists. I truly admire his works. It is a pity that he is dead, for it would be interesting how he answered that particular question. Actually the thought of an exhibition that brings his works together with mine is really inspiring.

JG The journey, the nomadic traveling and site visits, all this must sensitize you to local geography, landmarks, and the earth's biospecific character. Is the travel part of your art process?

MR The traveling, or hiking to the sites, is definitely not a part of the art process. It is simply how I get to the places where I create my works. For an artist who works with artificial color, the way to the shop isn't a part of the art process either. When I began making the river paintings I did not realize that this would lead to a nomadic life. The works themselves showed me I would have to travel to catch as broad a spectrum as possible, a spectrum that would enrich the work. My paintings have changed dramatically over the years. Fortunately, I am a person that cannot stand still. I have to move on in order to gather new experiences that enrich my life wherever they happen. So traveling is, in a way, an essential part of my nature. I am lucky this is part of my work because I like to be outdoors and love nature. So I do not consider the traveling to be part of my art process.

I would again like to return to the art process. The process involves more than installing a piece in a river. After the pieces are stabilized, I group them. When putting pieces together from a single stream, I put the emphasis on a strong composition. My aim is to create a sense of boundless space, full of light and shadows, floating transitions, unusual perspectives, and pulsating motions. My color fields change anew with every view. For each viewer, including myself, they can be perceived in different ways. For some people, my pieces are zenlike, while for others they are an adventure. They captivate the alert eye and invite the viewer on a journey through time and space. Of course, this doesn't happen by accident. It results from the compositions I create within the art process.

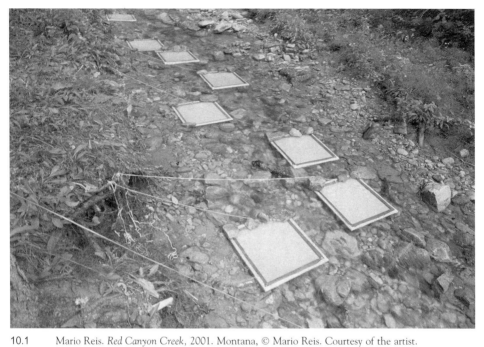

10.1 Mario Reis. *Red Canyon Creek*, 2001. Montana, © Mario Reis. Courtesy of the artist.

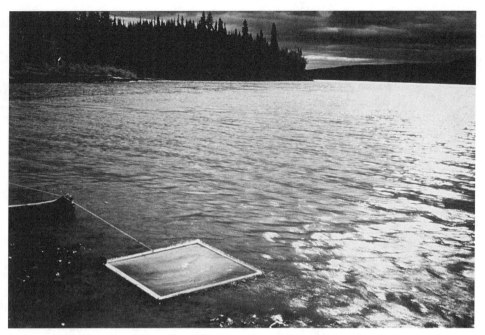

10.2 Mario Reis. *Nature Watercolor*, 1994. Yukon River, Alaska. © Mario Reis. Courtesy of the artist.

JG Do you think of your particular brand of artmaking as a celebration of nature? Does it consist of a reversal of the artist's role from primogenitor to postgenitor?

MR I wouldn't go so far as considering my art being a celebration of nature. Nature does not need me to celebrate. She does so by herself, simply by being what she is. My role as an artist is neither as primogenitor nor postgenitor. In a way it is both. But the main thing, to be even more explicit, is the interaction with the river, the collaboration between us.

JG Clean water is an increasingly rare resource. You have created works on some of the most polluted waterways on earth, like the Rhine, as well as in pristine, largely untouched rivers in Alaska and the Yukon. There are traces of manmade intervention, of pollutants, in some works, as much as there are nature traces in others. Is the selection of your sites a conscious choice or is it random?

MR The question of pollution is an interesting one. Basically you cannot see the pollution of a river, just the effects. The crudest one would be dead fish and wiped-out vegetation. But destroyed microorganisms can only be detected with the help of microscopes and other tests. Of course, if someone spills oil into a river, one would see it, and the canvas would catch it too. But most pollution is invisible, especially for the untrained eye. Therefore, my pieces more often show the traces of nature.

When I began to do the river paintings back in 1977, environmental concerns were slowly growing. The Green Party wasn't even founded. To be honest, my motives at that stage had nothing to do with environmental questions. I was simply fascinated by fleeting phenomena, by natural forces, and was trying to find a new expression that involved painting rivers. It had to be an expression that would show what was really going on in a river and what makes a particular river unique. I wanted to get the real thing onto the canvas. As time went by, my river paintings gained a different impact, because now almost everybody is conscious of the desolate state of nature. Pristine nature has become as much a treasure as clean water. There is no denying, however, that my art documents the state of nature, but I do not see them as a "raised index finger" telling the people, "Look here! That is pollution! Our nature and therefore our living base is endangered, so watch out and behave well!" Things don't work that way. It is almost the other way around. People care for things that they appreciate and love. If through their beauty and meaning, my works are able to sensitize people, lead them to appreciate and love nature more, this would be a fantastic result.

But through art I dare say that one could force people to change their attitudes by attacking them. Laws can possibly do this. I, for myself, have great environmental concerns, but this would never be a reason to choose a specific river. I have to fall in love with a certain place, a certain river, or a certain color to make that river my partner in action. I do not go for names or trendy

places. Often I inform myself, when possible, about where one can expect special features that result from geological particularities, but often I choose river sites at random. I am just driving or hiking by, and there it is, the perfect river to work with!

JG Do you eliminate certain of your *Nature Watercolors* after they have been created, select which ones will be appropriate or inappropriate for exhibition? How do you decide?

MR I never destroy works because I do not like them. This would be of great inconsequence. I am asking a question and I am getting the answer. It is not relevant if the answer does not please me. For my exhibitions I choose the works that I like most and that I feel are the strongest. The selection of works also depends on the specific space and location, so every show looks totally different.

JG There is so little intervention in your art. It's a natural process that involves reinventing the artist's role as someone who sensitizes the public to nature. Rather than leaving your expression on materials, materials leave their impression on your art.

MR That is true, but only to a certain degree. I will not and cannot influence the material's imprint, the natural pigments and their specific appearance, "hard edged" or "soft." The crucial point is putting them together in grids. Grouping them involves a lot of personal expression. The compositions come out of my inner feelings, my personal experiences, and the handling of autonomous material.

JG Do you ever feel marginalized from the mainstream art establishment? Does your audience extend beyond the traditional artgoing public?

MR I would first like to answer that question in general. Every art that does not follow the mainstream or a momentary trend will be marginalized, especially when the art involves deep meaning. The tendency is like that today. Art is approached with an attitude trained by consumerism. Art is treated almost like fast food. The notion of consumerism is: We want to have it all, here and now, easy and cheap. No effort please! Unfortunately, the cultural institutions, being in money trouble, are beginning to react to public demand by transforming the exhibitions into thrilling events that attract the masses. To achieve this they must compromise at the lowest possible level. That means that in the long run, we will see more and more exhibitions with less and less quality. Thrilling sensations, nice little shocks, easygoing and fun—that is what attracts the masses. So for an honest artist who follows his visions in a straight manner, it will be ever more difficult to receive recognition. Making money just for the goal of making money is becoming more trendy, even in the artist community. Many artists out there are jumping on every train that is leaving the station. But fortunately, for the time being, there are still a good many people willing to appreciate sensitive and meaningful art, people who like to use their brains and encounter new experiences that will enrich their lives.

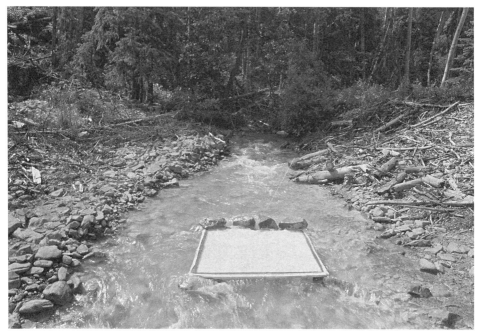

10.3 Mario Reis. *Gray Copper Creek* 2001. Colorado. © Mario Reis. Courtesy of the artist.

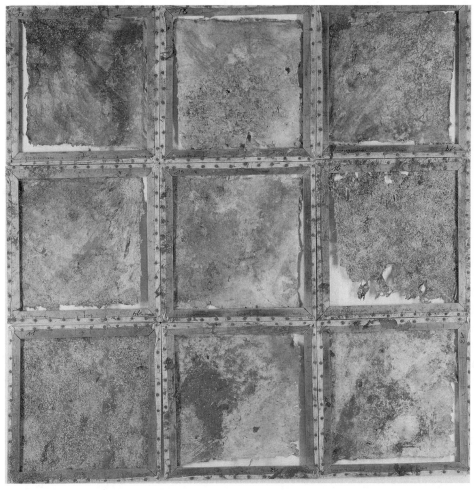

10.4　　Mario Reis. *Grid*, 1982. 66 × 66 in. Fleuth, Germany. © Mario Reis. Courtesy of the artist.

Another aspect of your question is the notion of categorizing. I am somewhat troubled by the way the art establishment usually puts my works into the category of land art. Much more is involved in my work than landscape. Maybe the title of the works is what created this trap. When I began working, I chose the title *Nature Watercolors* to indicate the medium, just as photography, sculpture, painting, drawing, or watercolor refer to the medium being used. At the same time, this title refers to the work itself as being river painting. Though, I have a broader vision of my paintings—if someone has to categorize them they also fall into the field of color field paintings, arte povera, abstract art, conceptual art, process art, and even realistic painting.

So, the *Nature Watercolors* cannot be easily categorized. They step beyond the borders of definition. The phenomenon of time is an aspect crucial to my work. Time is not an easy phenomenon to deal with. One can experience time because nothing is the same the very next moment. Everything is in a constant state of flux and change. But time also involves leaving tracks or traces behind. My works make one aware of this phenomenon. The *Nature Watercolors* record a fixed period of time, and at the same time, imaging the process of creation, they emphasize the constant flow of time as well. The process is like sedimentation. As time goes by, layer after layer accumulates on the cotton cloth. So what happens on a large scale in nature is also what happens in the little stretchers that contain my works. A lot of the natural pigment, that is the sediment that accumulates on the cloth, is many thousands of years old. Looking at the works, we can actually see into the distant past. But besides all that, my works can be appreciated without any knowledge of the process of creation. They stand on their own.

The audience for my art does extend beyond the traditional artgoing public. A lot of people from scientific backgrounds, like biologists, geologists, hydrologists, microbiologists, as well as educators, are interested in my work. So are a lot of people who have never been in a contemporary art museum. I meet them when doing my work outdoors: farmers, ranchers, fisherman, people digging for gold, and so on. They catch the idea of the works immediately. I have had many inspiring conversations with these people.

JG Early land artists like Robert Smithson whose works imposed on the landscape, seemed to conceive of nature as a fiction onto which the artist left his or her imprint. What is your opinion?

MR You can see it both ways. It depends on your point of view. I don't have any objections to the viewpoint. For my part, Smithson did some great work. But I chose a path that leaves few traces, other than some footprints. I do not mess with the environment or change it through my work. I don't even take out very much. The material residue on the cotton is no more than a few tablespoons worth and it was on its way to the ocean anyway; it was already leaving the environment where I am doing my work. So my artwork doesn't

harm the environment much at all. To say that nature is a fiction is a philosophical standpoint I do not hold. But I would still rather see the *Spiral Jetty* at Great Salt Lake than a drilling construction in the Arctic.

JG Screen technology, television, media culture, and so-called virtual reality inadvertently send us the signal that tactile living reality is secondary to the image. Your works are sending out a different message—that what is out there really is beautiful and has its own form, design, and layering process, and that it does it all naturally. Does the artist have a role to play in guiding us towards a more ethical understanding of how nature works, and how important it is to our children's future survival on this planet?

MR I can only speak for myself. I do not see my role in such a defined way. My pieces do send the message you have described, and if this message reaches people it is a positive result. Tactile living is the real thing. Of course, one cannot deny that new technology opens up new ways and forms of communication. The internet is able to connect people all over the world. But face-to-face communication is essential to human life. It involves vivid experiences like joy, trust, and sharing. The matter of trust is a very crucial one. Most of our life is based on trust, and I dare say that virtuality can teach trust and being trustworthy. So in a certain sense, the new media are disconnecting people at the same time as they connect them. And that might also be true for the arts.

Experiencing art, for me, is always very sensual, almost erotic. We cannot deny that we, ourselves, are tactile living realities as is the whole world around us. Overlooking this would be a total misunderstanding. In the long run, the idea that the tactile living reality is secondary to the image could be very misleading. But I do not believe the artist's primary role is as a teacher of ethics. I strongly object to any guidance that is exclusive. For my part, if the artist has a role, it is to open peoples' minds, to sensitize them, to bring new experiences to them that enrich their lives, and our lives too.

JG Why this fascination with water?

MR We could talk about that for hours. Basically it is the unstable character of water, as well as the fact that we are deeply connected with water anyway. Water always changes, by nature. Sometimes it is fluid, sometimes gas or solid. Water is able to carve deep canyons out of the hardest rock. It acts as an landscape architect, but it also runs softly through our hands. My fascination is a very basic one. I would like to let the Roman poet Ovid answer this question:

> There is nothing in all the world that keeps its form. All things are in a constant state of flux, and everything is brought into being with a changing nature. Time itself flows in constant motion, just like a river. For neither the river nor the swift hour can stop its course; but, as wave is pushed on by wave, and as each wave as it comes is both pressed on and

itself presses the wave in front, so time both flees and follows and is ever new. For that which once existed, is no more, and that which was not, has come to be; and so the whole round of motion is gone through again.[1]

NOTE

1. Ovid, *Metamorphoses*, 15, 177–85, Hermann Breitenbach, trans. Stuttgart: Reclam, 1971. English translation: Stefanie Lucci.

11

COSMOLOGICAL SHADOWS
Bill Vazan

Physically imprinted on the land surfaces of the five continents—North and South America, Europe, Africa, and Asia—over the past thirty years, Bill Vazan's land art projects originated out of the conceptual and minimalist art tendencies of the 1960s. Many of Vazan's land art projects from the 1960s and 1970s were ephemeral and survive only through documentation: photographs, books, catalogs, films, and videos. Among the early works were the *Worldline Project* and *Canada in Parentheses*. The latter work was created simultaneously on both coasts of Canada in collaboration with Ian Wallace in August 1969. Each artist created a crescent-shaped form—Wallace on the west coast at Spanish Banks in Vancouver, British Columbia, and Bill Vazan on the east coast at Paul's Bluff on Prince Edward Island. The parallels between land art's ephemeral yet conceptual approach to the land surface and the conceptual gridding and labeling of geo-forms found in mapping became evident in the photo sequences brought together from this land art initiative. Vazan's *Worldline* event (1971) established imaginary lines that criss-crossed the globe. They were actually set down simultaneously as taped lines at 25 locations in eighteen countries around the world joining the respective latitudinal and longitudinal positions of each site to the others as imaginary lines. As a performance/ event *Worldline* made evident how disconnected from real life, "objective" standards of measurement really are. They rationalize and segregate human culture from nature, quantifying the global environment.

Bill Vazan's most controversial projects include *Pressure/Presence* (1979) installed on the Plains of Abraham in Quebec City, a site that decided the future of Canadian history, the large-scale land art drawings created on the Nazca plains in Peru (1984–86); *Mag Wheel #3* (1993) in Utah and Nevada; and *Socle Circulaire* (1997) in Gotland, Sweden. He has undertaken recent land art projects that he calls *Stands for a Parallel World* amid the limestone monoliths of the Mingan Archipelago on the lower Saint Lawrence River (2000) and in the mountains of Thebes in Egypt (2001). A major traveling

exhibition of Bill Vazan's land-art-based photoworks was inaugurated at the Canadian Center for Contemporary Photography in the summer of 2003. Recent commissions include *Raven's Nest*, at Kamloops, British Columbia, in 2002 and *Mirage* at the Jardin de Métis in 2002.

One of Bill Vazan's main interests is with cosmological models, and the way all cultures adhere to systems that enable them to rationalize the universe we live in. The physical aspect of each site, its geology (and the human history that has taken place there) play a role in Vazan's land art. By circumscribing each place and siting it in our imagination, recreating quasi-mythological landforms and engraved stone sculptures (whose engraved markings look Aztec, Mayan, or Celtic but are actually self-creations), Bill Vazan makes us all the more aware of the geospecificity of a site and in so doing helps us recognize aspects of the universal and cosmological. Born in Toronto in 1933, Bill Vazan now lives in Montreal and is one of Canada's best-known and most consistent sculptors. His works are in many prominent Canadian collections including the National Gallery of Canada, the McMichael Collection, the Art Gallery of Peterborough, the Art Gallery of Ontario, and the Musée d'art contemporain de Montréal.

JG As early as 1963 you were involved in earth art projects. Was making art outdoors a move to get art out of the galleries, as was the case for Robert Smithson, Michael Heizer, and others?

BV No. I had never had any gallery experience so it was not a reaction to anything, just what interested me. I was not in an art milieu and came back to it from another view point. My system, my guts, my intestines were telling me I had to work as an artist. I had come down with ulcerated colitis and started to make art again while recovering in the hospital. I had two lives. Doing my art and a regular life. It allowed me to be much more open to many things. To go up north to the cottage country and arrange stones, to play around with tide levels, or try making a mix of concrete and stone into a mass was not a big aberration. It was fun!

JG By 1968 you were doing low-tide sandforms on Prince Edward Island and then *Snow Walk Maze* in Montreal (1973–74), followed by chalk line drawings in Toronto and Quebec City. These works were ephemeral. Do you feel a contradiction between these ephemeral works and your more recent stone landscape assemblage pieces?

BV It depends on how you look at it. I now find it kind of absurd for me to have done this sort of work. To find I have done something that has a permanence of thousands of years is another thing. Artists are contrary. Contradictions on contradictions. Whether the work lasts minutes or many years, it is all ephemeral. Time, by definition, is ephemeral. If you want to do a land piece when you don't have access to the land, which is often the case, you have to think of an interior thing. One way for me to make a land piece is to make maquettes via

engravings on small stone surfaces. So these become like sketches for possible large-scale land pieces.

JG The engraving on your stones sometimes has cosmological references—constellations, Celtic interlacing motifs, aboriginal song lines . . . sometimes they fuse forms from completely different sources. Do you feel any contradiction between the ancient and the contemporary? Are these forms you create and engrave on the stones an appropriation, an adaptation, a recreation?

BV I enjoy seeing it and I would like to celebrate it, even propagandize this artform. It doesn't get much exposure, and when it does it's always put down to a secondary or tertiary level. So I am quite happy when I see this. I develop it into my own kind of work. Its a way of expressing that underlines our basic reality, which is that we are not permanent. On a recent PBS show, Jonathan Franzen, the author of *The Corrections,* was criticized for not dealing with reality. He replied, "Yes. I deal with reality, but its hard to deal with reality because if you do, you don't want to be around." It comes down to that. The reality is our nonpermanence, and that is something I want to put into my art.

JG *Shibagau Shard* (1989), now re-sited at the McMichael Collection in Ontario, Canada, references the protohistory of the natives of North America. Native history mythology is generally something we know little about.

BV I was intrigued by the Peterborough petroglyphs at Stoney Lake and the Lake Mazinaw pictographs in southern Ontario. We don't know what tribe created them. The images I engraved reference these and other petroglyphs I witnessed along the Columbia River in Oregon, as well as the Australian aboriginal dream time. *Shibagau* is probably a French term used originally to describe the native tribe there. For me this piece is like a fragment of the Canadian Shield, rather like a shard of pottery, but a natural, geological, contextual one.

JG *Outlickan Meskina* is a land art recreation in rock form of the cracks in a caribou shoulder plate bone, the traditional way native shaman's read the best places to hunt caribou up north. In music you have the Celtic revival, or one may think of Australian aboriginal or Haitian voodoo art. Their art originally had a spiritual or ritualistic function in their society and now they make it for exhibition in museums. Is there such a thing as indigenous culture in its original context anymore? Are we largely re-creating religious, archaic, or even modern motifs in art?

BV When you have been around long enough you eventually come to see that everything is pretty well the same thing. It just comes in a different package. I guess what makes it of value is the way it is restructured and reformed in a contemporary way. When I get a stone from the land, its like bringing the land to me in a reduced form. I keep the patina—to keep its natural history—and create a miniature land piece on it.

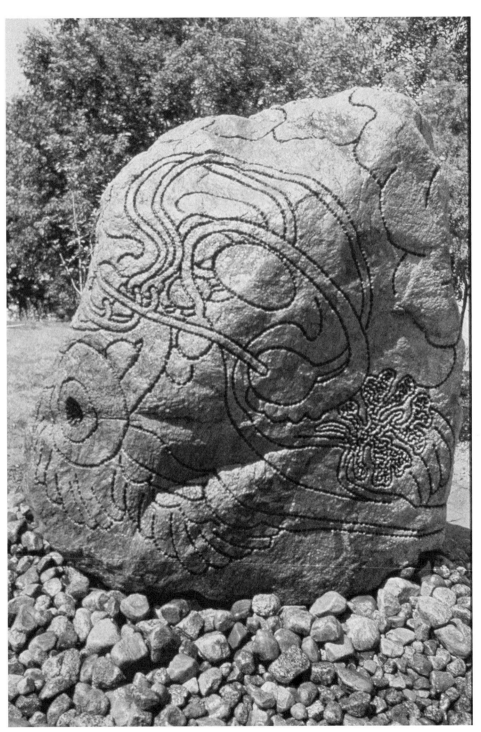

11.1 Bill Vazan. *Predateur*, 1996. Engraved granite. 6 ft. high. Sited at Ilot Fleurie, Quebec City. Courtesy of the artist.

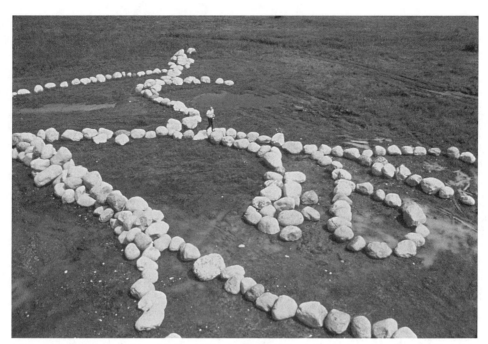

11.2 Bill Vazan. *Outlickan Meskina (Map for Caribou Hunt)*, 1980. Permanent site-specific work, Chicoutimi, Quebec. Courtesy of the artist.

JG Are the drawings preparations for larger works? Can you tell me something of the relation between your drawings and land art pieces? I don't want to call it land art. Let's call it earth investigation.

BV What is a drawing? It is a two-dimensional rendering. Where do I work? On the surface of the earth. Its a two dimensional rendering. Usually I don't go high, and I don't go deep. I may go down a foot. I may go up a foot. In the end it has a basic kind of physical form like a drawing, but on a bigger scale.

JG Like the *Uffington Horse*, or the *Cerne Abbas Giant*, two examples of land art from the Roman times in England.

BV Yes. These Iron Age people were making these drawings on their land. What that entailed was digging into their turf, exposing the white chalk rock mass. So what you had was a white on green. You can see that in the *Ghostings* (1979) piece I made next to the waterfront, at the site of the former baseball stadium in Toronto. It was a white-on-green, two-dimensional linework. The chalk outlines were of native long houses and the circular palisades around these tribal villages, those of the Neutral tribe, in southern Ontario. I included straight lines that suggested the direction of glacial scrapings during the last Ice Age. Those lines were based on actual scrape lines found in the bedrock during the original subway excavations in Toronto. These actual scrapes were under a foot long. I exploded it to hundreds of feet long in chalk, the kind sports stadiums use.

JG So there were linkages between native and geological history, the nature/culture dichotomy. Was the process for making *Pressure-Presence* (1979) in Quebec City the same? The markings reflect the geological history of the St. Lawrence Valley while the actual place is of great historical significance, being the site of the Battle of the Plains of Abraham, where the English defeated the French in 1763.

BV It was done by the very same process and was inscribed with a nontoxic, chalk-based paint on the grass. It even showed up the following spring after the snow had gone. I liked the idea of the white taking out the white. When the white went, which was the snow melting, the white came back in very pale green tones. When the grass grew, it disappeared. I incorporated the concentric circles seismologists use to indicate such things as earth movement, for the St. Lawrence Valley is on a major fault line. I interspersed the concentric circles with spiral lines. The spiral lines were like giant fingerprint whorls, and evidence of the human or cultural presence of the artist—identity marks. It was very massive, and measured fifteen hundred feet in diameter. The configuration is also a bull's-eye, a target, that references history. The problems that instigated the Battle of the Plains of Abraham in 1763 are still with us today. You still have this sort of ongoing cultural tension between the English and the French. The "presence" is of the artist, the "pressure" is the release because of this land movement, and thirdly, this bull's-eye, a pointer toward our cultural history, which is actually a bicultural history—English and French.

JG At the L'Ilot Fleurie in St. Roch, Bas Ville in Quebec in 1996, a place reclaimed by the local community and now a site for ongoing sculpture projects, you engraved a sculpture that attracted a lot of attention. Why the title *Predateur?*

BV The image looks very much like an extraterrestrial, something you would not readily recognize. The lines I engraved on it flow here and there, bulging, then collapsing, like the limbic system of the brain, and there are two deep holes at one end like eyes. There was talk of microscopic traces of life found on a meteorite from Mars in the news, so it became a kind of joke. Could this piece have fallen down to earth from Mars? This kind of stone is glacial debris from the Laurentian field and has a frosted surface with glances or slag marks all over from rolling about in the last Ice Age. You don't see the true colors on them until they're worked on.

JG Landscape has been a subject throughout art history. It recorded property, established geographic contexts, and provided the viewer with an image of unbridled wealth of nature in the case of the early colonial painters. Do you envision land art interventions as a way of getting away from representation, or the sculpture as object, a way of integrating your work in the landscape?

BV I think I get into deeper issues rather than talking about wealth and representing landscape. I titled a recent show at the Musée du Quebec *Cosmological Shadows* (2001) because from prehistoric times right up to now, despite trying to understand what's about us, we've never come to the end. We see only the surface of things, and it's constantly changing. When I try to do something on the land dealing with what has been on that part of land, whether its cultural or natural history, I use today's language, which is as a two-dimensional plane, to interpret it. I am an avid reader of *Scientific American* and other such magazines. What fascinates me is how science, with all its beautiful constructions that deal with essential reality, is hypothetical. Contemporary science and theory never come up with a final one. They keep changing it around. I like to deal with these scientific models when making art forms on the land and in these engraved stones.

JG Writers like Rosalind Krauss have referred to land art as decentered in that it is less formal or object based than sculpture. It may be decentered as formal art, but it's also integrated and with a strong sense of place. It's integrated into life. Isn't that more centered?

BV Its more centered when it represents a group thinking or identity and it is decentered when it is not one individual doing the work, because it takes other people to wander in and think of it. This is the kind of art many primitive or early societies created. They invited their shaman or their artist to recreate a common identity with nature about them.

JG Your photoworks stretch and expand our sense of time and space, and have developed over the years to become an artform entirely independent from your land art projects.

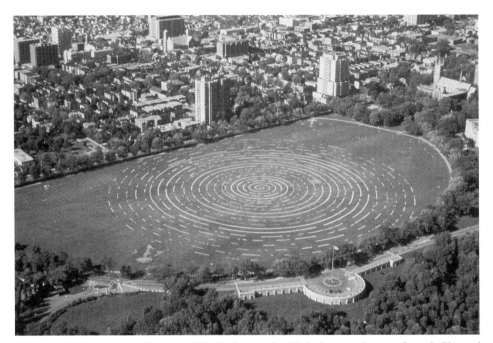

11.3 Bill Vazan. *Pressure/Presence*, 1979. Chalk on turf, 1400 ft. diameter. Site-specific work, Plains of Abraham, Quebec City. Courtesy of the artist.

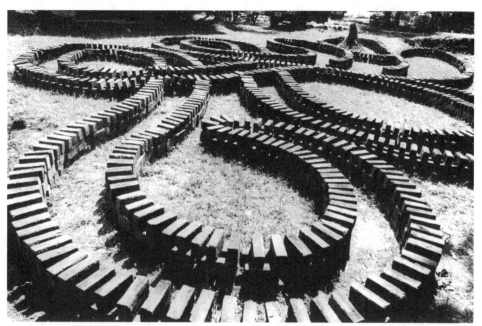

11.4 Bill Vazan. *3 Headed Serpent*, 1979. 2.5 feet high × 50 × 60 ft. Site-specific brickwork, Sri Lanka. Courtesy of the artist.

BV My photoworks are a direct outcome of my need to document my land pieces. Working in the field—whether its making lines in the sand on a beach or in the snow, using a machine to dig trenches, or assembling a rock configuration—involves a context so far from the art context that you want to bring it back into a sort of framing or box. The artist needs and wants to show. The scale and concept can be so vast that you can't capture it in a single photo, so I investigate the manipulation of space and time through my photoworks in a panoramic grid-sequential fashion.

JG Ancient civilizations like the Nasca and First Nations sought to communicate with the gods by way of land art. *El Dios de los Aires (The God of the Winds)*, a work you made in Peru, communicates this sensibility.

BV Yes. I hired crews to shovel and sweep clear lines to create configurations in an area adjacent to the actual archaeological sites where these earth markings existed—the cultural history of the area. We created two abstract god or wind forms derived from images on ancient Nasca pottery. It's a kind of engraving the early Nasca did fifteen hundred to two thousand years ago. Researching the Nasca landmarks, I found that the theory that holds the most water is the idea of getting water. The Peruvian coast there is mostly desert. Only in the valley runoffs from the Andes do you have these green belts of streams coming into the Pacific. So the Nasca went to these dry desert areas and made configurations mainly directed to the summits of the Andes where the gods were supposed to dwell. The supposition was that ritual, walking on these lines, would get the gods to bring more water down the mountain sides to their coastal irrigation systems.

JG The serpentlike piece you created in Sri Lanka in 1997 uses brick as a principal element but creates a kind of ontological drawn form. You were effectively drawing with bricks.

BV That was fortunate. When I got to Colombo the man who took me to all the sites was living in a brick yard. Some of the images I saw on the Hindu Temples had a three-headed, hooded cobra, so I decided I would focus on that kind of imagery when I got to making some land pieces there. Time is very short on these trips, but fortunately my guide had enough people in his brickyard to give me a hand to do this. That is why it is quite a wide spread.

JG In his book *Sensitive Chaos*, Theodore Schwenk examines the whorl lines, rhythmic forms and patterns we find in ourselves and in nature, on both a microcosmic and macrocosmic level. Water is one element Schwenk identifies as being important in determining solid and liquid shapes and forms in nature.

BV I am actually working on a piece called *Soundings from the Water Planet*, part of what I call my ongoing *World Works*. One series is *The Antipodes*, and then there's *The Stands*, and the third one is *Soundings*. *Soundings* is going to be a major visual thing, because it involves material I have picked up from the earth's surface over the past forty years or so from Africa. Australia, Europe, North and South America.

JG Will it be a configuration based on these materials?
BV No. Its not going to be one figure. Exhibition arrangements will vary and evolve. Actually it incorporates the material I picked up—usually earth or sand—and suspends it in an acrylic medium. I just pour it on to bring out its color and an expansive texture. The visual emphasizes liquidity—the essential of our existence. Sometimes there's a bit of scatter. I am putting earth and various elements like shells into it. There will be many of them. I'm up to 151 now.
JG And the *Antipodes* project?
BV To show how we have collapsed our range on this planet to be almost like a grain of sand. Whenever I go to a site, I ask the question, What is on the other side of the world from where I am? What I then do is represent what is on the opposite side of the world in reversed form. When I was at the pyramids of Geza, for instance, I made zig-zag forms, engraving by scooping the sand with hands and feet, a representation of the Pacific Ocean on the other side—as well as alluding to mirage refractions of the nearby pyramid silhouettes.
JG You're an endless explorer, innovator, and seeker. Do you ever feel you are trying to communicate with or express some greater transcendent force through your art?
BV I'm fascinated with how people, no matter where, have tried to make this communication with something other than themselves—the other. I guess my way of making contact with the other is by taking a parallel position with what these people have done. Of course I'm only in one time and place. Is there a connection with God? We all want to connect with God, whether or not we deny his or her existence. We eventually realize, one way or another, that we did not bring ourselves here, and we have no control of how we're going to get out of here.

12
NO WALK, NO WORK!
Hamish Fulton

Since the early 1970s Hamish Fulton has been alternatively considered a sculptor, a photographer, a conceptual artist, or a land artist. Fulton would more likely consider himself to be a "walking artist." In the late 1960s Hamish Fulton first began to explore the landscape in a way that involved actually physically experiencing the landscape as part of the art. While a student at St. Martin's College of Art in London (1966–68) and visiting South Dakota and Montana in 1969, Fulton developed the philosophy that art is "how you look at life," and has nothing to do with object production. He began to take short hikes and then to make art works that interpreted that walking experience.

From the time of those initial forays into artmaking and ever since, Hamish Fulton's practice has involved a set of interests broader than mere art, such as the environment and Amerindian culture. In 1973—the year Fulton walked 1,022 miles over a period of forty-seven days from Duncansby Head, near John O'Groats in Scotland, to Lands End, England—he decided that from then on he would exclusively make art that stemmed from the experience of individual walks. The act of walking has remained essential to Fulton's artistic practice ever since. He sums up his way of thinking in these simple terms: "No walk, no work." Through the texts and photographs presented in Hamish Fulton's exhibitions and through books published on his art, we can intimately share his walking experience.

JG The land plays a major role in your work. The walk is the art, and you have called it a short journey—made by walking in the landscape. How did you get there, make the move to working with the land in your art? Was the land a strong presence in your childhood, your early years? When you studied at St. Martin's School of Art, were you already beginning to make the difficult transformation and breakthrough to a performance kind of walking art? Can you tell me something about those early years, when minimalism and conceptual art reigned supreme?

HF "THE WALK" can be thought of as "an artform" but, unlike "an art object," a walk cannot be sold. I grew up in the northeast of England where kids always played outside, rain or shine. My time at St. Martins School of Art was both positive and experimental. At that time I did make one or two collaborative walks. The most important aspect for me of the late sixties was attitude. By the time I started to exhibit and make short walks in 1969, I already had quite a clear idea of what I wanted to do and also what I wanted to steer clear of. In 1973 I made the commitment to make *ONLY ART RESULTING FROM THE EXPERIENCE OF INDIVIDUAL WALKS.* I wanted my art to be about real experience, not fictional situations or media manipulation. When I started, I had no idea where the road would lead. I've spent the last thirty years trying to unravel my basic decision.

JG Both the typographical and written structure of the words and phrases that accompany your photos are conceived in a way that parallels how we might perceive and interpret the land while walking through it. These are like fragments, with breaks, almost like breathing, and yet they link together the experience. The text introduces an element of time sequencing and the photo an illusion of being there, of place. Other texts you have made involve visual spacing, recombination of letters and words, and still others a mapping of sorts onto the photo. Some are like Japanese haiku poetry, and sum up the entire multisensory experience of walking with a simple phrase or two. The texts play off the photos and the photos play off the texts. Does the phrasing, sequencing, and arrangement of text change to reflect the area, culture, and place you are in a given piece?

HF In the late sixties and early seventies, I did make a few small, text-only artworks. From the seventies into the eighties, my texts were mostly walk descriptions situated below black-and-white photographs. For the last sixteen years or so, I have become more interested in advertising—boulders instead of cars. If we can advertize cars, then surely we should be able to advertize a spiritual relationship with a variety of life forms: sharks, wolves, coyotes, clean water for drinking.

JG Are these textual elements drawn from memory, written while hiking, conceived afterward?

HF To answer your question: written while hiking. By the time the walk is finished I need to have updated my diary and formulated my basic texts. It is from this material, gathered on my walk, that I am able to generate the artworks. How these notes are written is up to the individual. Over the years I've developed certain ways of writing. One obvious expedition scenario is that you are so concentrated and then so tired on the trek or climb that you have no time to write your journal. And of course when you get home you can't remember the order of events. (I enjoy writing diaries.)

JG You once commented that the natural environment is deeply mysterious and religious. The natural environment—be it mountain, coast, plain, indeed

any nature—is itself an artwork of sorts, even before the artist intervenes. You tend not to want to leave traces of your presence in the environment, and this distinguishes your approach from Richard Long, and even more strongly from Robert Smithson, Michael Heizer, and the early land artists. In this way you integrate an ecological consciousness into your approach that is refreshing.

HF I think it's probably true to say that in contemporary art "the landscape" has come to mean only sculpture. From U.S. land art to English nature craft, it would seem sculptors have always been concerned with "natural" materials. I am not a sculptor, not even a conceptual sculptor. I have no desire to rearrange the environment or remove it to the city. I prefer to see plastic in a gallery, rather than pure natural materials, which should continue their lives under the influence of the elements: wind, rain, sun. What are the rights of nature? When all is said and done, my attitude is merely "symbolic." Ecologically sound art by definition can never exist (jet travel, jet air pollution). We need to fight on, find new solutions.

I have been inspired by the North American wilderness ethic of "leave no trace." Today, the world knows the Bush Administration ripped up the Kyoto agreement, but I have always felt that the most progressive ideas have come from the United States. Examples range from Chief Luther Standing Bear to Gary Snyder, and Jerry Mander to Dave Foreman, with a solid backing from Thoreau and Muir (a Scot) and Rachel Carson, and that only takes us to the 1980s! Turner and Constable have nothing to do with questions of environmental changes over the past fifty years. I feel that when their names are brought in, the discussion diverts to art history instead of fuel-efficient freight trains in Canada.

JG In a sense, by being conscious we have already made an ethical decision. Can one ever isolate issues of ecology from social and ethical issues?

HF I will give you an example. People who are poor and do not have the opportunity to participate in the consumer society are more ecological than ecologically minded consumers. They pollute less—consume less, but not by choice. It is hard to isolate our actions from the big picture. I have a friend for instance in California who mulches books and catalogs in his garden, uses them as fertilizer. Is this more ecologically conscious than publishing books and essays on sound ecological principles? I can't answer that conclusively.

JG Your art heightens our awareness of the wilderness, of the land. But our pristine wilderness areas are diminishing, encroached upon all over the world. Have you ever made any statements on this in your art? Is revealing nature's pure and simple beauty through art a more forceful way of communicating our inherent (and unconscious) links to nature and its immense resource than making overt political or ecological pronouncements about the destruction of natural habitat, climate, or atmosphere?

HF A good question. Your questions in fact bring too much to mind. Each answer could fill the chapter of a book. Although my answers are brief, I hope

12.1 Hamish Fulton. *Winter Solstice Full Moon, The Pilgrim's Way*, 1991. Vinyl wall work, dimensions variable. Courtesy of the artist and Annely Juda Fine Art, London.

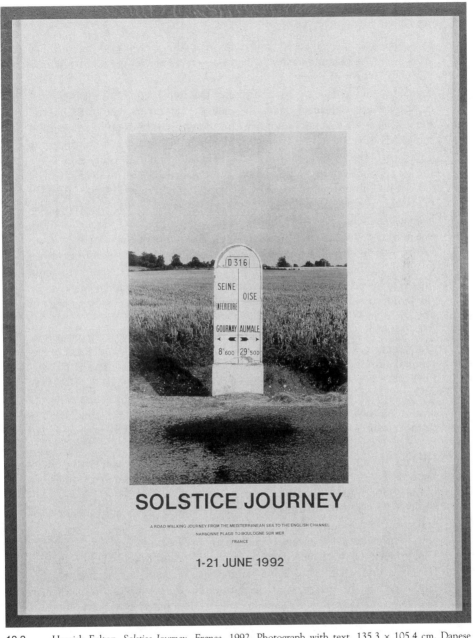

12.2 Hamish Fulton. *Solstice Journey, France*, 1992. Photograph with text, 135.3 × 105.4 cm. Danese Gallery, New York. © Hamish Fulton. Courtesy of the artist.

to be able to convey a few initial basic points. I have been working for thirty years. I like the idea and reality of change, even change for the sake of change. But many years ago when I became aware of the destruction of our planet I decided to take only a "positive" attitude. The translation of this is not that I cast a blind eye to the ever-increasing scale of environmental problems. At the time, what I felt was important was that these small birds *do* have beautiful songs. My love of nature is, I hope, implicit in my work. Referring to a photograph, the attitude of saying "this mountain should continue to look like this" is only one option. When I took this so-called positive position, I understood it might not be clear to everyone. At that time I totally rejected the idea of showing destroyed, polluted environments—because then the pollution becomes the subject—rather than these beautiful bird songs I was mentioning. We need to save the birds, for themselves. Having spent thirty years working first in this "positive" way, I feel now—in theory at least—able to consider emphasizing the "negative" as well. For example, this small stream in the city, full of chemicals and beer cans, is related to that clean and free-flowing river in the "wilderness." They are not unrelated. Whether positive or negative, my attitude requires what is called "joyful effort."

JG Have you ever made works that reflect a landscape that is lived in, such as cities, suburbs, and the like? Are your walk works exclusively wilderness, or are pastoral sites, ones with some human intervention, also of interest? Do you distinguish between rural and urban landscape, or are they one and the same thing? Can we ever define a landscape? Is landscape an outmoded concept, something that excludes human intervention? The Native Amerindians, for instance, who lived in harmony with the land, had no word for landscape, for wilderness, for example. Can you comment?

HF No. My walks are not exclusively made in the "wilderness." I have made many walks through agricultural areas. I've walked thousands of miles on roads, facing oncoming traffic. In the course of road walking, I have gone through many towns and a few cities. I have also walked across the full breadth and entire width of London.

Throughout the seventies, critics of my art said I was an "escapist." People imagined this lonely, poetic person ambling along leafy English country lanes. I've done that, but also many other types of walks. For me, nature, "the landscape," is the present and the future. For young artists the landscape represents the past. Popular nineties art was dominated by the one subject: urban existence. All this is quite easy to understand; there is no shock. But politically, the only issue for all time now is the condition of the planet. The energy source for tackling all the problems we are beset with must come from a spiritual relationship with nature. We are not superior to nature, we are part of it. Today in the United Kingdom, when as many as up to two million sheep and cattle are being killed in an attempt to eradicate foot-and-mouth disease, we are simply advertising this ongoing attitude of superiority (and profitability).

Maybe, after this disaster there will be a whole rethinking of modern farming practice. The Western church cannot really be seen to have failed here, because their position has never included an equal relationship with nature. **JG** Walking is a sacred activity. It brings us in touch with ourselves, with our body, and is an altogether uplifting experience. One thinks of Mahatma Gandhi's famous walks through India, for instance, which were a spiritual statement. Is the walk the ultimate art? There is a cyclical aspect to a hike. It has a beginning and an end, almost like a musical composition and with all the infinite variability therein. Do some walks resemble previous ones from other times? Does revisiting a landscape create a secondary experience of place quite different from a first walk? Is the walk, the art, a process that goes full circle and back to the walk?

HF Yes, I think walking is sacred. It is sacred because it binds land, mind, and body. Humans bind with nature in the activity of walking. My enterprise constitutes two separate parts: first the walk and second the resulting artworks. Although walks can be repeated, the days can never be repeated. Time is like a flowing river. One way.

As I have already suggested, contemporary landscape art has kind of come to mean only sculpture. But I think that because walking is not an art medium like sculpture, it is independent and open to many possibilities—for example there is a relation to dance. Throughout the nineties, I gradually became more influenced and inspired by events in outdoor sports, such as long-distance walking and mountaineering, activities that are outside the confines of "art." Although I'm an armchair mountaineer, I am aware that there has been a great increase of participation in this sport. So, from my point of view as an artist who walks, walking is evolving in society. Along with sport we can mention health, transport, and as you noted, marches—namely Gandhi's political spiritual walks—as an inspiration for us.

In recent years my mind has opened to the possibilities of group walking and commercial expeditions. Instead of only walking alone, I now enjoy walking with other people. I see this as expanding my repertoire, but I continue to enjoy the spiritual pleasures of solitude. When we speak of walking, we also need to specify whether we're talking about a rich country with many cars or a poor country, where walking is the essential form of transport.

JG You do not consider yourself a photographer in the classical sense. One thinks of the topographical photographers Antonio Beato, William Henry Jackson, Andrew Russell, John Thomson, Alexander Henderson, even of Edward Curtis. Must nature be represented as pristine, as a place segregated from our daily human activity? Does nature represent a higher level of consciousness to your mind?

HF Yes, nature represents a higher level of consciousness. That's my opinion. Everything is compared to the "wilderness." When we start criticizing words like "pristine" in an academic way, we are starting to lose the big picture.

135

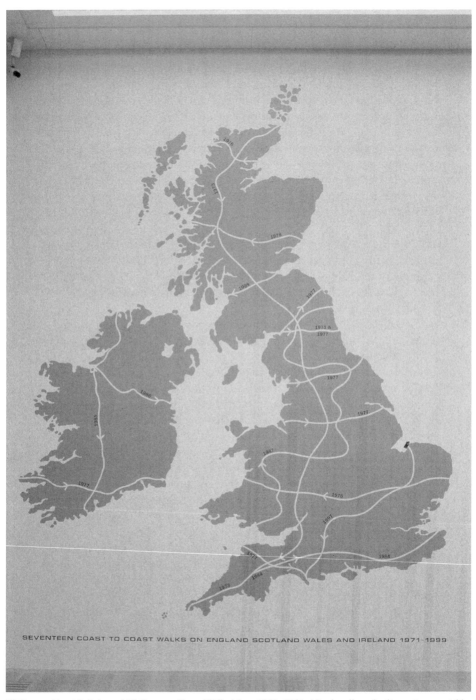

SEVENTEEN COAST TO COAST WALKS ON ENGLAND SCOTLAND WALES AND IRELAND 1971-1999

12.3 Hamish Fulton. *UK Coast to Coast Walks Map*, 1971–2001. Vinyl wall work, dimensions variable.
Courtesy of the artist and Annely Juda Fine Art, London.

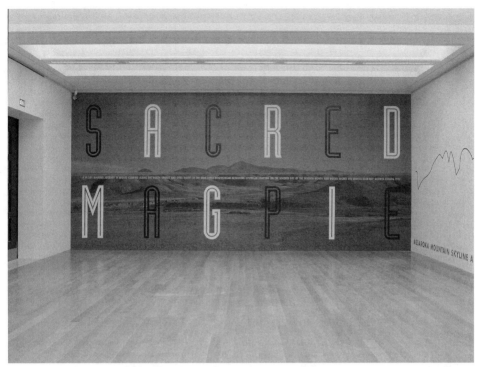

12.4 Hamish Fulton. *Sacred Magpie, Alberta*, 1999. Photographic wall work, dimensions variable. Collection of the artist. Courtesy of Annely Juda Fine Art, London. Courtesy of the artist.

JG The holistic experience of walking the land is objectified by the subsequent art production. Isn't this a perennial problem? Doesn't any art that seeks to unify creative expression with life end up drawing a line, because the creative process is removed from life in a sense. Even if this is not intended, the division between art and life can be there. This process of recording, recognizing, recreation of sensation(s), and production is a paradox of sorts, isn't it? Is your life and art ultimately a spiritual activity, and how do you reconcile the divide between walking and making art? How do you feel about this?

HF Art is essential in a healthy society. As they say, art is like oxygen. Whether we say art is profound, or worth investing in, sexy, or a rip-off and rubbish, it doesn't matter, because all those crazy and insulting and wonderful qualities all go to make up what we call contemporary art. You could say that minor, service-industry countries have a relatively high proportion of professional artists. For me it doesn't matter; what is important is that artists feel free to make whatever they damn well please. In fact, the world is a *BIG* place and variety is important.

Yes, it is difficult to make art *ABOUT* something else—in my case walking. For many years, the idea was that you made art that was itself. An abstract painting is an abstract painting, for instance. It can only relate to the history of abstract painting, to other paintings. From that point of view, advertising and design are lower forms of life. I like advertizing, and design seems liberating. My real ambition here would be not to advertize cars (until the advent of fuel-cell technology) but small birds, wild flowers, clean rivers, the smell of balsam. . . . From contradiction comes Energy. And the Energy that is required today is Spiritual Energy.

13

THE SPIKE
Egil Martin Kurdøl

Egil Martin Kurdøl is a Norwegian artist who has extensive experience as a mapmaker and hiker. He works in Russia as well as Scandinavia. For his project *Feste/Attach* (1998–99) he created and cast stainless steel bolts, attaching them to rocky surfaces in remote places. The configuration of the bolts resembled the actual landscape surrounds of the places the bolts were set down in. As a land art project, *Feste/Attach* attracted attention from various governmental agencies concerned about this artist's effect on the natural environment. The exchanges that took place between artist and government were part of the project. Elements of that project are now in the National Museum of Contemporary Art collection in Oslo, Norway.

For another project, *Perpetuum Immobile* (2001), a self-created device made of tempered stainless steel has been designed by Kurdøl to pull and work forever. Molded with concrete and iron plugs into the mountain, this "perpetual machine" is designed to function in that place in perpetuity. The actual site for this land art piece is a rather undramatic high Norwegian landscape where all you can see is mountains in all directions.

JG Your interventions in nature are frequently minimalist, mere traces, like the markings the natives left on trees. Though minimalist they integrate a notion of the landscape in their cast material forms and placement. They come close to being performance pieces enacted in nature. In particular, I am referring to *Attach*, a project that involved putting tiny iron handcast bolts into sites on mountains, valleys, in nature in northern Norway. Its a long way from the monuments and large-scale sculptures that we associate with modernism or postmodernism. Returning art to a natural context harkens back to our primordial beginnings when we were in tune with nature. Traveling though nature with your small collection of bolts, you mark your site modestly. Nature, your work seems to say, has the upper hand. You are merely a passenger, a visitor or nomad who passes through the landscape. Can you comment? How did your interest in this way of making art arrive?

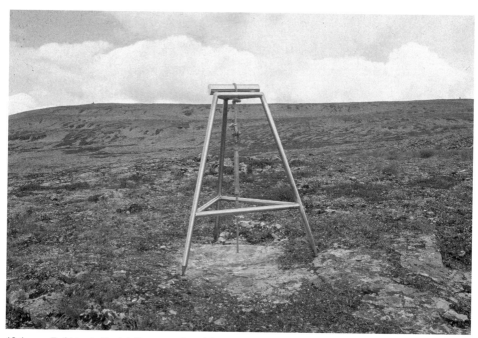

13.1　　Egil Martin Kurdøl. *Perpetuum Immobile* (installation view), 2001. Ringebo, Norway. Courtesy of the artist.

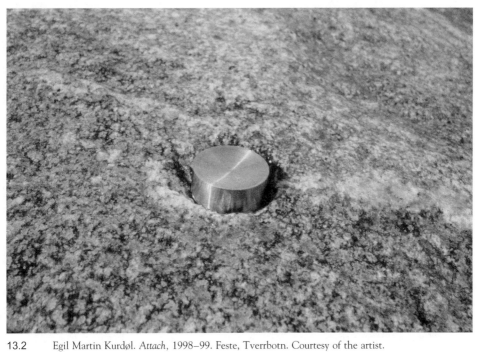

13.2 Egil Martin Kurdøl. *Attach*, 1998–99. Feste, Tverrbotn. Courtesy of the artist.

EMK The work you refer to, *Attach,* took place in the "heart" of Norway, in the most inaccessible mountains in the middle part of the country. I have been walking in this area now and then for more than twenty years. Through that time I reached a point where I needed to give my reactions to this landscape. For many years, I distinctly refused to work in this landscape. When I finally decided to make encroachments in this nature, I realized I would have to respond in a much more consistent and precise way then I had with my earlier installations, and I knew I had to make it last. All my former work in nature had been of a temporary nature. This time, it became part of the concept to make it a permanent installation. Much of my early work was influenced by childhood summers in the deep forest, playing around and exploring the woods with friends. As children we collected objects from nature (stones, feathers, snail shells, roots) and made them our own. These activities established our first personal bonds and understanding of nature, and it was of great importance in developing a basic respect for the nature later in life.

 Attach belongs more to the adult world. I worked for four seasons (1972–75), long before I even thought about being an artist, in the Norwegian Geographical Survey, making maps in the mountains in the northern part of Norway. During this period I also installed many bolts in the high and wild mountains. These years of making maps, signals, installations in the landscape, has been of great importance later in my artwork. Surveying and mapping are physical means of interpreting and processing nature. It makes nature more understandable and requires physical fixings or making marks in the rock. *Attach* is thus clearly comparable with survey work, except that it does not have the same usefulness as mapping. It still has a certain value in relation to the communities' attitude toward and understanding of nature.

JG Despite this, some local communities, county offices, and government bodies in Norway have firmly opposed your minimalist interventions, and you include the exchanges between yourself and governments in your documentation of these projects. Is the interaction between artist and government part of your art process? What makes your art different from other interventions— forest logging or cottage development, for instance? Or is it a comment on intervention per se?

EMK It was never my intention to get involved with bureaucracy. With *Attach,* I thought there would be no problem at all getting approval from the authorities. As the process went on, the dialogue with the different authorities became part of the artwork. Artwork often takes on its it own life while you work at it, and so it happened this time. I found it interesting, especially the dialogue with the national park. They gradually turned around and became positive about the project, after long discussions, when they found out that the idea of *Attach* was in line with the objectives of the national park. (A picture of the bolt and a description of the project was part of their yearbook in 1998.) I still discuss things with them on the phone from time to time, both formal

questions and my artistic approach to nature. As for *Perpetuum Immobile*, the project I am now working on, the process has taken some time. I knew this time I would have to get permission from different authorities and thought it would be very difficult. The project has caused some controversy, which engages people, and has given me the opportunity to communicate more about the background and the idea for the project in the media.

A problem for the authorities is that they don't have any system for dealing with art projects. Artwork has a totally different attitude and purpose than the kind of installations their laws and regulations are made for. My experience is that my encounters with bureaucracy have brought another dimension to the artwork. These meetings bring more attention and engagement to a project, and this again gives me, as an artist, a different and very welcome surface contact with the public.

JG Governments can apply a double standard—one for industry and development, another for artmaking—particularly in so-called natural settings. Our activities in nature often seem to involve seeing nature as a passive element, something that is just there, rather than a source of sustenance and resources. Boating, snowmobiles, rafting, all these activities involve an appreciation of nature, yet society does not evolve beyond this experience. It is rather like watching a living television, and the sense of time as a continuum is not there. There is no sense of past and present, of biohistory or geological time. Maybe our vision of nature has been forever altered by television, the internet, and multimedia hyperstimulation. Can you comment?

EMK Last week I spent a day on a mountain river together with some young men on the mountain where *Attach* is located. We paddled downstream, some with canoes and some on a raft. These young men are part of a subculture I don't know much about. They had great skill controling their canoes through the roughest streams, as well as a deep knowledge of the river. They had to work together with the river, take part in its rhythm, "read" and respect the river for their own safety. They used high-tech equipment but did no harm to the environment. Their attitude and interaction with the river showed me another way of understanding nature.

These guys communicate with like-minded people in other countries on the internet and occasionally meet up to paddle and compete. Some of them are part of the environment movement and are concerned about plans for power dams in this area. Their relationship to nature may not be very intellectual, but it is very personal. I think this could be a strong foundation for developing different kinds of interest in nature. A personal relationship to nature is vital if you want to respect and care about it. This day on the river with the younger generation made me happy and may even result in an art project one day.

In general, I am rather conservative and skeptical about technological progress. Mainly because it seems that all kinds of industrial and technological

progress make nature suffer in some way. For instance 90 percent of the mountain gorillas in Africa are now gone because mobile phones need a certain kind of metal from the mountains where they live.

JG Do you feel as interventions your artworks respect the landscape? They certainly do not dominate nature, yet their focus is not nature design or an aesthetic of integration, more like an imprint, however minimal and modest, onto the landscape. Are you seeking an essence, something more primal in your actions?

EMK Yes. I feel that my artwork respects the landscapes they are situated in. They always relate to the landscape through shape and idea, and they never do any harm to the animals or the ecological system. My purpose is to investigate a situation or an aspect of the landscape that interests me. Art has always tried to define man's relationship to nature. Through my actions, I believe that I can bring a focus and further interest in the problem of man and nature.

With *Attach*, the shape of the bolts is taken from a particular characteristic of the landscape at the site. It is modified, of course, but the basic idea is to let the bolt submit to the site and reflect the shape of the valley or the mountaintop nearby. Human beings have always left traces behind them in nature. Game pits, rock carvings, the marks of habitation and travel, are examples of the traces left by our forefathers. They are traces we now value and conserve and that are important for us. They belong to nature and are in many ways a link that brings us closer to nature, and to our past. In concrete terms, present-day hunters have, for example, learned about the movements of the game by studying the old pit traps.

Human intervention in nature has never been more comprehensive than in our time. It is usually in conflict with the interests of nature conservation and, when it is allowed, it is usually justified by referring to economical or social benefits. Even what we now call "unspoiled nature" is heavily marked by human activity. We find distinct traces of industrial pollution and we can measure the intensities of radioactive fallout. Many of us are ashamed and desperate about this behavior toward nature, and we feel a need to protect it from human ignorance.

But humans also go to nature to clean their souls and improve their own nature. I think it is a good thing for both the present and the future that there are physical traces of this—traces left that respect nature, without damaging the environment, and without the least utilitarian value. An intrusion into "unspoiled nature" can be positive. It is the quality and intention of the intrusion that must be decisive.

JG People living in cities often have a more romantic notion of nature and the wilderness than the people who actually live there. The idea of not touching nature is quite sophisticated and contemporary. Our ancestors, for instance, always left traces, and the interaction with nature was a necessity as much as a choice. One need only think of prehistoric cave paintings like those at *Al-*

tamira. The markings there are not only of animals, but also symbolic and objectified images of roof shapes, comb shapes, and quasi geometries. After a landslide in the 1870s opened up the site, Marcelino de Sautuola explored the place. It was his daughter who discovered the paintings while her father was looking for curios near the entrance to the cavern. She came running back through the dark shadowy cavern passageways shouting "Toros, toro!" In to-day's cities like Los Angeles, graffiti has become a trademark of various gangs. Like our ancestors, they leave their markings to designate their territory and also as cultural statements. Are your markings in the landscape a response to this desire to identify with your experience of a site or place?

EMK My method of working can vary, but the site always determines the art in some way. The site itself can catch my attention, so that I decide to work there, or I can seek a suitable site to realize my ideas. The desire to work in the particular landscape must be very strong before I start the physical work—much stronger, for instance, than the process of starting to make a drawing.

JG Perhaps in the future people will have no awareness of why you put these bolts in the landscape. They will raise questions that may not be easy to answer. You are creating a kind of instant archaeology of the future.

EMK The most important aspect of *Attach* is to make a significant trace—clearly from our time, put there with a clear purpose—and let it last into the future long after I am gone.

JG The Arctic ice is now melting and will affect the earth's ecosystem. Pollution from more southerly urban regions is likewise affecting the north. Even the treeline is moving as a response to global warming. As an artist interested in the relation between nature and human involvement, do you believe nature ultimately is more powerful than humanity's will to control it or vice versa? How does this reflect itself in your approach to making art?

EMK It is impossible for artmaking not to be seen in the context of the environment situation when you work like I do. But my starting point is always my personal experience. It is when I put my personal engagement out in the open that the public consideration comes into view. At the same time, I am also a man with a political attitude, and that will of course be reflected in my art.

JG Tell me about the project you are now working on called *Perpetuum Immobile—The Construction That Keeps the World from Falling Apart*. It is a steel structure—a permanent installation—whose system of pulleys are designed to work in perpetuity, forever and ever. You will site it in a rather monotonous mountain landscape site, cementing it in place. This interven-tion is high tech in conception and design. It brings an engineered ingenuity that is refreshing for such a remote siting of an artwork in an otherwise pristine mountain landscape setting.

EMK Science and technology have been, and still are, among nature's worst enemies. But they are also disciplines that can help us find possible solutions to

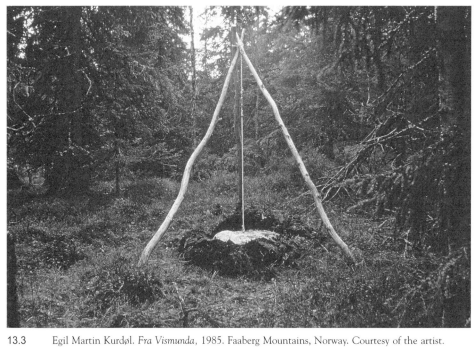

13.3 Egil Martin Kurdøl. *Fra Vismunda*, 1985. Faaberg Mountains, Norway. Courtesy of the artist.

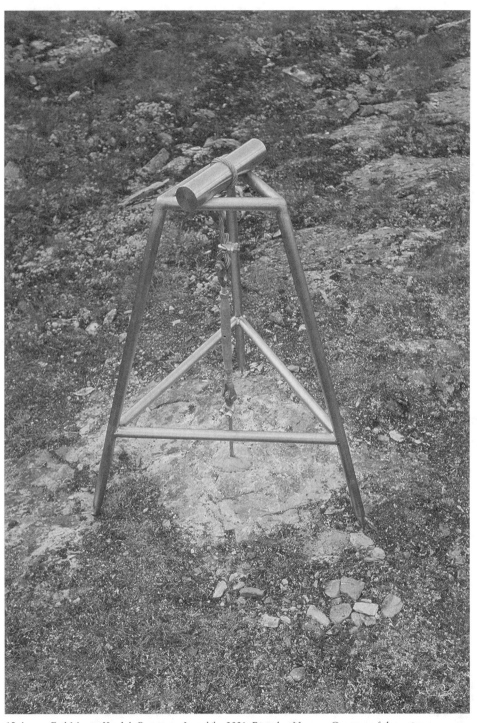

13.4 Egil Martin Kurdøl. *Perpetuum Immobile*, 2001. Ringebo, Norway. Courtesy of the artist.

147

the ecological deadlock we are in. Technology and science can be an important way of controling and repairing the damage we have done to nature. We have also experienced, and are aware of, the time factor when it comes to turning around or stopping damage to the environment.

Nature is everywhere. It has always been and will always be independent of man and even the existence of our own planet. We can never destroy nature, but we can destroy our own reality. When we speak of nature in everyday talk, we speak about our own reality. As for our quality of life and future reality, it is of vital importance that we increase general interest and consciousness about what nature is.

Immobile invites questions like Does technology control nature, or is it the other way around? Does the construction express a balance, and if so, what does this balance express? Or is the conflict between man and nature "forever"? *Immobile* will exist as a trace from our time in nature, with a message entirely different from power pylons, roads, or luxury cottage establishments, for instance.

JG You have mentioned how our sense of time is changing in today's world. We greatly value ancient monuments and antique artworks, yet neglect the traces our own society leaves behind. It is as if we lived in a throw-away world where permanence and permaculture were irrelevant. Our relation to nature is complex, and we seek to protect it from humanity, while at the same time humanity is eroding the pure or virginal natural sites around the world at an increasingly rapid rate. We do not seem to have resolved the ways we design materials and living spaces or use energy, to be in harmony with nature. What is the Scandinavian perception of humanity's relation to nature? Is it a tourist attraction, a place for recomposing and regenerating oneself, or simply a romantic, outdated concept that has nothing to do with the reality of the world we are living in?

EMK In Norway today we have an ambivalent and paradoxical relationship to nature. On one hand, we do have a strong will to exploit nature. We use advanced technology, tools, and machinery, and do irreparable damage encroaching on nature. On the other hand, we express a strong will to protect nature from ourselves and maintain a moral or spiritual attitude. *Immobile* can be looked upon as a comment on this paradox. Unfortunately, our moral or even religious feelings toward nature often seem to give in, when strategically economical interests come into play.

Perpetuum Immobile—The Construction That Keeps the World from Falling Apart is very concrete and can be thought of, with a bit of humor and fantasy, as holding the world in place. *Perpetuum Mobile* is our idea about the unattainable machine that works forever without energy. *Perpetuum Immobile* must be the opposite; the idea of eternal standstill. The construction will, at first glance, look rather absurd. It stands still and "works" without achieving anything at all, much like lifting oneself by our own hair.

Time is not a static phenomenon, even if through technology (clocks) we try to control it as best we can. We think in linear time. The past is behind us and the future is ahead. At the same time, eternity is incomprehensible. Our notion of time has changed through history and is interpreted differently in different cultures. Our sense of time also depends on how long we live. A year for a small child is experienced very differently than it is for an adult. I do not imagine time as "one time." I think more that at the "bottom" of time it is close to a standstill, and that nature/reality has its own rhythm that is an extension of this. Society, on the other hand, separates time, more and more, both from the beginning of time and from natural time or rhythms. Never before has the world been faster or changed more unpredictably than today. I hope that *Immobile* can "get in touch with the beginning of time" and raise questions about our own relationship with time.

14

CULTURE NATURE CATALYST
Betty Beaumont

Betty Beaumont's underwater *Ocean Landmark* (1978–80) project, an inter-disciplinary intervention, is a public art work that most people will never have the opportunity to see, as it is in the Atlantic Ocean. Created by a process of coal ash recycling off the coast of New York, it is a kind of public art that changes the world we live in by transforming the ecology of the fish habitats near Fire Island. Since its inception, the habitat has encouraged fish and vegetation to thrive in an area of the ocean floor once devoid of such life. Still in production, Beaumont's *Decompression* cyber project will enable the public to experience the *Ocean Landmark* using a variety of technologies. *Teddy Bear Island* (1973), *Riverwalk* (1989), and *Toxic Imaging* (1987) can be counted among Beaumont's earlier interventions, and evidence her profound ecological and political interest, as well as her ability to integrate political concerns into actively transforming and improving habitats and environments. More recently, education has increasingly played a role in her art.

JG Art can often be segregated from the flow of life and from real living environments. Human creation is placed at a higher level than nature's on-tological processes of birth, life, decay, death, and rebirth.

BB The first industrial revolution is now officially over. And another one is beginning to take form. It is in this space, this gap or cusp between these revolutions, that my work has taken place over the past thirty-three years. It is in this new transformative space that I will continue to work. It is a political space that has the potential of aligning and integrating how we support life economically and ecologically. To imagine this space, it is vital we change our belief systems. I am suggesting a cultural transformation that will encourage our community to consider nature as an integral part of the human value system.

JG Your ambitious and farsighted *Ocean Landmark* project was unlike most art practice at the time. It remains a landmark work, and actually involved creating a living underwater ecology that is sustainable.

BB At the end of the 1970s I wanted to do a project that combined metaphor with underwater farming. The result was *Ocean Landmark*, which exists underwater and is made of five hundred tons of processed coal waste, a potential pollutant transformed into a productive new ecosystem in the Atlantic off Fire Island. It was during the first OPEC-constructed oil shortage that I became interested in energy. I was concerned with the consequences of converting oil power plants to coal use. Today more than 50 percent of our electricity comes from coal. Coal is a fossil fuel: the transformed remains of plants that have been underground at high temperature and great pressure for millions of years. It is mined, burned in a flash, and then its ashes are thrown away.

Ocean Landmark is not meant to encourage the use of fossil fuels. While fossil fuels are used they generate tons of waste material. *Ocean Landmark* considers stabilized coal waste as a new material and plans for its sustainable future.

Renewable energy such as solar and hydrogen-cell technology are energy sources that we must embrace. While investigating the Atlantic Continental Shelf, a dream emerged: to build an underwater "oasis" that would be a productive, flourishing site in the midst of an area of urban blight caused by ocean dumping. The work was inspired by the potential of the continental shelf and a team of scientists experimenting with coal waste looking for ways to stabilize this industrial by-product in water. I watched their test site for a year before proposing to use their materials to create an underwater sculpture in the Atlantic Ocean. In researching Japan's construction of artificial reefs, I discovered that a certain shape and size block or structure placed underwater will attract a particular kind of fish, which will then reside there to eventually be harvested as food.

The *Ocean Landmark* project developed over time with the participation and cooperation of biologists, chemists, oceanographers, engineers, scuba divers, industry and myself. We dove for a season and found a site just off Fire Island about forty miles from New York City's harbor. It was selected for its close proximity to shore and potential for fishing. Seventeen thousand coal flyash blocks or bricks were fabricated and shipped to the site. *Ocean Landmark* started to change when it was installed on the continental shelf. It has since developed into a thriving marine ecosystem and continues to evolve. The work is listed as a "Fish Haven" on the NOAA (National Oceanographic and Atmospheric Administration) "Approach to the New York Harbor" coastal navigational chart. *Ocean Landmark* is a realized artwork that suggests a new industry, which makes use of recycled coal waste with the potential to revitalize the coastal fishing industry.

Ocean Landmark is an historical precedent for today's art and science collaborations. There have been no images of the artwork. Underwater photography is not useful in imaging the entire "body" of work because of the limited visibility of the underwater site. I plan to work with multimedia

technologists to image this work in its life-giving, mature condition and in its entire form.

JG I believe your ongoing *Decompression* cyber project will allow people to experience the living underwater *Ocean Landmark* and *Living Laboratory*.

BB *Decompression* is an in-progress cyberworld created by electronically collaging multiple stories and images of the contiguous worlds of technology, science, and art. *Decompression* will image *Ocean Landmark* in its life-sustaining form. The technologically mediated images of this underwater oasis will be dynamic. As *Ocean Landmark* is a flourishing ecosystem, *Decompression* will develop into *Living Laboratory*, a thriving information system in cyberspace. Modeled on virtual environments in which the user's perception and spatial position affect their experience of the space, *Living Laboratory* will be a dynamically changing art space with an architecture that combines technologically mediated images and diverse virtual perceptual displays. The realized *Ocean Landmark*, a model for ecological equilibrium in the invisible underwater world, is an interdisciplinary project that for two decades has resided in the domain of the imagination. By visualizing *Ocean Landmark*'s invisible realm, *Living Laboratory* will elucidate and elaborate on virtual perceptual models of different ways of experiencing information within a contemporaneous context.

Global positioning satellite technology will locate *Ocean Landmark*, and images will be created through the use of underwater remote sensing and side-scan sonar. Its progression as a sustaining environment for marine life will be codified in the images of the continuously evolving underwater sculpture. Audio recordings of the reverberations of underwater biological growth, water tones, sonic fish noises, and the timbre of breathing underwater with compressed air will also be part of the project. Images and audio that define the broader continental shelf site will be obtained from a variety of sources. *Decompression* offers access to *Ocean Landmark* while simultaneously being a new work of art. As our oceans become overfished to near depletion of specific species, activists might use the cyberspace laboratory to articulate the underwater project as an intervention that would effect policy and revive the offshore fishing industry. While bringing together environmental scholarship and activism, this cyberspace work is also a new work of electronic art that will evolve to be sited in museum and gallery venues as an interactive media installation.

Admittedly *Decompression* and *Living Laboratory* are ambitious. *Imagining Imaging* and *Ocean Landmark vrmlWorld* (2000) are among the first elements to be realized and will evolve to eventually be integrated into the complete work. An art and technology collaboration, is a virtual world using vrml (Virtual Reality Modeling Language) technology to dynamically image the architecture of this underwater work. Seen initially from a birds-eye view, falling blocks pile on an invisible stage for imagining the

153

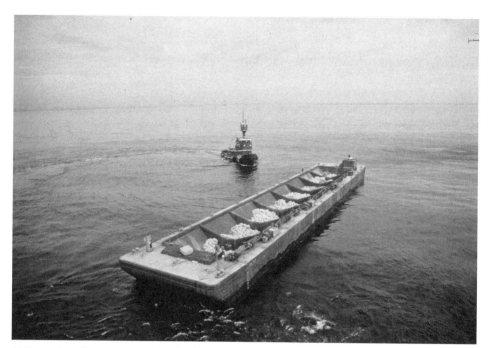

14.1 Betty Beaumont. *Ocean Landmark* (detail), (1978–80.) Combined media—500 tons of processed coal waste (17,000 coal fly-ash blocks) dropped into the Atlantic Ocean near Fire Island, forty miles from New York Harbor. Courtesy of the artist.

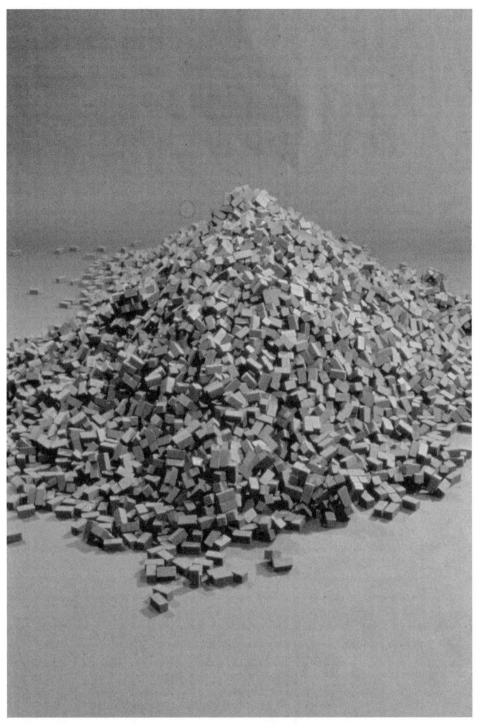

14.2 Betty Beaumont. *Ocean Landmark* (materials maquette), 1980. Combined media. Courtesy of the artist.

155

lush underwater garden that is *Ocean Landmark*. The interactor in this virtual world may move through the falling blocks and around the virtual construction. *Imagining Imaging* is a fifty-two-image color digital-print installation that informs *Ocean Landmark*'s invisible realm. It is comprised of technologically mediated images including side-scan sonar of the underwater environment and microscopic views of biological growth, as well as lunar images and renderings of complex data. This large work is the second in the *Imagining Imaging* series.

JG A more direct involvement with environmental despoilation was the documentation you made of the clean-up of the worst oil spill in United States history on the Santa Barbara shoreline in California (1969). Can you tell me something more about that work?

BB In 1969, the country was shocked when an oil tanker capsized off the coast of Santa Barbara, California, creating the worst oil spill in American history. I was doing graduate work in the College of Environmental Design in the School of Architecture at the University of California at Berkeley and documented the devastation in a series of photographs recording the technology used to rinse oil from rocks—hoses ejecting high-pressure steam. Although it was then known that this technique caused considerable damage, the steam was again employed on many other spills including, twenty years later, the fragile coastline of Prince Edward Sound in Alaska. The photos seem to transcend their status as mere documents of a specific oil spill and serve to remind us of the continued assault on ocean life around the world. This is especially true in the large format print *Steam Cleaning the Shore, 1969—Worst Oil Spill in U.S. History* (2001) in combination with *Time Line of Global Oil Spills 1960–2004* (2001).

JG With *Teddy Bear Island* at West Hill Pond in Connecticut you were already exploring "nonvisible" underwater sites for art making. In fact the island/site was submerged by flooding to make way for a dam. Plastic cables floating above were the only record of this lost landscape. Wasn't this around the time you began your involvement in performance?

BB In the piece *Teddy Bear Island* I rimmed, with plastic cables, the submerged Teddy Bear Island—plunged into obscurity by the building of a dam to create a reservoir. This work rejects the then popular notion of dam building by locating the island and its ecology lost by flooding. This underwater island was delineated with plastic cable: the cable was wrapped twice around its 40 × parameter. In an effort to reconnect this lost site, one thousand feet of loose cable floated in a memory-trace on the surface of the shifting water. This cable became the conceptual demarcation of that lost land. Underwater photography to image the work, in the murky depths, was used to fathom an "underwater consciousness," by mimicking a weightlessness from a cultural past and floating, as in a dream, in an unknown realm. The fragmentary nature of the

work with its unframed space addresses the cumulative past of the location and mourns what was taken away.

In the performance *Riverwalk*, with a permit issued by the National Water Board, I led an interdisciplinary team made up of a gallery director, city engineers, and an architect under Europe's widest bridge, built at the time of the Industrial Revolution to "cover up" the historically polluted River Roch in Northern England. Because of the initial pollution, bridges were built over the river, and then expanded as the city grew, completely hiding the water and thus shaping the history of the city of Rochdale. While developing this intervention, I contacted Greenpeace to find out the status of the river and discovered that it contained none of the industrial and other waste previously there. The river was pristine. *Riverwalk* reveals that the Roch, though thought to be tainted, today runs clear. The performance was a reinvention of history. It has dispelled the myth that has determined the relationship between the people of Rochdale and their river. Questions regarding the formation of "knowledge," truth, and history are raised by this performance, such as How can we acknowledge the invisible change that has occurred? How is one to reverse the erasure of the river? What else that has been soiled and abused has been made invisible? And who, along with the river, has been hidden from our history? *Border Crossing* (1993) was performed in the Bohemian region of Germany, the largest coherent forest in mid-Europe: the Czech side is a flourishing primeval forest, while the Austrian and the German sides are witness to abuse and devastation.

JG *Border Crossing* followed *Toxic Imaging*, a multimedia installation shown at 55 Mercer on the ecological tragedy of the Love Canal community in northern New York State.

BB Throughout the 1970s, across the country I realized a number of site-specific works in the landscape. In 1978 ArtPark asked me to do a work in Lewiston, New York, on the U.S. side of the Niagara River. While on a research fieldtrip to the site, I noticed, interspersed throughout, were iridescent pools of a purple liquid. Upon returning to my New York studio, the *Village Voice* broke the story of Love Canal in upstate New York. The Love Canal, in Niagara Falls, New York, was used by several corporations including Hooker Chemical Company as a dumping site for some decades. The chemical wastes that were poured into the empty canal eventually migrated throughout the soil of the entire, later developed, Love Canal neighborhood. The resulting contamination to groundwater led to health problems, including chromosome damage to many children, and finally the evacuation of the community by the state and the establishment of the SuperFund law that helps clean up polluted areas. I immediately revisited the area and photographed the recently boarded-up homes of the Love Canal neighborhood just after it was declared a manmade federal disaster. This was the beginning of

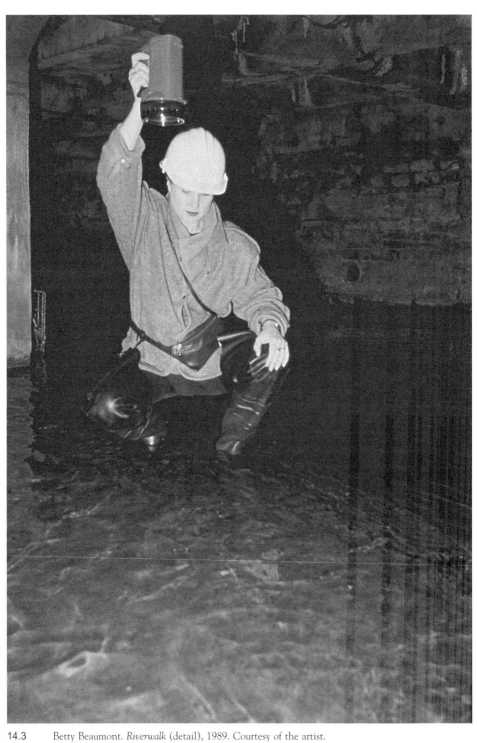

14.3 Betty Beaumont. *Riverwalk* (detail), 1989. Courtesy of the artist.

158

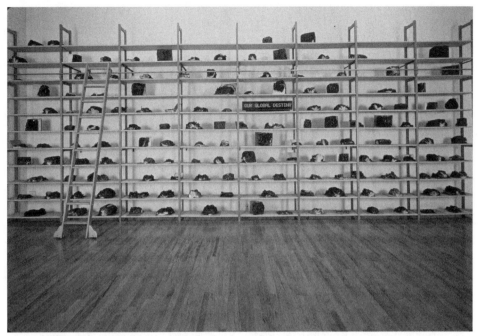

14.4 Betty Beaumont. *A Night in Alexandria*, 1989. Combined media, 11 × 32 × 4 ft. Courtesy of the artist.

a decade-long process that became the multimedia installation titled *Toxic Imaging*.

JG *Windows on Multinationals in the Third World* (1984) is another strong statement exposing toxic chemical abuses by multinational companies in third world countries, and gets closer to one of the root causes of environmental irresponsibility worldwide—the multinationals.

BB *Windows on Multinationals* appeared at the Richard Demarco Gallery in Edinburgh and is composed around seven fifty-five-gallon steel drums in which chemical pesticides are shipped from the United States to Central America. An hour-long scanning text is viewed through a corroded fissure in one of the steel drums. Flickering across the display screen are excerpts from published journalistic accounts of the trade in banned insecticides and fungicides by large U.S. chemical producers such as Monsanto, Shell, and DuPont. A deadly irony is revealed in the green pulsing of the printed text. Chemicals that have been legally prohibited for use in the United States because they are dangerously toxic even at very low levels are being sold by huge multinational companies in countries that have not yet developed mechanisms for banning poisonous agricultural chemicals. The irony is complete with the importation of the deadly chemicals back into the United States as residues on fruits and vegetables that are consumed by millions of Americans. Western Europe, Eastern Europe, and Japan are also exporters of pesticides to developing countries. The death, pain, and genetic damage suffered by peasant farm workers, all callously ignored by profit-motivated chemical producers, are given expression through the use of x-ray film as well as documentation in the scanning text.

JG *El Otro Sendero/The Other Path* (1988) was exhibited at Exit Art's show on third world debt in Central and South America.

BB *El Otro Sendero* presents the debt in less-developed countries from a global economic political view and from the position of a local underground economy. This installation consists of a seesaw mounted on a wall at a height over one's head. The eleven-foot-long seesaw supports a bulldozer next to a caramate (an eighty-image slideshow) in the middle, with two light-emitting-diode (LED) moving message boards on each end. These LED boards become text/drawings, and in order to create them, I engage in in-depth research, analysis of information from various sources, and assembly or presentation of that research in script form.

The bulldozer, as corporate toy, and the seesaw make allusions to a game. Consequences of economy in the third world are presented in the images of the people as their stories scan on one moving LED message board while first-world facts scan on the other. Images on the caramate and the text reveal to us the invisible connections between first-world and third-world economies. In combination with erratic movement of the seesaw, an imbalance between entities is present. I would like to read you a portion of the scripts that scan simultaneously in *El Otro Sendero*.

El Otro Sendero: The Problem

What is called the debt crisis is really a crisis of political power relations in less developed countries. The state-led "development" has left piles of rusting iron, crumbling concrete, and yellowing loan documents. Unable, thanks to their policies, to accumulate savings in their own countries they relied on initially compliant foreigners to supply them with the capital to build what the Brazilians call "Pharaonic" projects.

El Otro Sendero: The Solutions

What is to be done? There may be a shortage of money in the indebted countries, but there is no shortage of self-appointed "policy experts" ready to tell people about the debt problem. The fast answer is: just repudiate the debt. But that's already been tried in places such as Peru, Brazil, and Nicaragua, and far from freeing the countries from bondage, repudiation has been a complete disaster.

JG Can artistic practice help bridge the gap, reawaken people to the fact that they can change the existing order of things?

BB *Riverwalk*, a work that we just discussed from a performative perspective, is an example of an artwork that effects a paradigm shift. This artwork connects people to their unique landscape by dispelling a belief they held—that their river was polluted—a myth that had separated them from their river. The river runs clear and *Riverwalk* draws attention to, and celebrates, this reality. It is a work that gives nature back to its community. To my mind, observation is the key to changing the order of things.

Longwood Lake Project is meant to be a place where one can listen and observe. Feelings and ideas coalesce while being in and observing nature at this site, less than one hour from New York City. The project is part of an ongoing series of site-specific ecologically sustainable landscape works. The actual site is a 670-acre cabin owner's association, where a summer community of eighty tiny bungalows rings the lake, leaving 640 acres of natural landscape that includes two mountains and a lake adjacent to four square miles of forever-wild state land and over ten square miles of military preserve. It encourages participation in the management of this environment to maintain it as a habitat for songbirds and other wildlife and includes developing one of the bungalow sites with an integral design of paths, landings, observation decks, and a tree house that allows the viewer to observe the unique and diverse wildlife environment.

JG Joseph Beuys often commented that the most important thing is to create the world as an artwork. As an artist you have shown great commitment to changing actual environments. Social engagement is definitely implicit in ecological restitution. I am thinking of *A Night in Alexandria . . . The Rainforest . . . Whose Histories Are They Anyway* (1989).

BB One of the parallels between Beuys's work and mine is the expansion of thinking about what art is. Both his work and mine are accomplished cooperatively, creatively, across disciplines, toward contributing to the redesign of the world. *A Night in Alexandria* . . . is an installation concerned with the loss of genetic information in rain forests. It consists of thirty running feet of shelving stacked high and open with a rolling library ladder leaning against the shelving. On the shelves are the charred remnants of 150 books that have been treated and burned in a delicately controlled process. Here again, an LED display becomes a text/drawing near the center of the installation. In this work, the LED scans information about the importance of the rain forest as a habitat for a still uninventoried multitude of plants and animals. *A Night in Alexandria* . . . suggests a parallel between the burning and complete destruction of the city of Alexandria's great classical libraries and the rain forest ecosystem, both sources of encyclopedic knowledge. It has only been shown twice, originally at PS1 Museum and ten years later at the Hudson River Museum. At the time of the second showing I had not looked at the work since 1989 when it was made. Each burnt volume is unique. I have since photographed each book for a series of 150 framed color photographic prints. Apart from the installation the photographic images illuminate each of the distinct burnt volumes, which speak not only of unique form but of specific detail. The natural burnt forms metaphorically signal the lost life forms in the rain forest. The remaining inside cover of each book both presents the ashes and bears witness to the transformation of the book from geometric object. The new organic forms evidence the loss of the book as cultural icon as well as the signs and symbols contained within that construct knowledge.

JG Do you ever feel there is a conflict between the issues you address and the museum or gallery exhibition venues they are presented in and all that entails in terms of formality, politics, and compromise?

BB No. Museums and galleries continue to support works that expose them. Two such bodies of work are Hans Haacke's real estate works about the Guggenheim Museum and Jenny Holzer's *Truisms*. I wonder why one would choose to make art if they are going to compromise.

JG Where is the individual in all this? Is there any room for reflection? Does the art follow from some sublime act of self-recognition that comes with accepting an ethical and catalytic role in society?

BB The installation *Morals, Ethics, Values (whose, what, which)* is one of three works in a series that uses text tablets. Leaning against the wall are three slabs of cast glass, carved into each are one word: *morals, ethics, values*. Above these, mounted on the wall is a tear-off book of the words *whose, what*, and *which*, one per page. The observer is asked to participate by tearing off a page and dropping it on the pile that accumulates in front of the glass slabs.

The same year I made a related work in Prague, for the first anniversary of the Czech Revolution, using books of five hundred pages each per lectern.

The books had *whose* voice, *what* voice, or *which* voice on each page. During the exhibit, participants pulled off pages and left them on the floor, going through twenty books until the pages were spilling onto the streets outside. I was thrilled when Vaclav Havel attended the opening.

Morals, Ethics, Values (whose, what, which) expresses my deep concern and artistic involvement with the state of our world today. In much of my work, I present issues and ideas that challenge us to reexamine accepted norms; to reexamine our own beliefs, actions or inaction, acceptance of misinformation, and our own potential to effect change. This work is intended to cause us to question Who is responsible for the state of our world? Have we allowed others to choose and decide for us? Where do we stand? What action will we, or will we not take? Rather than focusing on one crisis in the world today, this work asks the broader question: Who has control and authority over the decisions being made? By what moral or ethical standard are we deciding? Whose values are being represented? The words themselves, *morals, ethics, values*, overlap in definition. The words *whose, what*, and *which*, are meant to question and provoke an individual deconstruction of these complex issues. The work suggests that each of us has a responsibility to be informed.

This moment of cultural transformation is a critical historical juncture at which, to my mind, we have the opportunity to make a huge difference. It is not based on commodities, nor on money nor materialism. Its economy is spiritual values. Art has a role in shaping the environment in which we live. Art and industry will redesign everything in this productivity revolution whose basis is in ideas, art, and education.

15
NATURAL/CULTURAL
Alan Sonfist

Considered a pioneer of public art that celebrates our links to the land, to permaculture, Alan Sonfist is an artist who has sought to bridge the great gap between humanity and nature by making us aware of the ancient, historic, and contemporary nature, geology, landforms, and living species that are part of "living history." With a reawakening of public awareness of environmental issues and of a need to regenerate our living planet, Sonfist brings a much needed awareness of nature's parallel and often unrecorded history and presence in contemporary life and art. As early as 1965 Sonfist advocated the building of monuments dedicated to the history of unpolluted air, and suggested that the migration of animals should be reported as public events. In an essay *Natural Phenomena as Public Monuments,* published in 1968, Sonfist emancipated public art from focusing exclusively on human history, stating: "As in war monuments that record the life and death of soldiers, the life and death of natural phenomena such as rivers, springs, and natural outcroppings need to be remembered. Public art can be a reminder that the city was once a forest or a marsh." Alan Sonfist continues to advocate, in his urban and rural artworks, projects that heighten our awareness of the historical geology or terrain of a place, earth cores become a symbol of the deeper history or geology of the land. His art emphasizes the layered and complex intertwining of human and natural history. He has bequeathed his body as an artwork to the Museum of Modern Art. Its decay is seen as an ongoing part of the natural life cycle process.

Sonfist's art has been exhibited internationally at Dokumenta VI (1977), TICKON in Denmark (1993), and in shows at the Whitney Museum of American Art (1975), the Museum of Modern Art, New York (1978), the Los Angeles County Museum (1985), the Osaka World's Fair (1988), Santa Fe Contemporary Art Center (1990), and the Museum of Natural History in Dallas, Texas (1994). Best known for his Natural/Cultural Landscape Commissions, which began in 1965 with *Time Landscape* © in New York City and

include *Pool of Virgin Earth*, Lewiston, New York (1973), *Hemlock Forest*, Bronx, New York (1978), *Ten-Acre Project*, Wave Hill, New York (1979), *Geological Timeline*, Duisburg, Germany (1986), the *Rising Earth Washington Monument* in Washington, D.C. (1990), *Natural/Cultural Landscape*, Trento, Italy (1993), and a seven-mile Sculpture Nature Trail in La Quinta, California (1998), as well as *Natural/Cultural Landscapes* created for the Curtis Hixon Park in Tampa, Florida (1995), and Aachen, Germany (1999). Sonfist has recently completed a one acre neolithic landscape titled *The Lost Falcon* near Koln, Germany and a fountain and stream reconstruction for a hospital in Pistoria, Italy.

JG From the mid-1960s you established a name as one of the first environmental artists who, unlike land artists Michael Heizer and Robert Smithson, did not emphasize a minimalist aesthetic in the creation of artworks and monuments. What do you feel brought you to environmental art?

AS My art began in the street fires of the South Bronx, late 1950s, when I was a child. Gangs and packs of wild dogs were roaming the streets where I was growing up. The neighborhood was a landscape of concrete, no trees. The Bronx River divided the two major gangs, and the river protected a primal forest. It was my sanctuary as a child. The human violence didn't enter the forest; it was my magical cathedral. I would skip school to spend every moment I could in this forest and replenish my energy, my life. The forest became my life, and my art.

JG When you first turned your attention to artmaking, what inspiration did you draw from the art world? Were there certain artists or teachers who drew you in the direction you wanted or was it self-learning?

AS It was self-directed. I have always been tuned to collecting and gathering fragments of the forest. Labeling it as "art" or "not art" was never an issue. It was more the uniqueness of these elements that attracted me. Even when I went to school in the midwest, later, I brought with me some of the seedlings of my Bronx forest after it was destroyed by an intentional fire.

JG As early as 1965 you produced a work called *Time Landscape©* involving actual living growth in art. Indigenous animals were reintroduced into an urban setting.

AS The reconstructed forest was a way of going back into my childhood forest in New York as it would have been, initiated in Greenwich Village. I transplanted living tree species such as beech, oak, and maple and over two hundred different plant species native to New York, selected from a precolonial contact period in New York. These are still there on site. Besides experiencing the indigenous trees of New York City, *Time Landscape©* allowed me to experience and interact with foxes, deer, snakes, and eagles, and this was part of my experience.

JG *Interactive* is a word that has been appropriated by many artists who are simply working with images on a screen. When you worked on the nature

theater as early as 1971, the interactions were real, involving nature and sound orchestration in the forest.

AS The "Nature Theater" idea was to construct a physical fragment of a forest (I have done several including one at Goethe University) and then allow nature itself to be the sound, for instance, as opposed to constructing noises of a forest. And, allowing the animals themselves to become the performers, the migration of the birds becomes a special event.

JG And animals for you have souls, just as we do?

AS Exactly. Trees do too. They definitely do communicate with each other and they also communicate with humans if they are willing to listen.

JG And your photo work is related to this and various other projects. I know your photographic works have inspired other artists. How are they presented in galleries?

AS I showed photographs in my early exhibits in the 1970s. The photos are more observations of nature, trying to understand how we see and relate to the environment. My first art dealer didn't even want to exhibit my photographs because he did not consider them art. Now, there are several artists who have created works similar to these early photographs. Each photographic event is an exploration of human interaction with nature. For instance, *From the Earth to the Sky and Sky to the Earth,* is more about walks through the forest and how we see the forest, how the movement of the landscape shifts as we relate to it and the light quality. Examining nature's interaction with urban life was a radical concept at the time.

JG In a way, every environment is unique. We talk about bioregionalism and the global culture, for instance. The irony is that quite often there is this idea that elsewhere is exotic and where we live is not. New York City vegetation is actually as exotic as South American.

AS Exactly. It is always easy for one to look at another environment and say that is special. The cliché goes: the grass is always greener on the other side of the hill, instead of looking at one's own environment. I have always been concerned about the particular location I am working with, because each is unique and has fascinating vegetation to be discovered. The forest I witnessed as a child ended up being bulldozed and set in concrete. That was the end of my forest, and the beginning of my art.

JG The idea of the continuity of time has almost been erased in this culture. Yet there is this ever present physical continuity between the various elements in the environments that surround us. We are not often aware of this. By presenting nature as a presence in your work you are allowing us to see how integration of our culture with nature will become one of the keys to development in the twenty-first century in technology, science, and the arts. Technologists will have to develop new forms of transport and products that use less and renewable resources, which emphasize a cyclical resource system rather than an exploitative, one-way nonrenewable system. Your work is less that of

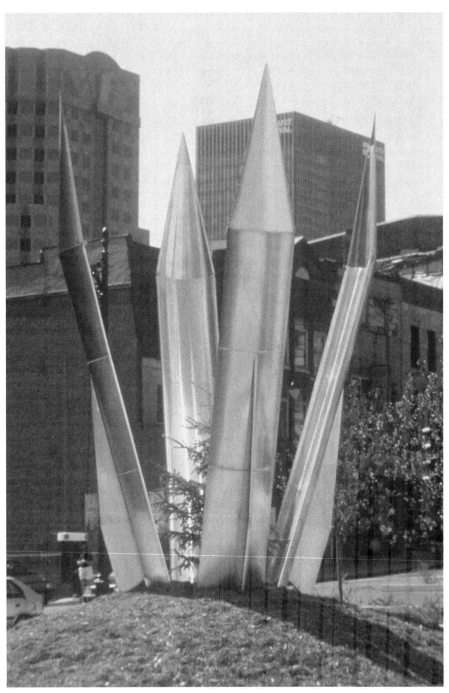

15.1 Alan Sonfist. *Growing Protectors*, 1991–92. Earth, white pine, pine needles, and steel; 555 cm.
high × 680 cm. diameter. Montreal, Quebec. Courtesy of the artist.

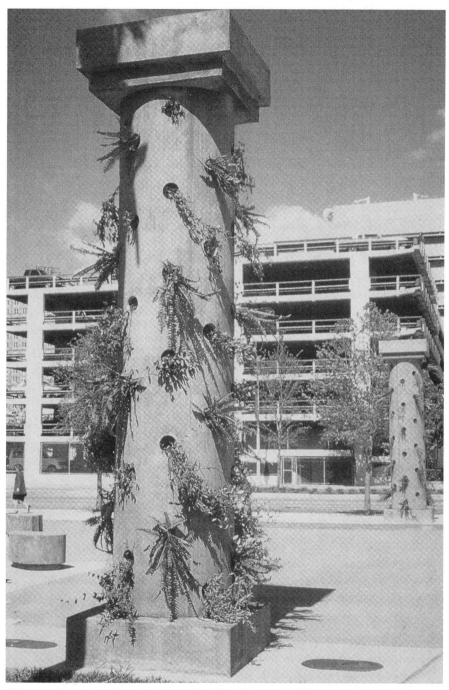

15.2 Alan Sonfist. *Time Landscape* © (detail), 1995. Tampa, Florida. Courtesy of the artist.

169

an ideologist than that of a biohistorian who works with the culture/nature crossover.

AS Biohistory, as in the *Circles of Time©*, is the layering of nature in time. Each area of the project represents a unique event in the continuum of Tuscan history. We look at each fragment of time and begin to realize this layering is a continuum. It's not one fixed moment. The photographs I take, for instance, emphasize that it is not an absolute. Within this continuum one can select out different unique events. The Tuscan landscape was so radically changed over the centuries that the original forest's history had been virtually erased.

JG Isn't that one of the problems with parks and nature sites in many cities? Planners bring in so many foreign plant and tree species that are not native to the land in an effort to make their parks and public places exotic. In Oslo, Norway, interestingly, the tree and shrub species replicate the nature that surrounds the city of Oslo. You see large fir trees, nesting places for birds, that mirror the natural landscape of the region in Oslo. There is a kind of relief in that idea that the nature of the city reaffirms the landscape surrounding the city.

AS One of the earlier artworks I created for the New York City Parks Department was a landscape with natural flowers and artificial flowers. This was for the first Earth Day at Union Square Park in 1970. The question was Which is real and which is artificial? My project in the Mojave Desert is similar to what you mentioned. Most landscapes there use plants taken from lush environments that need continuous watering, such as a grass lawn. When I said I was going to introduce only indigenous plants in this desert environment, some of the local people said, "That's ugly! How could anyone respond to that?" When I started to select out and go back into the historical plants native to the region, people were shocked and amazed at how beautiful was the spectrum of flowers. There was such a diversity that it became a visual laboratory of understanding of the environment.

JG Undoubtedly, the work stimulated thought and controversy as well as providing a cathartic living environment for the people who live there. Your *Rock Monument of Manhattan* (1975–2000) exhibited at the Dorsky Gallery (2000) in New York in a group environmental show involves cross-section samples, what we do not see: the hidden landscape, the geology under New York City.

AS These samples were taken from the underlying strata of New York City geology. Over the years, I have created similar artworks throughout the world, and predominantly in Europe and North America. They are cylindrical cross-sections of the earth, now in the collection of the Art Gallery of Ontario. I have been commissioned to do similar projects, such as the one for the opening of the Ludwig Museum in Koln.

JG This idea that there is a permanent culture that exists underneath the manmade culture or environment is an interesting one. It undoubtedly will

persist for much of this new millennium and plays an important role in providing us with a sense of permacultural geological time. Understanding this permacultural context can help us to design our urban environments with a sensitivity to the brief history of our civilization vis-a-vis natural history.
AS Exactly. A key to our understanding of the environment we live in is literally locked into the rock formations under our cities and the evolution of our solar system around us.
JG I was going to ask you about the less well known crystal works you did in the 1960s and 1970s. These growing crystal projects seem to be fascinating.
AS I created a series of what I would call *Micro-Macro Landscapes*. The crystal structures were to illustrate the fact that within everything there are the microstructures of an element. From a practical point of view, by taking elements that are very unstable, I was able to put them in a vacuum and allow them to inter-exchange so that they transformed from dense solids back to this crystalline form. When exhibited, the viewer could see this interaction occurring within the structures.
JG The effect was always constant. You could actually see it occurring?
AS It was continuous. Again, it was occurring in relationship to the environment. If the sun was hitting the structure it would heat it up and it would create more pressure inside. Therefore the crystals would dissipate and then, as they cooled, they would condense onto the surface. At the Boston Museum of Fine Arts (1977), I created a window for them, which was on display for many years. The window itself would move as the sun moved during the daytime. It would gravitate to the movement of light. This is something that occurs in the natural world, and yet many people have never seen it. My intention was to integrate these things directly into the path of human interaction.
JG Your *Heat Paintings* from the late 1960s again involve the volatility of internal structures. As the metal transforms, the alloys change color.
AS The *Heat Paintings* parallel the crystalline pieces, so you see the internal molecular structure of the metal.
JG Heat circles transform the alloy into color variations. The physics of nature actually transforms the artworks, kind of like Andy Goldsworthy's pigment and snow drawings.
AS This is a real-time event. The artwork allows you to see the composition of the material. I created a series of different artworks, decoding the process of the materials.
JG Your series of micro-macro landscapes titled *Elements Selection* from the sixties to the early seventies, are structural changes that are part of a natural physical cycle. This natural entropy became a reading of the environment. Did you select the elements that would cause these changes or was it left up to nature to decide the course of these works?
AS I unrolled the canvas and, as the process began, I selected the elements exactly as they existed. The canvas was then left in the natural surroundings,

171

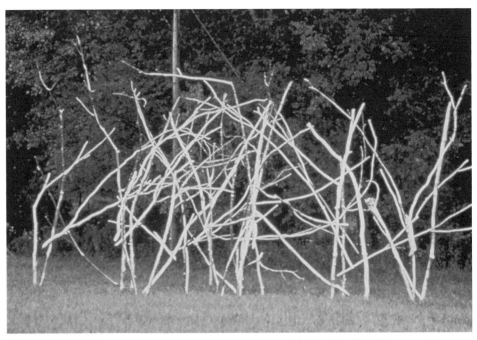

15.3 Alan Sonfist. *Walking Limbs*, 1976. Bronze, 16 × 22 ×15 ft. Rye, New York. Courtesy of the artist.

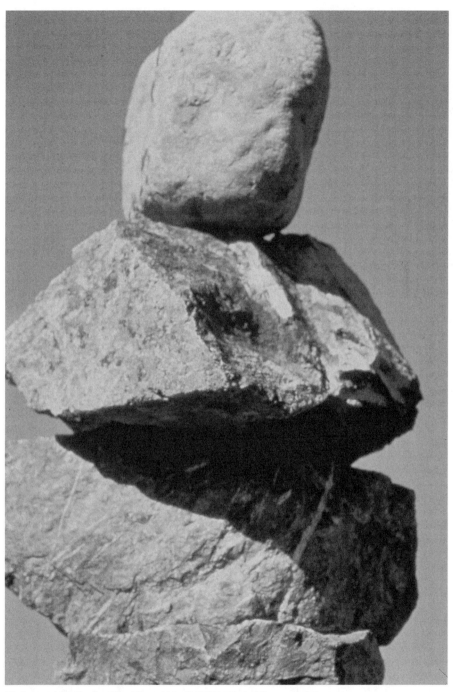

15.4 Alan Sonfist. *Time Totem* (detail), 1987. Alaska. Courtesy of the artist.

so that the twigs and leaves that were selected as well as the canvas would go back to it's natural state in nature. I also created a series of paintings where I selected a series of slices of the earth such as fall leaves, which was titled, *Leaves Frozen in Time* (1971). These artworks have ended up in numerous museum collections.

JG *The Pool of Virgin Earth*, created in the early seventies at the Lewiston Art Park in upstate New York, regenerated a section of what was, and still is, a chemical wasteland.

AS The area was a toxic-waste dump for several years before it was given over as an art park. The area was a desert of toxicity. With the consultation of specialists, I was determined to create a pool of virgin earth that would show the rebirth of the toxic dump. The pool was so successful that eventually they used my method to create the entire site.

JG The plants would help purify this area of earth?

AS Yes. The plants were selected to help heal the earth.

JG *Natural/Cultural Landscape©*, created for the Curtis-Hixon Park in Tampa, Florida, in 1995, is a more recent crossover work. I know you have created many commissions throughout the world concerning the natural evolution of the land, as you said in your early writings, published in 1969, that within landmark cities you plan to create "Landmark Nature Monuments." Do you feel your more recent *Natural Cultural Landscape©* project involves a compromise in working with landscape or city architects?

AS No, all my public projects involve the community. I always have public meetings to discuss my ideas. I invite the local artists as well as architects and landscape architects. They became part of the process of creating the artwork.

JG Why were four classical columns integrated into your *Natural/Cultural Landscape©* in Tampa, Florida? It seems curious as you are often working with natural, as opposed to human history.

AS The columns correspond to the human history of the site. The first Europeans there were Spanish, and they built colonnade buildings. The columns represent the human past and were planted with plants that represent the natural history from early human intervention to contemporary landscape.

JG What sort of species of plants and what kind of configuration did you finally arrive at for this living landscape work?

AS All the plants in the site represented different historical events from human to natural history and how they both intersect. The pathway represents these intersections.

JG So did it become a kind of community exchange, a point of encounter and learning for the local citizens?

AS Yes. I think when one involves the community there is a kind of interexchange of ideas. The park becomes the community. For me that is what determines the ultimate success of a public sculpture. When I create private commissions I am responding to the corporate structure.

174

JG There is always this problem of designers moving into an area where they don't know the history of a community. They will place the benches in the wrong place; people don't walk in that area or whatever. Involving a community helps to create a kind of ensouling or consecration of a place.

AS Exactly. Everything from the seating areas to the walkways will all correspond to community needs.

JG So the process was quite democratic.

AS It was democratic, and from my point of view as an artist, it was almost like a palette. In other words, I had a palette, maybe several hundred images that could be utilized for the project, and had to select out which ones would be most effectively integrated into the project, visually and culturally.

JG And these pathways you designed going through the grassy landscape are nonlinear in shape, like motifs.

AS The pathways were designed to correspond to the natural history from the Ice Age to the present.

JG A kind of histology, a history of nature and culture brought into a living dynamic. There is a patchwork design to it, using colored brickwork and slabs, various grass species, and walkways. It becomes a nature/culture quilt that references various eras and epochs.

AS A quilt where each section is interconnected by its own uniqueness in history. Seen from the air, the leaf structures in the pathways are most evident. If you knew the leaves, you would know that each leaf represents a different time frame within the ecology of that region. The pathways are a 21st-century view of the land, not a typical landscape concept that parks are being created at this time. Walking through the park, the entrance becomes an echo of our understanding of the history of the community. The park progresses to the water where we see a reflection of the Ice Age.

JG When you exhibited at Documenta VI in Kassel, Germany (1977), you created a series of photographic essays that were like a composite of a forest, with relics of a forest underneath the photographs. Can you tell me about this?

AS The photographs became the forest. Each photographic artwork exposed multilayers of the forest. Through each one of these artworks, one viewed a special moment within the forest. Some of the more significant artworks of the 1970s is where I created 180° and 360° "Gene Banks," (1974) with real-time fragments of the forest.

JG We are the gods of our own consumption and we are now eating ourselves. There is also this confusion between technology and experimental science. The two are fusing. You are getting an involvement of new technologies with experimental science. Sometimes the blurring of these two disciplines means there is a further manipulation of science. The technologies are forming the processes whereby the scientists are working—the lenses, the ways that science is evolving, are technologically controlled, which may not allow more

creative solutions to be arrived at. In other words we may not be seeing as much as we think when we involve ourselves in pure science.

AS There are two levels of reality: we want to create alternative fuels, but at the same time we also remain consumers of fossil fuel. Through my art, we can understand our relationship to our community, our world, and our universe.

JG Which would be much better for the environment and for us.

AS Exactly.

16
SHIP OF LIFE
Peter von Tiesenhausen

In Demmitt, a sawmill ghost town in northern Alberta where he grew up, Peter von Tiesenhausen builds pods, ships, towers, and any number of woven willow forms on site in the landscape. Before becoming an artist he worked as a laborer, miner, roughneck, and cat driver in the Klondike, Antarctica, and the oil fields in northern Canada. He lives off the land through his art, which often explores his relation to that same land. As he has stated: "I'm not trying to make a monument to anything. I want to have a dialogue with the land." *Ship (in field of timothy)* (1993), a willow boat structure, references the journey his ancestors made to arrive in the New World. Ephemeral, like so many of the works von Tiesenhausen creates, it suggests the theme of a passage or journey through life.

During a stay at the Banff Center for the Arts' Leighton Colony, von Tiesenhausen actually carved a boat out of ice, set a rock into it and sent it on a journey floating down the Bow River. When the work eventually melted at some point on the river, the rock dropped unseen into the river's depths. When an oil company asked to run a pipeline through his land he refused a lucrative buy-out offer. To preserve his land for future generations, von Tiesenhausen had to claim the land as an artwork through the use of the copyright act. The oil company subsequently abandoned trying to get their pipeline to cross his land.

Lifeline (1990–) is a lifelong work that began with the arbitrary placing of an eight-foot section of picket fence at a point easily visible from the artist's studio. Each year an additional eight-foot section will be added to this fence structure until von Tiesenhausen's death. As the project evolves, sections will decay as others are added. One of his most recent projects, called *Figure Journey*, involved touring a collectivity of carved larger-than-life figural sculptures. *The Watchers,* as the five sculptures have come to be known, have traveled thirty to thirty-five thousand kilometers through every province and territory of Canada, and have even gone by boat through the Arctic's North-

west Passage. They have stood at the edge of the Atlantic, Pacific, and Arctic Oceans. The sculpture's journey established a dialogue as people in logging towns, restaurants, gas stations, in cities or the country, reacted to the figures in various ways. While that journey ended at the same point where it began nearly five years later in Demmitt, Alberta, *The Watchers* have now been cast in iron at a foundry in the city of Hamilton and will be permanently installed in front of Olympia and York's new building on Queen St. in Toronto.

JG Peter, could you tell me what got you into making art?

PvT I've always been painting and looking around, excited by art, and it was only at thirty that I had the opportunity to finally do that fulltime. I didn't know what it meant to be an artist. I thought I would give it a go anyway. I started with what I knew, which was the land and landscape painting. I loved to paint and I just responded to what I saw around me.

JG When you studied painting (1979–81) it was at the Alberta College of Art and you left there without graduating. It was ten years later that you began your first environmental site-specific project *Lifeline* on a fifty-acre field in northern Alberta. This is an ongoing project that will last your lifetime. It involves building, the scale of the land, demarcation, growth, and decay. Can you tell me something about the project?

PvT That was the first thing that I did that was at all successful. It was just after working in the gold mines, and in Antarctica. I was embarking on a different life, setting to rest the previous one. I built a section of fence to mark that time, and will add an eight-foot section each year for the rest of my life, never again painting or repairing the previous sections.

JG Your recent painting seems increasingly to draw from your sculpture. The forms are quite resolved in the images you make on wood and paper and even resemble primitive cave drawing. The symbolic presence is there in the de-limiting and reduction of form. The elements are so simplified. If it is a boat or a figure, the various components are drawn or painted as if they were actually made of sticks or willow and fire, which is an element often used in your sculptural process. There is a kind of osmosis going on between the sculpture and the painting. Do they feed each other?

PvT I think everything I have ever done is influencing what I am doing now. You go through these stages. When I built the willow fence around my prop-erty it allowed me to see that as sculpture. It was a fence, a functional thing, but it looked like a drawing somehow. That opened up the ship, the boats and all those things. I began to leave behind landscape painting at that point to conceive of line and form in the actual environment.

JG Your first boat piece was made in Demmitt, where you live, and then you made another boat piece in France as a guest artist at Espace d'art contem-porain near Poitiers (1995). With the second one, instead of building onto the land you dug into the clay earth recreating the outline of a ship to original dimensions. Sand was brought from the sea one hundred kilometers away and

filled in. The first boat piece involves drawing in space with branches, while the second is drawing or engraving into the earth. The actual building involved repetitive actions, a kind of ritual of recreation, yet the boat suggests a journey, emigration or immigration, arrival and departure. How did you come up with the concept for these works, or was there a concept?

PvT It is a flow of ideas. You start with the idea of a ship and one thing leads to the next. Before I actually made the first piece in Demmitt I measured out the ship in the field. I walked on the snow, back and forth, pacing it by foot. Over the winter period, every time it snowed I would trample it down. I came back from traveling somewhere and during a thaw, here was this frozen outline of snow, which was a white line on the land in the shape of a boat. It influenced the piece in France a great deal. I could draw the outline in this red earth in France, but wondered how I would do it. It was summertime, so I decided to dig it into the land.

JG How did people in France react to the image of a boat in the earth?

PvT It is an area of France where there are a lot of Merovingian ruins. When I first flew into the area I could see traces of foundations all over the place that had been gone for a thousand years. Everywhere you went, driving through the villages, there were these troughs that were actually coffins, sarcophagi, that people were using to water their cattle. The history there is fantastic. So I thought, *Why not leave a trace in the land that is not harmful?* I would make this trench below the ploughline so that it would always be there in some form. As the field gets worked it will remain. When I began work there people were quite negative. They thought I was some kind of art star who was going to do something that would attempt to change their way of thinking. I had no intention of changing what they did on that land or of altering the land. I was just going to create this work in the land. Then people could go back and, while farming it, reflect on what is below the surface.

JG This interaction with the public is often part of your work. It justifies a public reaction because you integrate a human element in environmental art, and that is something that is not so common. A lot of people build structures or design pure aesthetic forms. Pure design is a neutral thing. Your work always has this reference to history and the human element, to shelter, travel, and so on. And so it stimulates a different reaction from people. An example is your *Forest Figures*—that have since become known as *The Watchers*—which you toured across Canada. You have put them in urban sites like Calgary and Kelowna, and floated them at Coutts Paradise for the Zone 6b show in Hamilton, Ontario. You have also driven them along rural routes, across farmers fields, on the highway, across parklands. They have even been up in the Arctic and on the Queen Charlotte Islands. Casts of these figures are being permanently installed in front of Olympia and York's new offices in Toronto. The *Forest Figures* stimulated a reaction from ordinary people wherever you brought them.

179

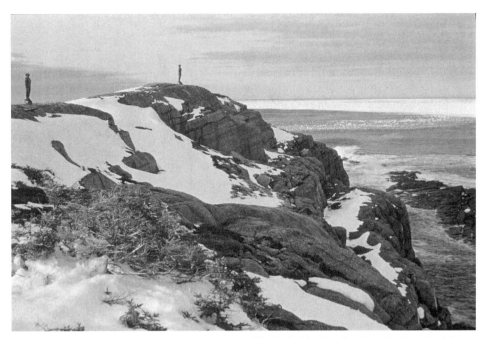

16.1 Peter von Tiesenhausen. *Forest Figures*, 2001. Flat Rock, Newfoundland, overlooking the Atlantic Ocean. Courtesy of the artist.

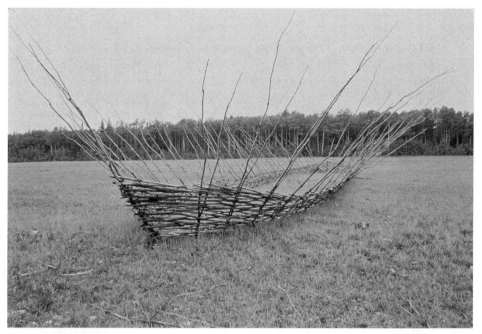

16.2 Peter von Tiesenhausen. *Willow Ship*, 1993. Courtesy of the artist.

PvT Yes they do, and I don't think I would use the term *touring*. I would use the term *driving around* because I am interested in the whole idea of being inclusive rather than exclusive. What I do can be done by anybody. There have been instances where people have been included in ways they don't necessarily want to be included. A guy in front of a coffee shop was looking over to the side at *The Watchers* when he should have been looking ahead and it totaled his truck. The way I see the *Forest Figures* is like a huge drawing, drawing a line across the whole country. Little bits of charcoal fall off the figures, large chunks of rust are continually dropping off the truck. People take souvenirs of rust off the truck, get into the truck and have their pictures taken when it's parked in the street somewhere. It's often traveling at sixty miles per hour. Just imagine sitting at a stop light watching this thing go by. You just get a glimpse. And that too is a drawing. It somehow gets imbedded in the mind of the viewer in a way that's much more immediate than going to a gallery to look at art. Just as the rust bleeds into the snow or into the road over time, spreading this little seed of seeing, these figures (you can't ignore them) imbed themselves into people's minds, and maybe that bleeds and feeds into the other things they think about. I have had people say that they have seen these things five hundred miles from where I meet them. They say "I saw it in Regina. Were you in Regina?" Its interesting to be inclusive without preaching. When people ask what it is about, I ask "What is it about for you?" and then they tell me.

JG So *The Watchers* stimulate stories?

PvT Constantly. With gas-station attendants I never talk about the price of gas or the weather anymore, I talk about what's worth doing. We talk about their father that died, or the kids that they love, the job that they would like to have, or whatever. That's really meaningful stuff for a three-minute conversation.

JG After the boats, you did the woven willow pods up in the trees, and huts on the land, and the *Maelstrom* funnel at the Richmond Art Gallery in British Columbia. These works are a continuation of the boats and again they reflect the human presence in nature. Does this relate to your own rural roots in Alberta—that you bring the human into outdoor work and don't set nature aside as a pristine place? You don't differentiate between people and the landscape. People are reflected in the landscape.

PvT First of all I don't consider myself a nature artist. Its just that I am surrounded by the land. I don't think we need more stuff in the landscape. We've got enough. I am conscious of my mark on the land and try to leave as little of a mark as possible because I really love what I see. I understand my humanity and need to be connected to the land.

JG There is no ideology of nature or art that does not eventually become redundant. The only thing that remains is the art. Life is short, art is long. It seems art that leaves the most lasting impression on people has a physical

presence and impact. I myself believe in sculpture for this reason. I do believe nature or natural materials maintain a stronger impact on people therapeutically and unconsciously than video, TV, or screen technology, particularly if it is well made. I also think that if we live in a world where people have less direct experience of nature, it is possible that because of that deprivation they don't know how to respond to nature. Maybe we have lost some of the instinct or knowledge that was part of our ancestor's experience, are less able to identify with it.

PvT We are totally removed from the land, out of touch with what is actually happening. We have lost our sense of being part of the whole thing.

JG Our culture emphasizes distraction and entertainment. Permanence—the idea of working together to build, and working together toward a better society—is subverted by the pervasiveness of the entertainment and consumer industry. People do not have the opportunity to produce at their highest level and are being diverted into a kind of passive distraction. I feel the same goes for a lot of art. It has as much staying power as a micro chip—video art in particular. . .. Video that has a narrative can be interesting, but when it is composed of fragments, it has no staying power, no meaning or purpose other than to comment passively on powerlessness, the demise of democratic traditions. A way of building a dynamism into sculpture is with environmental sculpture outdoors, building and creating with the context in mind, by responding to the particularity of a site. Is it a place where there is a lot of human interaction or is it out in nature, something to be discovered? The Squamish tribe in British Columbia, for example, put a *Cedar Woman* figure sculpture in their traditional lands in the upper Elaho Valley, amid first-growth forest where few people actually go.

PvT I have sculptures built out in the land that nobody has ever seen. That's not to say they are my weakest things either. They are often stronger works. I have shown them in photographs. Why was it so important to drive out to the East Coast with the *Forest Figures*? Because somehow it embraced all the potentials that I can possibly embrace. Its like this quest for this thing that I don't know and I don't have any end result in mind. I had this concrete idea, that I would send the figures out to sea on a boat made of ice. But that was abandoned after this horrible tragedy at Pouch Cove where three teenagers drowned in the icy water. So I had to rethink the whole thing. I have to be completely open and sensitive to whatever presents itself, remain attuned to what is happening around me at any point in time. If the people that are clear-cutting around where I live actually went outside a few times a year and walked through those forests before they clear-cut them, they couldn't possibly bring themselves to do it. They're focusing on some kind of entertainment, usually television, and can just say "Yeah. Take the trees. They're worth $40,000." Everywhere you go is an important site. This year, I was asked to do a TV interview and talk about my connection to the land. I was thinking to myself

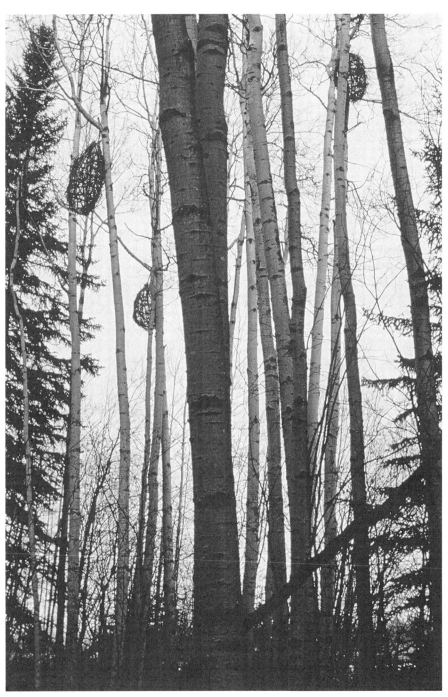

16.3 Peter von Tiesenhausen. *Pods*, 1993. Courtesy of the artist.

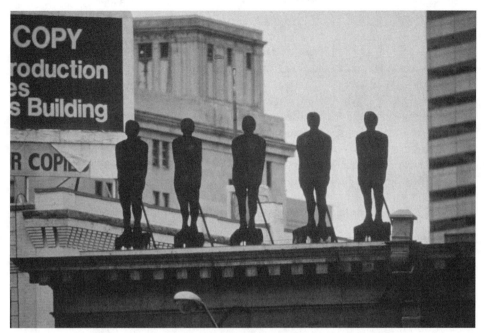

16.4 Peter von Tiesenhausen. *Forest Figures*, 2001. Calgary, Alberta. Photo: Marc Hutchinson. Courtesy of
the artist.

Well what the hell do I know? A day before they arrived, I went down into the muskeg and lay down on a piece of moss in an area where I never go. It is kind of a sombre place so I gave myself a half an hour to lie there and look up at the sky thinking maybe some thoughts would come to me. After half an hour of lying there I was noticing all kinds of things that I never knew existed in that place! I was so exhilarated that all kinds of thoughts came to me, and I wasn't doing anything. It was a kind of healing. We need to take the time to sense and feel what is there so we don't destroy it. A guy who is sitting in a feller buncher cutting down twenty-five hundred trees a day, listening to his discman is no longer conscious of what he is doing.

JG Maybe sensory deprivation is part of a formula for environmental destruction.

PvT You remove yourself from it. I myself have done it. I have run heavy equipment and cut down more trees than most people in the world have done.

JG Do you like to leave the forms you make partially incomplete to let the materials speak for themselves. Do materials have a voice?

PvT Absolutely. My marks are all about superficiality. They are my idiosyncrasies or skills showing up. My sculpture is not about technique. It is about spirit. If you bring the spirit of the idea of those *Forest Figures* for example, which are crudely carved, the fire begins to bring back what is intrinsic to that wood. The charred nature of that wood brings back its own texture. It is just a rough idea, an approximation of what you want. I believe that's more honest than being intricate.

JG Isn't that a very contemporary idea, or state of mind, to think of artmaking as a sketch? In classic times people sought the perfect form, proportion, and everything. It is very much related to media culture and our current state of mind that even a sketch or an approximation is hard work.

PvT When I look at a tree I think a tree is never wrong. A tree is always right. Why is that? Even a rotted out stump is still beautiful. Why is that? Even an old log cabin that's rotted and laying there is very interesting. It becomes more interesting as nature takes it back. The rest is all pretension. I find that there is nothing that engages me more than going for a walk in the woods—just being anywhere, actually just being alive, pulsing with that vivid magic that we have here.

JG Your art is an expression of your experience and growth, of where you have lived. Isn't what you are doing an expression of your identity?

PvT Perhaps. The other aspect of that is I have learned to recognize what is beautiful for me. It's that recognition I am always looking for. A lot of it is just kickin it around until I recognize it is beautiful. Then I take that thing that I believe is beautiful and I do something with it. I put it in a gallery, cast it in bronze or drive across Canada with it, or burn it or take a photograph of it. Photographs present this flow of ideas to other people—a documentation of the trail.

186

JG At the Art Gallery of Southern Alberta in Lethbridge you recently created a work called *Deluge* (2000) that was completely different, a kind of visual maze or optical illusion. People could not immediately see what the suspended branch forms represented. It was only in walking through the gallery, in a sense interpreting the work visually in the whole environment, that its form became evident. How did you conceive this piece, its effect?

PvT It came to me after the piece I planned initially became impossible. I was walking through the wilderness area near Lethbridge with my nephew Michael when he observed how the trees formed an arch where they came together. I noticed in that arch that when I moved to a certain point two other branches formed a cross in the arch. I realized that the drawing only formed itself from one perspective. That enlightenment led to the piece *Deluge, Constellation*, and three-dimensional drawings.

JG A lot of art these days has lost all sense of history or continuity. Maybe it's because we have lost touch with our storytelling or narrative traditions. This need not be religious. It can just be a verbal thing.

PvT As a culture, we are so used to being entertained. Everything is didacticized to the point that you just don't want to look at it anymore. I just built a little 10×14 foot-long cabin as a refuge—to focus. The most recent project I have been doing involves a quarter section of 160 acres I bought this past summer. There is an abandoned apiary on this land, and in one of these buildings I found the plywood bases for the beehives—190 of them. I have made them into individual paintings with a chainsaw and an axe carving the image of a fire in low relief. They have wax and traces of the bees on the back, and charred wood on the front. I will be presenting them on a wall in a grid pattern. I have also had each digitally photographed and edited. The plain images will follow each other. They become the individual frames of a film. A film with these images will be projected on one side for exhibition and this wall of fire will be on the other side. The thing that I really like about this particular project is that it is part of a film. Each one of those pieces will potentially go off into a private collection. I will use the money that comes from this to purchase a new piece of land for conservation purposes. Then I will find what is there to make art out of. The process continues.

JG You are the only one who knows the origins of these pieces, where they really came from. They integrate this cultural and natural history together. Here you are putting your imprint after the bees have left their imprint, and the bees were a source of sustenance for the person who ran the apiary and then finally they become art. That's interesting.

PvT This project has all the things I have ever been interested in. Culture, the abuse of the planet, protection of the planet, and all the different media affecting the art. It puts it all into one thing. It shows you can put a variety of different elements into one piece and it still makes a comment on what you like and what concerns you.

187

JG It's true that video can add another dimension and brings to life object-based art when you juxtapose the object with video. We are so trained now to look at video that if you do it in reverse, it becomes a way of introducing people to the object. Its goes backward and works in reverse. You almost have to do that now. It becomes a way for people to seize the object's presence and appreciate the art.

PvT Every piece of a work should be engaging and able to hold our attention on its own. You should be able to take any one of those elements and remove it, and it should still be interesting. Otherwise it is just theater, pretense.

JG What about siting? Wouldn't it be nice to have a work on a billboard?

PvT I think actually people don't notice it. There is so much going on; everybody is blind to it. If you put a ship in a field where there isn't any art at all, it is a profound thing. If you put that willow ship on a wharf beside a bunch of ships. Who cares?

JG One of the few permanent pieces you have made is for the City of Calgary Centennial at the waterworks. Can you tell me about it?

PvT I did this piece out of white Vermont granite. It is twenty-seven feet long, five feet high, and weighs sixty thousand pounds. It is sited in a very beautiful place overlooking the Glenmore Reservoir in front of the waterworks filtration building. It is a piece that talks about time. Originally I thought of making it out of marble, but marble doesn't last as long, so I decided on white granite. If you go inside the white granite, it becomes a calming, meditative space. I like it now, but it is still too full of my marks. Too new. It's very much about time, and in ten thousand years it will be remarkable, possibly even a sacred place.

JG It seems to refer to a journey like so many of your sculptures, one that is both an inner one and that involves the real life. Its a ship of life.

EARTH IN CONTEXT
Reinhard Reitzenstein

Born in Uelzen, Germany, in 1948, Reinhard Reitzenstein has long been preoccupied with the nature-culture dialogue in his artmaking and sculpture. I first met Reinhard at the first Art and Environment Symposium at Queen's University in Kingston, Ontario, in 1991. He pulled out a bag of stones after the talk, handing each member of the audience a stone in a symbolic gesture of solidarity with nature. In the early 1970s, Reitzenstein excavated the entire root system of an ancient ironwood tree on family land near Ottawa in Ontario, Canada. The roots he uncovered had grown around obstacles, boulders and stones. The immensity and majesty of the tree, this ancient mythical symbol found in the writings of many ancient religions, was impressive. More interestingly, after the earth was infilled, the tree flowered better than it had in years due to the aeration of the soil (1982) An early work titled *Sky Cracking* had configurations representing lightning and the moon these heavenly signs, in mythical terms, are part of the cyclical balance that characterizes male and female principles.

While hiking in the Yukon in 1988, Reitzenstein discovered a group of trees whose bark had been partially stripped by an act of nature—an avalanche— years earlier. Struck by the way nature had regenerated the bark around the scars, he applied a layer of clear beeswax over the scar in an act of identification with and pragmatic support for the regeneration of this tree. In 1992, at the biennial in Caracas, Venezuela, where he represented Canada, he created the controversial outdoor installation *Compromiso Viriditas* (1992) using blood, milk, and a tree as elements to underline the political and environmental situation there. *The Sound Lodge*, an interactive sound sculpture built with David Keane in 1993, traveled extensively in North America and Europe. Most recently Reitzenstein has exhibited the *Lost Wood Series* (1999) at Olga Korper Gallery, effectively outdoor seats with sinuous and undulating natural forms cast in bronze from sections of wild grapevine. At the Rodman Hall Arts Center he made a direct cast from a Carolina Poplar, now on view

there. His latest commissions include designing and elaborating on a walkway promenade for the Tridel Corporation in the City of Toronto, a private fountain project, and for the Robert McLaughlin Gallery in Oshawa. Reitzenstein held a major exhibition of his work titled *Escarpment, Valley, Desert* at the Hamilton Art Gallery in the summer of 2002 and he has created a *Festival Walkway* (2002) for Tridel Co. in Toronto, Canada. Upcoming projects include a commission for the Memorial Art Gallery in Rochester, New York.

JG At the Woodland Cultural Center in Brantford, Ontario, a Six Nations native arts center, you made a sculpture piece in 1992 titled *Replanting T-his-tree*. I guess you were the only nonnative invited to participate there, which is an honor. It also breaks the stereotypes of contemporary native art.

RR That was the initiative of Jim Moses, a native journalist who was taken by my enthusiasm for trying to heal the rift between culture and nature. He introduced me to traditional medicine people who were also very pleased with the fact that a white guy would ask permission to work on their land—because to my mind, physically and originally it is their land. Jim Moses introduced me to Tom Hill, the director of programming, who invited me to participate in AS SNOW BEFORE THE SUMMER SUN, celebrating five hundred years of resistance and survival in 1992.

JG The natives say the trees are their books and the forest is their library. With *Replanting T-his-tree,* you have actually taken pieces of nineteenth-century colonial history books—one story among many—and spliced them to a living tree.

RR I actually pushed them through the tree in the hope that as the tree traces its wounds, it begins to reabsorb the entire contents of the books—the books themselves, the tree itself, a white spruce, was used as a pulp tree.

JG A return to a kind of physics of materials is something that endlessly resurfaces in your works—the physics and energy of place and material. Many of your works lead to early metaphysics. In *Displacement Viriditas* (1992), enacted at the Art Gallery of Peterborough, and *Compromiso Viriditas* in Caracas, Venezuela, you were dealing in a sense with cosmic forces.

RR And human forces. They were also very much about displacement, the fact that this force of nature is continuously displaced to make way for architecture, habitation, development, so-called progress. *Compromiso Viriditas* in Venezuela was a very contentious piece dealing with the ongoing danger to, and exploitation of, the rainforest. Viriditas refers to greening, healing energy, the grow energy of the Mother Earth, first referred to by Hildegarde von Bingen (1098–1179) in the eleventh century in Germany. This goes back to my own cultural roots. The bridge I am trying to build with these works is to take the ethical and environmental position that indigenous people have always had to the land, ideally, to bridge between the respect and care people historically felt to the land in my culture, as in native cultures the world over. What I am stating is the fact that ideally in indigenous cultures the reverence

for the land and nature is as powerful as it is in art. This is not a romantic notion, I think it is what we aspire to.

JG In 1987 at Topsail Island near Sault Ste. Marie in northern Ontario, you upended eight fifty-foot-tall trees, planting them upside down in the ground. The sixty-foot-diameter circle configuration that resulted again refers to the native cosmology, but the circle is likewise a Christian symbol.

RR The circle is a universal form. This piece, called *No Title*, referred to the titling of land. I worked in collaboration with Dan Pine, an eighty-eight-year-old medicine chief from the local reserve there, to create a site where the appropriation of land, the ownership of place could be discussed. By inverting the trees and placing their tops in the ground, I tried to address the inversion of priorities, of what the desire has been, to establish a balance. Consequently the piece became a tremendously controversial exercise in the cultural context of the area.

JG There is also this aspect of ritual that resurfaces in your work. I am thinking of the ancient ironwood tree whose root system you dug up in the Ottawa Valley in 1975. The root system of this immense tree was exposed, yet when the earth was replaced, the tree flowered better than ever. There is also *Wound,* which involved putting beeswax onto the opening scar on the bark of a tree in the Yukon in 1988. This artistic action is pure ritual, a way of building a language of communication between the artist as human and the earth. As can so often be seen in your work, you address the actual site and place. This contrasts how early land artists like Michael Heizer and Robert Smithson displaced land to the maximum to establish a concept, to leave a mark in the 1960s and 1970s. I feel that the great difficulty you had working in that era was that you were dealing with mythology, and that art and ecology had not yet linked in any strong way other than as a conceptual or minimalist-inspired land art. The land art era historically paralleled the NASA space program where the notion of escaping the earth, of leaving the earth to leave a mark on another planet (site), to bring earth garbage to another planet, was as conceptual in its attitude as land art. Your work has to do with a kind of relinking of the human with the land.

RR I use the word *viriditas* in the titling of several of my works. Viriditas was a word used by Hildegarde von Bingen in the eleventh century, based on the color viridian green. She talks about the earth sweating green and that the earth embodied viriditas, draped in viriditas, which is a very erotic and compassionate percept. She felt that eros and compassion were connected, not in the sexual sense necessarily, but in the passion sense. The concepts that she developed in her time are out of step with her era, but are really pertinent to our time.

JG In some of your cast metal sculptures like *A Gathering of Spores,* exhibited at Carmen Lamanna Gallery in 1989, the symbolism and quasi scientism is almost too apparent. Some people saw your work becoming too conceptual or

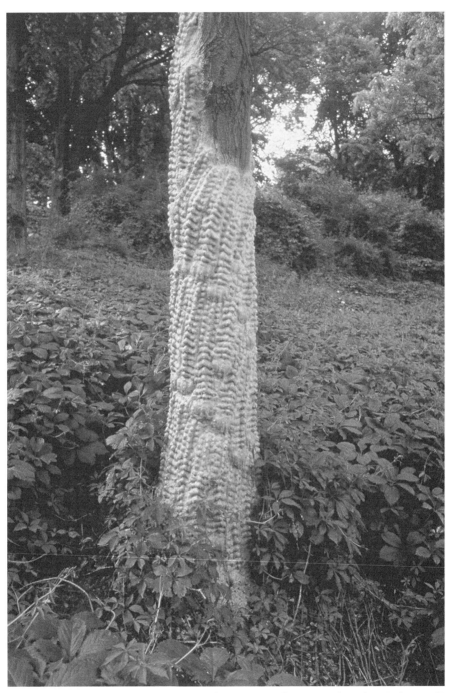

17.1 Reinhard Reitzenstein. *Carolinian Symbiosis*, 2000. Walker Botanical Gardens, Rodman Hall,
Saint Catharines, Ontario. Courtes of the artist.

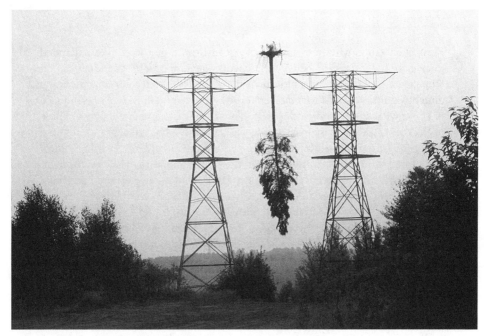

17.2 Reinhard Reitzenstein. *Transformer*, 2000. Cime et Racines Symposium, La Gabelle near Trois Rivières, Quebec. Courtesy of the artist.

ideational, embodying a kind of foggy scientism. They were like expanded microcosmic forms. Yet I believe these works developed a broader dialogue on language and the structures of human thought. The micro- and macrocosmic dimensionality of *Waiting for the Verb* (1987–88), a missile-like silo assemblage of books with barbed projectiles atop, likewise has an alchemical flavor. These projectiles could likewise exist as micro-organisms, a natural adaptation found in nature. Other works from the same period, like *Sweet Drop Yielding* (1986), represent a fundamental disjuncture in the nature and form of human thought.

RR I have been accused of eclecticism and a kind of diverse vision. I celebrate that criticism simply because it reinhances the diversity found in culture and nature that is synonomous with strength and health. If I reflect diversity and it is perceived as disparity, then that's not my problem. I celebrate the fact that the perception of my work is problematic. To address what you asked about micro-organisms, in the contemporary life sciences we talk about the body when being reduced to matter in very essential form in these terms: bacteria being the fauna and the flora being the plants. That is in the body's essential form. That tells me something that native people have always said: "The body and the land are the same place." There is no separation between the inside and the outside. We have now learned that our bodies are composed of flora and fauna. The land around us is an extension of our bodies and is composed of parallel elements in varying scales and intensities. There is a conduit between these so-called separations. Separations are caused by language. In Western European language cultures we tend to create objectified separations in order to identify specific primary elements. But as you name things, you also control them, compartmentalize them, take them out of relational process.

JG There is a lot of objection to this notion that science, so-called objectivity, this process of measurement alters the elements being measured. Things change as they are being observed. Isn't it strange that we see ourselves as apart from what we are observing and measuring. There is this distancing going on.

RR I think it is a product of language again. If we understand that culture is linked to language, the lens of a culture is their language. If this disappears then the entire construct around which that language has evolved is gone. That is why I am using the verb-based thought process in language to offset the hegemony of the noun. It is ironic for an object maker to try to heighten the relational aspect of what I make as opposed to the object aspect. If you make an experiment as an anthropologist and move into a community, that community is forever changed. It is very disrespectful to not acknowledge that you may be affecting that which you are studying. If we intervene in the study of cells or microbiology, we have changed that process in order to tend to our already established rules of analysis. You have thrown a grid at it, imposed a system on what you are supposed to be studying. Nature is volatile and finds a way out. Think of mutations in hospital settings, where micro-organisms have mutated in response to using antibiotic technology. The cells mutate, the

Übermensch, how do they change their response? No life systems are superior to others.

JG *Arbor Vitae* (1997), exhibited at the Toronto Sculpture Garden, was a bronze piece representing a human backbone fused to a tree trunk, an incarnation of the interdependence of human culture and nature. Fused together they support each other. Our ideas of economy are somewhat abstracted from the real economy, which is ecology. We say the economy is going well in today's world, yet *Arbor Vitae* suggests that nature actually provides the substance and support for human culture, something we are not often made aware of due to the prognostications of the New World Order.

RR No question! If there is a plea in my work, that would certainly be to understand more deeply and significantly the symbiosis that is shared between natural systems because we are one aspect of a natural system. Increasingly, we can actually direct the look and the evolution of living things. There is a responsibility that comes with this knowledge that has to be addressed. We need to better understand what it is that we are actually dealing with. It is an area that culture can address—the areas of proof and exploration.

JG Are we really looking at an extension of the human mind when we look at the physical environments our civilizations has produced?

RR If we make a distinction between body and mind, we chose mind over body. Artists have been trying to push us back into our bodies. In the Buddhist tradition, for instance, the body and mind are not separate and in fact the mind is connected to the heart. The body is actually the brain. The head, the mind is related to the body. True intelligence forms a kind of loop between the mind and body.

JG A linkage, a fragile balance.

RR If you look again at language, you realize that Western European languages are noun based, object based and consequently conceptually based. The more traditional verb-based, perceptually based languages involve relational thinking.

JG For *Memory Vessel* in Chile, you actually made a circular cutting in a seventy-foot-long eucalyptus tree. How strange!

RR Eucalypti were exported from Australia to South America and Asia by colonials to produce fast-growing lumber. They grow quickly, create a shade canopy, and do not attract insects. What the colonials didn't see was that in order to grow so hugely they tap all the water under the immediate surface area. The leaves are so highly toxic they discourage any other plants. Southern India and Latin America are full of these forests that have become semidesert, and people have little local water. If they are left to grow, ground water levels are tapped dry; if they are cut down there is massive erosion. This piece is about that dilemma. I carved twelve bowls into the trunk of the tree and lined the bowls with beeswax because bees encourage and embody diversity in the plant kingdom. Then I put milk and blood alternately in each bowl to evoke

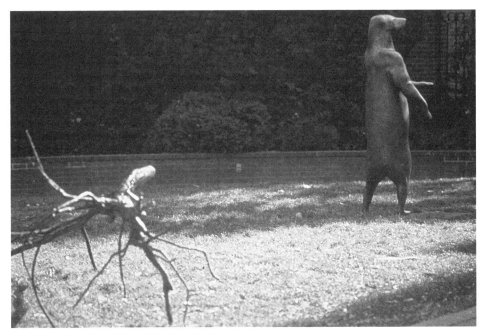

17.3 Reinhard Reitzenstein. *Arbor Vitae* (in foreground), 1997. Toronto Sculpture Garden. Courtesy of the artist.

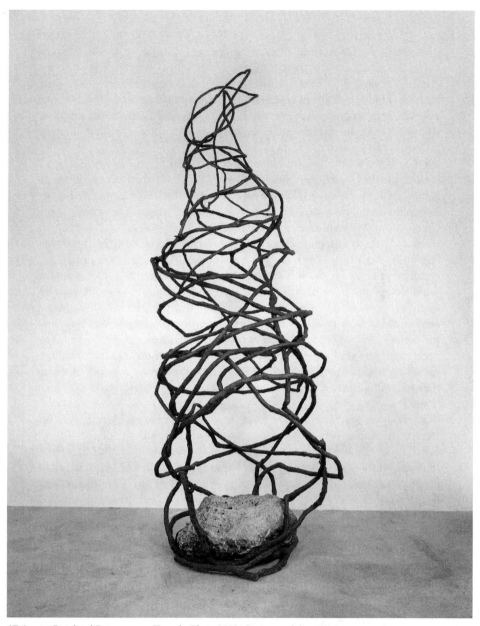

17.4 Reinhard Reitzenstein. *Tornado Chair*, 2002. Courtesy of the artist.

this sort of nurture/torture dichotomy. Being exhibited in Chile, *Memory Vessel* also alluded to the postcolonial dilemma of the years leading up to the Pinochet regime. It is a far-reaching piece, and so outrageously in-your-face. Blood and milk stink after a couple of days! You can't escape the stench of life.

JG Supporting this eucalyptus are other tree sections, like the colonial system.

RR That's right. Propping itself up. I had to put it into pieces to put it up in the gallery . . . to get it into the building.

JG The bowls with milk and blood cut into the eucalyptus tree in Santiago. Again, you had bowls in spun aluminum and steel with steel supports in *Natura/Cultura* at Carmen Lamanna Gallery in 1988. You incorporated olfactory elements to allude to the unconscious revivifying itself. The other *Natura/Cultura* containers are placed in a circular configuration around the central basin with these different sensory, olfactory effects coming from the bowls.

RR Three aluminum bowls, each twenty inches in diameter, contained oil of cedar, oil of lavender, or oil of wintergreen, which respectively referenced the forest floor (wintergreen), the mid ground (floral), and the canopy (cedar), essential forms of oils. One huge steel bowl thirty-six inches in diameter, contained black india ink. The olfactory dimension takes sight and vision into the memory level, goes much deeper into the individual and collective memory. I want the multilevel experience to be very sensory. Odors transmit a catalytic memory provenance of the senses. You conjure up all kinds of things that you ordinarily wouldn't, that you can't do, with the logical circuits of your brain.

JG Tree of life symbolism can be found in a lot of your work. Does this symbol itself work against your search for prehistorical origins and symbols?

RR They can if they become didactic or ideological symbols. With the tree of life you get a symbol that is universal, cross-cultural. The symbol in that case becomes analytic rather than absolute. So when I deal with trees it is because they are essential as a system, a system that has to do the origins of architecture, the origins of the university. According to Socrates they gathered in the forest to talk to the students. So around the idea of culture—the forest, symbolically mythic—and one's encounters within these places of solitude or grandeur are catalytic multilevel experiences.

JG There is a sensitizing to the human body within the space or place that engages us in a vital dialogue.

JG In fact you are alluding to the symbiotic body and its relation to gardens. Is this the original Garden of Eden or a symbolic garden or just any garden?

RR I certainly am not going the Biblical garden route. I think that is symbolic again of our relation to nature in general. The works referred to in your questions were specifically oriented to the garden all gardens. I called them, orthogonally through the garden.These seedlike structures are made of components of nature—vines and cedar leaves—that are actual models based on what I have seen in plants and sense organs in the body at the microlevel.

JG Your work communicates so viscerally and is so obviously visual that it brings an immediate response from the public. I am thinking of *Transformer* (2000), where you inverted a fifty-five-foot spruce tree between two hydro pylons above the La Gabelle hydro dam in Three Rivers, and *The World Tree* where this inverted ghost of a tree hangs inside the conventional 1960s-type architectural well inside the Confederation Center Art Gallery in Charlottetown, Prince Edward Island. The two contexts are diametrically opposed, but the tree is a constant. The inversion of the subject: One thinks of Baselitz's paintings, where he inverts the body subject. What does inversion mean to you?

RR The initial response that inversion creates is that it arrests your attention. It is perceived as extraordinarily unusual. Inversion stops you no matter where you are. Inversion talks about the fact that there is another reality. There is a parallel reality, and that reality is where we all meet. It is subcutaneous, it is cultural, it is subcranial.

JG Nature confronts ideation, human-built structures and energy transmission systems. The public can immediately respond to the visual aspect of your work and yet maybe that is all we need. Maybe good art only has to do that. Why do so many artists try so hard to develop an intricate and complex, even inaccessible language?

RR There are many ways to answer that question. The hegemony of academe has forced itself upon art, allowed art to become part of its matrix. To justify its relationship it develops a language-based response. This academic response has to prove itself within the diachromatics of language, whereas I am involved in catalytic responses to things. My work exists catalytically in order to create a parallel visceral response in your body, in your person. Whatever your cultural baggage may be, you cannot escape the reality of what it is I face you with, and that reality exists in something as tangible as yourself.

JG More than anything, your work occupies a real physical space in real time. And this is something that is diametrically opposed to a lot of postmodern art that says everything is hypothetical. Even the creation of artwork is seen as hypothetical.

RR Even though I have a great deal of respect for the attempts people made to create a common language, a kind of transnational language, postmodernism is an art movement that is in parallel with the multinationals. If you accept the postmodern paradigm, you also accept the possibility that you are being intellectually colonized. Just look at the hegemony of French culture. France has lost some of its economic and political influence, but it has not lost its cultural clout. One of the last vestiges of its colonialist enterprises is its grasp, hold, and control over current discourse. I refuse to be colonized intellectually or forced to become an illustrator of something that I am not.

JG Each individual's response to the world around them is legitimate and justified. Diversity counts! Each artist's response is legitimate and justified as

well. Any attempt to control discourse or to unify it will fail in the long run, because cultures are diverse, and that's how they grow and evolve. Even a philosophical discourse that is monocultural or seeks to unify expression into a hermetic theory-based paradigm will, in the end, do itself in by just boring the hell out of people Developing a self-reliance actually turns people on to do great things. We can create an economy that is self-reliant and regenerative. It is a much more exciting prospect than maintaining a growth economy that exhausts our natural reserve. At this time, the Kyoto accord is on hold. The new global economy seems to be moving in the opposite direction, encouraging wholesale abuse of resources and overproduction without considering natural capital as a fundamental principle of economy.

RR Unfortunately that directive is a very linear one.

JG Where's the democracy in that?

RR In the forest!

JG Nature is democratic and more powerful than human culture. It is denied by the world leaders. . . . Japan, America—any country that is performing at a high economic level—will deny that because it is antithesis to the very notion of overproduction, or so-called high-performance economy.

RR If you deny that you are in control, you lose control. Hierarchically, practically, and ideologically you can't survive by admitting this. We know that our allies are not the people who are in control because they will not admit this.

JG Your *Lost Wood Series* of benches cast in bronze from grapevine assemblages made for the Loblaws's *Dream Garden* have a wildness aesthetic to them that is immediately appealing. Wildness has always been an important facet of your work, as is the incorporation of active chaos into artmaking, something that links it to nature's own processes.

RR Wildness is the one thing we cannot track. It cannot be measured. I am learning to allow my mind to be open to its own intuitive process and earth-based realities rather than the definitive rule.

JG The problem with capital *H* History and capital *A* Art persists. We are still trying to wrestle art out of the museums, to remove the walls that confine artistic practice.

RR That's right. We talk about diversity in art, as in nature, and I celebrate diversity. The edge at which life forms come into contact with each other—the edge of the river, the edge of the ocean, of the forest—that riparian edge is the place where there is the most activity, the most fecundity. If my work is going to be located as being marginal, then I interpret marginality as the riparian edge.

JG That gives you a great advantage!

RR It also allows the greatest amount of freedom.

JG I am impressed by the innovations of an artist like Friedensreich Hundertwasser, who created a whole language of organic architecture, now imitated by

architects. Putting trees on building roofs, refurbishing the exteriors of industrial buildings with color, form, decorations. Regenerating buildings rather than destroying them, making organic living spaces, with walls and floors that are curved, not flat, roof gardens. A whole new area for artists to explore in the real environments we live and work in. This idea of developing an organic city state out of organic living space.

RR I am interested in this possibility of organic systems, of biological shelters, cavities that can be seen as architecture, a symbiotic response that innovates and integrates without destroying nature . . . the living house idea.

JG The combination of new technologies and organic design using living materials could be a way of approaching this. Friedrich Kiesler's endless house was a prototype for this. Correalism, for Kiesler, circumscribed artistic activity as the mutual competition between species for energy, food, shelter. Wouldn't it be more interesting if we built a world where nature was celebrated rather than denigrated? Parks in our cities with wilderness integrating indigenous tree and plant species from the immediate regions.

RR At the root of these quandaries is our lack of relational understanding.

JG Something unprotected survives better than something that is protected.

RR The more likely it is to produce superior life forms. Viral bacterial cultures are decimating populations to remind us to be humble. Being humble in relation to something else is healthy. In all of my works, I try to heighten the experiential aspect of the relationship you suddenly feel between you and what you see as something else.

EARTHBOUND MYSTERY
Ursula von Rydingsvard

Born in 1942 in Deensen, Germany, Ursula von Rydingsvard builds cedar sculptures that range from small works, reminiscent of tools or domestic objects, to large-scale walls and environmental installations. Ursula von Rydingsvard's heavily carved wooden sculptures are imbued with a strong sense of human identity and a memory of the land itself. The layering effect seen in her largest works suggests a sequencing or natural process we might associate with the passage of time. In 2001 von Rydingsvard installed a new large commission at the Queens County Court House in New York. During the summer of 2001 her large outdoor sculpture *ence pence,* was exhibited at the DeCordova Museum in Massachusetts. Her outdoor sculpture has been exhibited at the Nelson Atkins Museum in Kansas City, the Indianapolis Museum of Art, Koln Skulptur Park in Cologne, Germany, and in Central Park, New York City.

The siting of works and use of earthbound materials make von Rydingsvard's sculptures most interesting for they establish a rapport between nature's history and human history. Memories of farm life and agararian roots in Poland, of survival in German refugee camps, and of simple wooden churches, implements, and dwellings, establish an unusual rapport between the primary materials derived from nature and the social and cultural history of her own family heritage. Sensitivity to site likewise plays a role in Ursula von Rydingsvard's sculpture, as does the use and history of language.

JG There is an uncertainty in your work. You take shapes, put things together, reassemble and carve the forms, but they remain tentative. It is as if you believe there is an inherent ambiguity in the structures themselves. The wood and materials you use have a structure of their own, and you recombine them in a kind of additive process.

UvR That's right. The material—and this is so important—doesn't even look natural. The cedar gets cut into long beams 4 inches × 4 inches wide. I feel that

this is a neutral form. ' . . . I therefore don't have to respect it too much. I can take control of it.

JG A standardized form you are working with and bringing it into a natural or archaic configuration. . . . Many of your pieces have a gray chromatic finish that achieves a kind of unified surface effect. You talked about wearing gray clothes as a child and never being able to forget this. Does the gray surface color allude to these childhood memories? Do you get a sense of security from it? There is also a kind of joy and muted exuberance that surfaces in the way you bring these materials and forms to life. The result is a unique and complex kind of art that asks questions and doesn't provide the answers.

UvR That's right. And I always try to be even more questioning because I don't want to arrive at any conclusion. There really is no such thing. The piece I am presently working on is another little letter. I am fooling around with it but have no idea where it is going to go.

JG You call these works letters?

UvR Yes. This one is actually the letter M, or at least it started as the letter M. It's bottomless, as if I wanted the lace to be deep. In fact it is no longer lace, but something else. It is like a series of layers or strata. Some of them you cannot see. They are hidden and occluded, all texture and surface.

JG Do you like working with wood?

UvR Wood is my way of speaking. I can communicate through it. It is good to me when I use it right. Sometimes it drives me nuts. I am wise and mischievous about the way I mobilize it, but I have also been lazy with it. I have had all kind of relationships with it. It feels really familiar. You see I come from many generations of Polish farmers whose lives were surrounded by wood—their homes, domestic objects within these homes, as well as farming implements.

JG Are you echoing those agricultural links to the land? *Paul's Shovel* (1987), *Large Bowl with Scoops* (1999), or *Comb with Inlays* (2000), for instance, like many of your works have a folklorish aura to them. Maybe it is not a nostalgia about the land, but more an identification and reclamation of that identity.

UvR That is a good way of putting it. It might almost be on the noble side. I would never verbalize it that way. I say it in my own way of thinking. . . .I want to make something that feels exciting to me. That may sound vague and small, but to me it's not so vague. To me it is specific, and it is especially productive if I have done something that raises other questions.

JG You let the materials have their own voice in the expression and don't impose. While there are your traces and surface markings, you identify with and respect the wood for what it is. It allows a kind of anonymity to enter into your work that's childlike and joyful. We don't immediately seize the form. The vernacular language and cultural-specific references are your own. Each piece of wood is like a phrase, the combined sections are like a paragraph, and the whole thing together becomes a fragment of a story. The language uses

standard elements, but the overall tone and inflection is of a more complex history and collective memory.

UvR I am really kicking my work into wayward places where it shouldn't be. I do not want to impose my will too heavily on the direction of the work.

JG *Song of a Saint (Saint Eulalia)*, this collectivity of totemic forms you made on the land at Artpark in Lewiston, New York, has a simpler identification. It says: "This is here, this has a presence and that presence is temporary." The poles make you think of sacrifice. One thinks of mediaeval folk carving and crucifixion scenes. And these poles have bodies, tiny bundles attached to them. It is like a collective tragedy, but not from a war, more about the human condition in general. With your more recent work, the surface effect and process becomes more intricate, but the sense of physicality remains intimate, like a conversation with your inner persona.

UvR I agree with you. The later work is much more complex. *Song of a Saint* is a very early piece that I named after Saint Eulalia. Federico Garcia Lorca, I believe, wrote that she was burnt, maybe not at the stake, but she endured some horrendous death. He goes into beautiful poetic detail about the falling of the ashes on her skin.

JG Your sculptures have an enigmatic presence that builds links between cultural and social activity on the land and in nature. *Koszarawa* (1979), exhibited outdoors at Wave Hill in the Bronx, has these carved forms that are set on top of one another across the land like cow fences. Their zigzag arbitrariness is humorous, particularly as the ends are elliptical and people have to deal with that.

UvR The elliptical ends are sexy.

JG You have often integrated the sky and horizon when siting your work. In *Saint Martin's Dream* (1980), there are these standard wooden supports and a kind of flutter of wood above each of them. The sky and horizon become an active part of the piece.

UvR *Saint Martin's Dream* is about 260 feet long and was installed in a man-made landfill site, which is now Battery Park City. I couldn't have done this on a sand dune made by nature, because I would not have been able to control it in the same way. I raised the little armlike sections up to the horizon, which had the whole financial center of New York in the background with the Twin Towers of the World Trade Center. The little arms are groping whatevers. I wanted this contact with the backdrop of the anchored geometry of skyscrapers.

JG There is an illusionary aspect to *Lace Mountains* (1989). It has a kind of persona, and seems to grow out of itself, always with these recombinant shapes and forms.

UvR That is one of my favorite pieces.

JG *Maglownica* (1995) has a kind of modesty and humor to it—sections of wood joined with a verticality that makes you think of a cruciform. Most of the

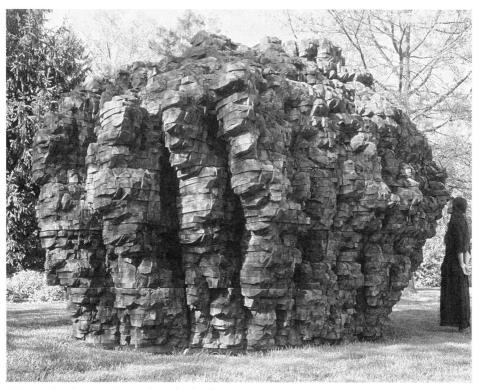

18.1 Ursula von Rydingsvard. *Bowl with Folds*, 1998–99. Cedar and graphite, 12 × 16 × 16 ft. Courtesy of
the artist.

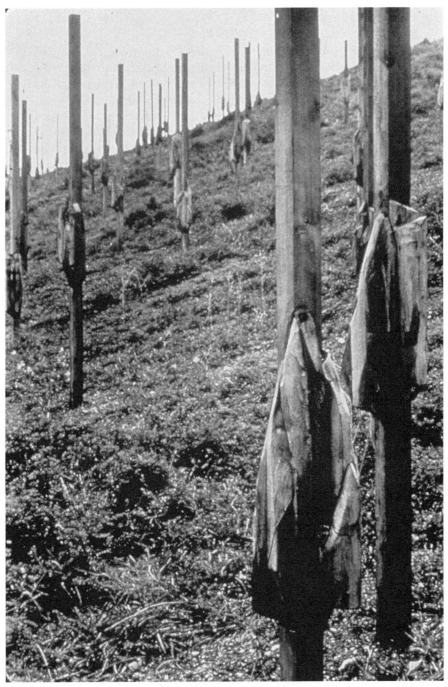

18.2 Ursula von Rydingsvard. *Song of a Saint (St. Eulalia)*, 1979. Cedar, 12 × 330 × 160 ft. Art Park, Lewiston, N.Y. (Destroyed). Courtesy of the artist.

piece is wrapped with cows intestines. The stretched skin suggests pain and suffering. It could allude to the structure of religious hieratic thinking that the skin (which we could take for human) is stretched over this very bumpy cedar plank structure. It resembles a human torso, bandaged over.

UvR The title comes from the Polish word for a paddle—a long wooden paddle with a corrugated flat side. At one time, the linens in Poland were very harsh. When they were still damp from the wash, the corrugated side of the paddle was repeatedly run against the sheet, wound around a wooden bat, to soften the crudely woven fibers. There is a Polish folk song in which a woman's lover goes to war in a faraway place, and she yearns to be with him. She sings, "If I followed you, I would use not a wooden Maglownica but one made of gold."

JG *Ocean Floor* (1996) conjures up the sense of a place we cannot see or go to naturally, yet the ocean floor is like a bowl. This piece you made is a very human one that also resembles a natural form that ironically contains nature within it. This ocean floor we cannot naturally see is what gives life to this form. The bladder forms look like the floats the Inuit use for their fishing lines and embroider the edges of it, grounding it.

UvR When I first exhibited *Ocean Floor* at Exit Art, it was for a show about sound and form. People actually sat inside the bowl and had to participate in the experience. If they talked inside the sculpture it echoed and reverberated. The sound of your voice actually changed as you moved upward from the bottom of the bowl.

JG The energy of nature is the energy of art.

UvR The interesting thing that you are bringing up is that it feeds the cycle and is an important aspect of keeping that cycle of life going, with its beginning, middle, and end.

JG *Five Cones* (1990–92), at Storm King Art Center in Mountainville, New York, almost reminds me of capitals. Corinthian capitals, but natural ones. Your imagination becomes engaged and sees things, finds them in it. There is a sense of natural growth in these forms, like the spoken word. It starts with a base, and as it proceeds upward it takes on its own life.

UvR I would rather shoot myself than to follow whatever design I made. I haven't designed anything really—as this feels like dooming myself toward a contrived end. By not making a model, I get a thousand chances to feel my way in the process of building. It's like reaching toward the sun. It can be all I need. At Storm King they have given me a new site on a much lower level so that one can look down into the deep openings of the bowls or tunnels. People thought this piece was a solid chunk before. It is like a deep honeycomb, all the way down to the bottom.

JG There is this respect for the land in *Iggy's Pride* (1990). You are reflecting the forms of the mountains that one sees in the background on the other side the valley. There is this respect for the land forms that are there. The art opens

up the space even more than it is naturally. These parallel forms with the many different erosions created by the artist are kind of laying there, looking out on the other side of the valley. It is a very modest integration that still leaves traces of the human presence.

UvR Yes. I made it on the Oliver Ranch in the Sonoma Valley, California. Steve Oliver, who commissioned the piece, doesn't really want art objects and I feel there is something very courageous about commissioning outdoor sculptures. Its so different from the stuff you hang on the wall. You can walk between the wedges and don't feel overpowered. You don't feel any aggression when you're around them.

JG You have achieved a very subtle balance. It doesn't dominate, and instead fits so neatly into the land surface.

UvR Internally, I hate when an artist creates contrived impositions on the land. It feels unnatural and depressing. *Skip to My Lou* (1997), at Microsoft California Main Campus, is another work that uses letters. I built them up from letters and a dance that I did with my assistants. We all held hands and I drew around their feet. I drew a plumb line from their elbows down to the floor at the point their hands joined. I made them go around in a circle in a very rugged way, very quickly, and had them stop, then drew the points. That, in part, is what influenced the configurations in *Skip to My Lou*. Another influence was an Indian tribe who lived there. I saw some of the rattles and boxes they had made. Their understanding of the ocean, of the way it worked, felt so profound, and they indicated that on the surfaces of the boxes. So that there is a little bit that I took from that, but it is really a much more complicated mixture. But those three things—the letters, the dance, and the Indian artifacts—all affected my making of the piece.

JG The coastal tribes used to follow the top of the wave when they were traveling by canoe, so less energy was used. They never fought nature's energy. They followed nature's energy lines.

UvR That sort of summarizes their life's philosophy.

JG There is this language thing again, folding in the culture . . . it's like the writing process. At a given point you are no longer in control of it and a spirit energy enters. The rest is automatic and the words come as if by magic.

UvR I think that is kind of what the creative process is. *Mama, your legs* (2000), one of my most recent pieces, was so much fun to make. It has all of these bowls and seven motors that lifted the solid cedar inner portions of the bowls up. I call them thighs, but they are really like mortar and pestles that get lifted up and down slowly—all at different times. You can hear the sound of the wood hitting against wood. There is an echo, a really dull, laborious echo that you hear again and again. There is this point where you almost disavow that you really had that much of an input. It's a search, a groping. You become a vehicle. It is the life of it.

JG It is a struggle.

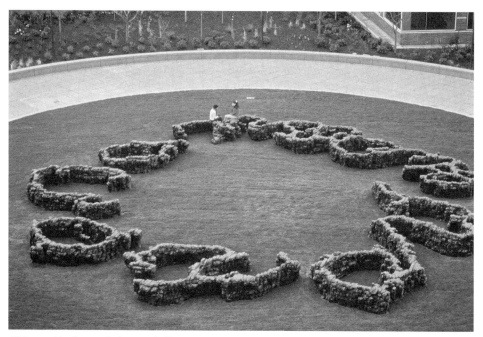

18.3 Ursula von Rydingsvard. *Skip to My Lou,* 1997. Cedar and graphite, 3 ft 6 in. high × 67 feet in diameter. Courtesy of the artist.

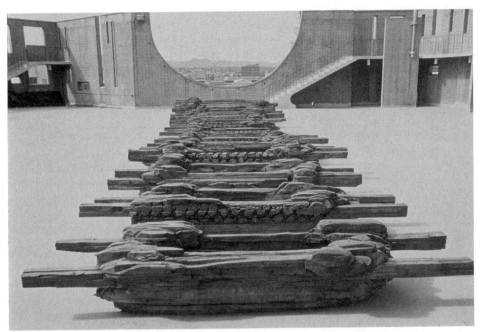

18.4 Ursula von Rydingsvard. *Slepa Glenia*, 1994. Cedar and graphite, 13 pieces @ 3 ft. × 3 ft. 4 in. × 14 ft.; overall dimensions: 3 × 14 × 150 ft. Courtesy of the artist.

UvR And the struggle is recorded and it is the life of it.

JG It all begins with such a simple premise, and the forms grow almost organically out of it like flowers.

UvR Like a seed.

JG By chance or accident? Does accident play a role?

UvR It feels like writing a letter freehand on a blank piece of paper—without any lines. I am just dropping these little wooden knobs in a way that feels natural, just wandering from left to right. There is a connection because my body does the throwing and I don't linger too long. So there is some record of the way your body travels through the earth. It is almost (I just thought of this) it is almost like planting seeds on the ground.

19
HEALING GARDEN
Mike MacDonald

Mike MacDonald's installations are direct evocative presentations in defense of nature. Best known for his video work, he also does photography, works on the worldwide web, and has been planting gardens that attract butterflies on the grounds of museums and galleries across North America. Quilt and video works have grown out of the garden projects. Born in Sydney, Nova Scotia, Mike MacDonald moved to British Columbia in 1977. His first years there were spent making environmental and antinuclear video tapes. As well as addressing concerns over the preservation of the environment, Mike Mac-Donald has also worked directly with British Columbia's native peoples on land-claims issues. In Hazelton, B.C., he documented the testimony of elders for the Gitskan Wet'suwet'en Tribal Council's ongoing land claim.

Merging a political and social conscience with native traditions, Mac-Donald uses technology as a healing medium. Largely self-taught, MacDonald has exhibited his *Electronic Totem* at the Vancouver Art Gallery (1987) and the Ksan National Exhibition Center (Hazelton, British Columbia, 1988). His *Seven Sisters* video work, presently on view at the Art Gallery of Ontario, was earlier exhibited in the Canadian Museum of Civilization's Indigena: Contemporary Native Perspectives show. MacDonald has exhibited his video installations in the United States, completed garden projects in various Canadian locations, and was presented with the first Aboriginal Achievement Award for new media by the Center for Aboriginal Media in Toronto. As MacDonald states: "I am a video installation artist in the U.S., an artist/gardener in Canada, and an Indian in cyber space."

JG Mike it is a pleasure to talk with you about issues of technology and permaculture. I would consider you to be one of the contemporary artists who is making breakthroughs in using technology for spiritual purposes, as well as generating gardens and permacultural installations—I guess they could be called that, but they may just be what they are in place. In general we think of modernism and we see this kind of lineage of artists with their movements

making breakthroughs and so on, but a lot of the search for meaning involves a desire to attain a higher spiritual order. In a way artists became almost like preachers. We think of the abstract expressionists or the Cubists, and so on, explaining their times in various ways. Ironically a lot of pre-Columbian art, native Amerindian, became the source for Henry Moore and abstract expressionists like Barnett Newman. And yet these artists considered their art of a higher order than mere fetish objects. I doubt they would have admitted that art they produced somehow embodied a message of historical and materialist progress. Indeed, while nature remained a source, art effectively relied upon a distancing from nature. How do you feel about it?

MM I am inclined to think of a large colored pencil work by Vancouver artist David Ostrem. It shows an artist in his studio pausing to think while working on a piece, and the caption is: "God wonders if art isn't just another way for the middle-class to deal with their guilt." You did not use the A word in your question, but I guess we should talk about "appropriation." Emily Carr has often been accused of it, but she was working at a time before the concept of appropriation as we currently understand it had even been defined. She was given an Indian name, Klee Wyck—the laughing one—and was thus accepted into the culture.

One cannot be appropriating a culture if one is a part of it. She also understood the culture very well and, in an essay she wrote for the *McGill Quarterly*, she explained the native approach to art with a prayer to ask the spirit of the living tree to stay with the object made from it. If masks, spoons, and bowls can contain spirits, why not stories too? Perhaps having the talent to tell a story well is more important than the ancestry of the storyteller. We talked a lot about appropriation in the eighties and nineties, and though the discussion seems to have become more rare, appropriation never seems to fall from fashion.

JG I think that a lot of art has as much to do with fashion and the look of things as it has to do with a kind of search for breakthroughs or a higher meaning. In a way we almost have an over-production situation, where art is fine and society is in bad shape. It is one of my main concerns right now, The programs are working. Artists are producing. But the actual society is breaking down in many ways as a collectivity and becoming digitalized. We have become digitalized producers and consumers.

MM I sometimes think that people are seeing butterflies more frequently on the web than they are in real nature.

JG That's right. The loss of this tactile, experiential side of life is happening at such an early age. I know there are fears of violence and so on. But by avoiding this and trying to hide our children from these problems we may actually be contributing to the overall problem of a loss of social context and direct experience. I have always found your own videos like *Seven Sisters*, which I saw

recently at the Art Gallery of Ontario and for the first time in the Indigena show at the Museum of Civilization, to be a fascinating work. The images in various-sized video monitors of West Coast mountains played with the space between the monitors. In a way it activates that space between the monitors, through this strange formatting and sizing of the piece as a collective seven-monitor piece. Are you reflecting on the immediate experience of the viewer as well as the imagery of pristine nature that you are projecting?

MM I videotaped these images in the Seven Sisters mountain range near Kitwanga, between Terrace and Smithers, in north central British Columbia. The area was threatened with clear-cut logging. I was in that area working for the Gitskan land-claims case. It was there that I really became enamored of butterflies. I was working for the tribal council with elders and attempting to preserve the knowledge about traditional native medicines and their uses and the names for them in the native languages. I went to an elder one day because as I was videotaping and photographing their traditional medicine plants I was getting more and more butterflies in my pictures. So I took some of these pictures to an elder medicine woman and showed her. It was a wonderful visit, and she explained that butterflies are to be treated with the utmost respect because they represent the spirits of the medicine people who have passed on. Another day when I was not feeling very well and had visited her for tea, she told me: "When you are not feeling good you go find a butterfly and follow it and it will lead you to a medicine that will make you better."

JG Since that time you have been making a series of quilts as well as project-ing imagery of butterflies. *Touched by the Tears of a Butterfly*, a video that I saw, is a very eloquent and rich piece. It is a powerful work that works in microcosm almost like Yoko Ono's *The Fly*, but your work is not at all modernist. It develops its own narrative within its own context. In that sense it is not modernist or postModernist, but more a narrative. We see close-ups of but-terfly wings, leaf fragments, and so on, but there is a lyricism, a build up of tension that develops in the work that has very much to do with the essence of life itself. Can you tell me something about how you came to the idea of producing this?

MM I was living in an old house with a beautiful garden in Vancouver for about fifteen years. The people who had previously lived there had paid attention to growing things that the butterflies liked. It occurred to me that it would be easier to photograph and videotape butterflies if I studied and grew the plants that they liked. As regards the style of my work, I do long shots compared to those used in broadcast television. A thirty-second commercial will use many shots, but most of my individual shots are thirty seconds or longer. I want people to slow down and think about things. In fact, each of my shots is like a commercial for nature.

JG And you have since done numerous butterfly gardens across Canada.

19.1 Mike MacDonald. *Lac St. Jean Butterfly Garden*, 1996. Métabetchouane, Quebec. Courtesy of the artist.

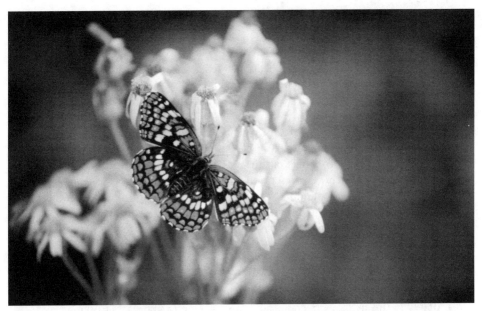

19.2 Mike MacDonald. *Checkerspot on Senecio,* 1998. Golden, British Columbia. Courtesy of the artist.

MM Yes. I believe there are eighteen of my gardens from coast to coast. Most of them still exist but some have been allowed to return to nature, where they were grown in pots and so on or as temporary gardens.

JG I find that native culture generally viewed the process of making and working with objects as an ephemeral one. These things, whether clothing, object, architecture, or ritual masks, would eventually return to nature. It was a regenerative and cyclical system. The idea of ritual in daily life was as much about appropriating the spirit of things as it was about the reification through representation or hybrid representation of spirits and personages as images. Do you feel that, in the long run, the hope is that we can learn to understand the common denominator between cultures? Is this what you are working on trying to develop—a new narrative that is transcultural?

MM You know, with these new gardens, I am hopefully providing a space where people can focus on and think about questions that I feel we need to think about so as to come up with some better alternatives. Our cities are becoming pretty ugly in terms of what happens there.

JG It is the myth of freedom and this anesthetic approach to public and private space that has developed with the increasing regimentation of property and ownership. Public spaces are degenerating. Moving toward living artwork which you have done with your gardens,—is an effort to generate a new healing.

MM Yes. Living here in Winnipeg, there is not a week that goes by that we do not read about someone being stabbed, someone being shot. For the most part it is young people who are doing this, people in their late teens or early twenties.

JG So there is some kind of hole in the soul of this culture that we haven't put our finger on.

MM Driving through downtown Winnipeg, I love many things about the architecture of it. But stopped at a red light, closing my eyes for a moment and imagining what it was like when the native plants grew there and butterflies flew there, it seems that it was a more integrated and healthy environment than now.

JG In a way we need to move slower and reflect on life, to have time and space to see the deeper meaning.

MM I think if we paid more attention to the subtleties and what nature put into the environment and brought more of that back, we might have less violence and a happier existence.

JG Well, nature is the house that supports us all. We sometimes forget that. The same thing can be said for the world of art. What really nourishes art, more than ideas, is the physical world, and it is the main sustaining feature of any kind of aesthetic, even so-called immaterial ones.

MM Yeah, but for me as an artist if I didn't occasionally have the kind of conversation we are having right now, I wouldn't enjoy as much either.

JG George Sioui's book *Towards an Amerindian Autohistory*, mentions that the white colonial culture has many aspects of Amerindian culture in it that it cannot even perceive, due to the many centuries Euros have lived in North America. Yet in our art, we always talk about this myth of originality. I feel that it may be possible to be more original by not ever considering what one is doing is original in art or any endeavor for that matter.

MM I do not know the elder's name, but an expression that came from an elder and that I heard many years ago often comes to mind. His comment was that the crime on this continent was not putting us into boarding schools, abusing us, and beating our language and culture out of us; the real crime and great loss was that the people who came here didn't adopt the culture of the land.

JG They applied a technology that came from a different place and forced it on the natives. When we think of the distortion of potlatching that occurred after contact on the West Coast, for instance. In a way to see these artifacts—the masks, basketry, boats, totems, all these facets of a living culture—put in a museum, boxed, and decontextualized like products. I went into the Royal Ontario Museum recently and what did I see, not one Buddha, but forty Buddha's from different sites, all crowded together. Each on their own lotus leaf. Overproduction again. Where is the sense of the sacred, of the meaning or spiritual aspect these sculptures once had in this voyeuristic context?

MM Currently there is a show of magnificent huge sculptures outside the Winnipeg Art Gallery. And there are so many of them at the gallery that its like a warehouse. They don't have the space they need so one may approach them from a distance and take in what the artist is trying to say through them.

JG Yeah. Sometimes all you need is one or two to get the idea across. The same applies to artistic practice. With limited resources, good ideas develop. But with a surfeit of information and matter, as Neil Postman says in *Amusing Ourselves to Death*, we have actually become incapacitated; we don't rely on our own thought processes because of the data overload. It actually ends up scattering people's resourcefulness and productivity.

MM Right. Living our lives.

JG So technology affects our lives directly. Your healing garden initiatives put people in touch with their feelings, encouraging them to change real physical environments for the better. The gardens are prototypes that stem from the indigenous cultural experience. They can help to inform us as to what can heal us, in this time of great pain in North American culture.

MM It is always a great treat for me to talk about these issues, with people such as yourself, with a depth of understanding and a talent to articulate it in ways that make what I am trying to say more accessible.

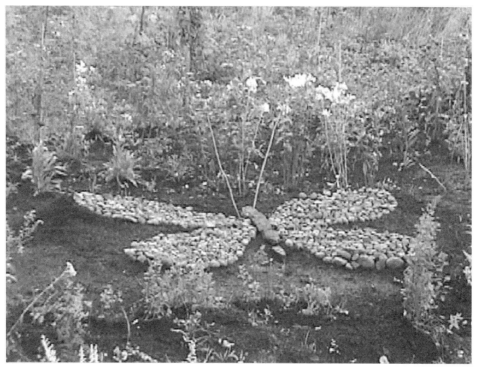

19.3 Mike MacDonald. *Garden at La Gabelle Hydro Dam*, 2001. North of Trois Rivières, Quebec. Courtesy of the artist.

19.4 Mike MacDonald. *Bridge Garden on the LaSalle River,* 2001. South of Winnipeg. Courtesy of the artist.

20

CHANCE & CHANGE
herman de vries

herman de vries' sense of a transcendent unity is both mystical and functional. Texts of Zen Buddhism and the Hindu verses of the Upanishads influenced his early artworks. In 1959 he made his first *white painting*. Typically this resulted more from de vries' reading of philosophy and mysticism than the happenings of the artistic avant garde in Europe. Trained as a scientist, de vries continued through the 1960s to work as a researcher at the Institute of Applied Biology in Nature in Arnhem, a post he held until 1968. His artistic output in the 1960s existed entirely separately from his scientific work, although randomness and chance, which appeared as a major theme in his art, would have been encountered in the use of random number tables and the statistical design of biological experiments.

de vries' belief in the capacity of art to communicate and his sense of objectivity led him to abandon the use of capital letters in his writing over a period of forty-five years. herman de vries' texts are never capitalized, as he seeks to avoid any hierarchy of words, language, and structure. In 1988 de vries published a book titled flora incorporate. Each page gave the name of a plant species that he had eaten as food or taken as tea, medicine, or drug. The book listed 484 plant species. As de vries comments: "taking in our food is participating in the unity of existence, the world." His installations often have a scientific or objective aspect to them and involve collecting elements or objects or plants. More recently, de vries has presented a design for the development of the Weeribben nature reserve in the northwest Dutch province of Overijssel, a project de vries views as an integration of various scientific disciplines, concrete art, and philosophy.

JG Moving from botany into art at the age of forty is quite a transformation. What drove you to get into art making?

hdv in fact I started painting and drawing as early as 1953, about a year after beginning work for the plant protection service. i did research work on the biology and geographic distribution of mice and rats and their extermination

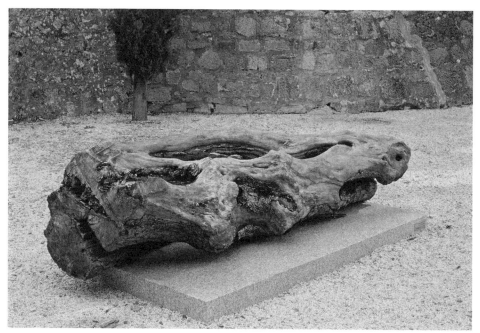

20.1 herman de vries. *the witness*, 1991. Trunk of an olive tree, 220 cm. Parc de l'Espace de l'Art Concret, Mouans-Sartoux. Photo: Jean Brasille. Courtesy of the artist.

20.2 herman de vries. *ambulo ergo sum* (a phrase from the philosopher and mathematician Gassendi). Detail from *sanctuaire de roche-rousse*. Alpes de Provence, Digne. Photo: Nadine Passamar Homez. Courtesy of the artist.

there and was not satisfied with my scientific work. i felt it was incomplete in its approach toward reality. my first art work was spontaneous abstract painting, later informal.

JG The *white paintings* you began making in 1959 are very minimalist, not expressionist, and more purist in inspiration. Was this series a way of bridging the transformation into artmaking and out of science, and a way of discovering some essence? Did philosophy play a role in bringing you to this way of making art?

hdv under the influence of suzuki's books on zen buddhism i reduced the color and expressivity more and more until I came to empty white paintings without any form, but i followed different tracks in my early work. so from about 1954 or 1955 i also made collages. the beginnings of these were original: my fascination with the fragments that remained of advertisement walls in paris. i was later influenced by the works of kurt schwitters, always playing with used, thrown away, weathered parts of reality, found on roadsides, litter in the forest, and so on. there was a strong trend toward reevaluating things which lost all value: "what is rubbish?"

JG You also created works that involve a musical component.

hdv yes. it began in 1962 and '63 with bird voices, recorded with a large one hundred centimeter parabole microphone i borrowed from the institute of applied biological research in nature. in the morning at about 4:30 am i would record them in a place with many gardens, bordering a large forest region. it was in fact a kind of *z e r o* work—no composition, no selection—just recordings. these recordings were reality-music: *natura artis magistra,* a title derived from the full nineteenth-century name for the amsterdam zoo, usually called artis. the next tape i made was *humanae vitae* in 1963 at a busy street corner with traffic lights during the morning rush hour when people go to work and trucks are entering and leaving the city. later, in the early 1970s, i recorded six little waterfalls in a small brook. the waterfall phenomenon had fascinated me for a long time as it is always the same water in the same stream, but manifests itself differently under different conditions. at the time i could sit for hours near the proximity of little falls contemplating their reality/actuality. it parallels other processes and existencies. later on i added other water sounds such as rain, coastal breakers, surf, the sound of dripping water in a small forest spring, produced in a record as *water—the music of sound.* it was all expression of our reality and there was nothing to add, nothing to change, complete information and poetry, perfect.

JG In 1970 in the Seychelles, you made the first of what you call your "real works," *collected mahe, seychelles, august 1970.* There are traces of Paracelsus, even of your earlier botanist beginnings in this approach. Since then you have collected other elements—leaves, flowers, stones, grass, and earth—for other works. One of the most ambitious of these is *natural relations* (1989). Are these phenomenological installation works a way of bridging the gap between what

226

we humans call creativity and nature's ontological processes, which likewise involve constant transformation?

hdv *chance & change* was a word pair i came to formulate during my travels, in the summer of 1970, in teheran. it led me to make a lot of documentary work. i used to call this "reality as its own document." change is everywhere. nothing remains the same. every manifestation is a new one. every moment is new. nothing is stable. the process is durable. douglas huebler called this "duration." i call it 'change'. duration and change are the same as "fact." change brings chance. without changes no chances. things can be different but can still be identical, an embodiment of the world as fact, as happening.

my publication *chance fields* (1973) shows that our chances are endless.[1] the only limitation is the conditions of the chance field we are in. poetry became truly concrete at the moment i gathered a handful of shells at the beach of mahé. the theme "different and identical" was started with that small work.

natural relations consists of approximately two thousand samples of herbs, seeds, roots, bark, and plant substances from morocco, india, senegal, and the village of eschenau in germany where i live. it evidences many relationships that connect us to our original life-space. it's a connection that is in danger. i dedicated the work "to that which is forgotten." we are living beings only because of what we eat, drink, and breathe. the conscious union of our organism with our life space is re ligion (the original meaning is derived from the latin: to join, to link, to connect, unite). it is yoga, from the sanskrit root yuj, meaning to connect, to join. taking in our food is a way of participating in the unity of existence in the world.

JG Your use of water as a component of your work, recording the sound of streams and movement of water, was truly breakthrough material as a nature-art interaction. Again, with your "real works," reality is reified. . . . Nature is an active participant in the process.

hdv water is in all and everything that is alive. the sound of a brook, the sound of six miniature waterfalls, each has a different sound and a different identity. each is formulated by different circumstances, under different conditions, but still it is the same stream, the same water! i will only exhibit what I have seen, found, and collected. so the work is from nature, and the role i play in "my" works is modest. it is simply a presentation of these facts, of the result of processes, of "the process."

JG In the mid-1970s, you arrived at a point where you decided there is no such thing as chance, that we are simply incapable of recognizing the multiplicity of variables that are occurring simultaneously and influence the world we respond to on a variety of sensory levels. This instant and continuous evolutionary process is part of the reality of nature. With this realization, you went on to create *random dot fields* (1974) and *random blocks* (1975). Can you tell me more?

hdv from 1962 to 1975 i worked with programed randomness. the works i constructed were random objectivations, free of any personal message and open to interpretation. i later came to question what this randomness really was. i tried definitions, such as the monod randomness and necessity, sometimes my own. i came to the conclusion that *randomness* is a word we use to help us when we can no longer discover or identify all the causes that lead to a certain fact, position, or situation. i learned a lot of my work in this period.

the random programed works were models, but I realized that the most complete model of reality was reality itself! my work with randomness thus came to an end and i preferred to document real facts and real processes. i documented these processes of chance and change, of the different and identical, of the poetry of fact extensively with a camera but resisted exhibiting this aspect of my work for a very long time. the photo has its own reality, and is not identical with that which i choose to photograph. i now think one day i will publish them as "reproductions" of fact and process.

JG I love the way you will take elements of nature and exhibit them as artworks. *the witness* (1991) presented the trunk of an olive tree with all its convolutions and variations of texture, matter, and color. It is like a time capsule that carries with it all the variability and change of its life. The same goes for *the oak* (1992–), which was left to decompose and remains a testament to nature's ongoing cyclical processes and entropy. Unlike Carl André, who uses prefab materials—bricks, cut wood sections, and so on—that reference built structures and engineering, you reference nature as a source. Nature is neither structure nor product, even if our structures and products derive from nature . . . it procreates itself into infinity.

hdv yes.

JG The artifacts series you produced from the 1990s approaches the object from a different level than, say, Tony Cragg's assemblages have done. The process can involve rediscovering manmade objects that have been reclaimed by nature. Books found under a hedge covered with moss, for instance. While many artists reference the object-product, your art seems to remind us that the way we define and perceive nature has been inverted by manufacture and production processes. Rather than seeing matter from nature's point of view, as part of an ontological process, we often see it as an extension of production systems.

Whether it is pottery fragments from the beach at plefouti or stone and moss fragments, the ongoing changeability of things is part of your "real works" expression. This is less clearly expressed or understood in the field of art than in science, perhaps because there is no clear answer or definition. The process is more complex, less cartoonlike, and causes us to reflect on nature's omnipresent role in the total environment of contemporary life, whether it be product, architecture, or nature.

228

hdv entropy doesn't stop. it is in nature and in our cultural domain. in our manmade world, the laws of nature still rule! it is important to bring together our different attitudes about recognition, and knowledge collecting, and unite them. science and art, art and science. they are two boulevards of our creative approach toward reality. actuality. the sanctuaire de la nature de roche rousse has a fence that surrounds a ruined house, already taken over by nature. rose bushes and a box tree (buxus) grow inside what remains of the walls. it shows how humanity is transitory, a part of nature, that we need not fear this process. we can respect and enjoy the power of nature, always ready to heal her wounds, overtaking what humanity has left behind, forgotten or destroyed.

JG Indeed. And when we define and segregate elements, whether it be trash or a new product, we are willing participants in a process of identifying with overproduction. It is as though we have become afraid of recognizing nature as anything more than a resource. When nature is manipulated, or altered, we believe it has value. What a conditioned paradox!

hdv what a conditioned paradox indeed! scientists have participated in this exploitation. science is no longer a way of gathering knowledge, or a base for philosophy, but mainly a base for exploitation, for being useful, in this way. much of the "advancement" of science is a degradation. often the scientist has become a slave of "progress," and works for shareholders.

JG You once framed a book by Yves Klein titled *le dépassement et la problematique de l'art*. There are three tiny leaves floating within the frame together with the book. Was this a comment on the secularization of art from nature, how art hermetically sealed itself off from nature in the modernist era? It is as if artists of that era feared nature would call all that expression a ruse.

hdv in recognizing nature, our natural reality, as the only direct and available revelation, we can pass by and forget many of the cultural achievements we thought so important. leaves will fall over written words. words always play a part in the division of the world. in fact, the world is o n e. words give man a great collective power, but we pay for that power with a loss of unity. language is a digital analysis of actuality: yes-no, you-me, we-them, here-there, and so on. the fact remains. time doesn't exist. time is just another human invention that helps us to get a grip on the actuality/reality. when a leaf falls on a book we are reading, it is a beautiful moment!

JG From 1961–64 you published *la revue nul* = 0 with Henk Peeters. Collaborators included Pietro Manzoni, Matthias Goeritz, Lucio Fontana, Aubertin, Dieter Roth, and others. Was your orientation ultimately conceptual, involving concrete art and poetry, or were were other orientations? Did you find the discourse published in its pages generated new ideas and actions on the part of the artist/contributors?

hdv *revue nul* = 0 and *revue integration* (1965–72) were, first and foremost, documentations of new ideas and developments in art from z e r o artists. later they included more or less related topics.

20.3 herman de vries. *what is rubbish?* 1956. Found collage, 15 × 12 cm. Paris. Photo: Falko Behr. Courtesy
 of the artist.

20.4 herman de vries. *sanctuarium*, 1997. Muenster. Courtesy of the artist.

JG The sanctuaries you have created, a circular wrought-iron fence in Stuttgart (1993), the circular brick structure at Muenster (1997), the open meadow at Eschenau, the path through the bois sacré around the sanctuaire de la nature de la roche rousse (2001), are an attempt to rekindle this notion of a private place, of a place where we can go to to reflect, find ourselves, and identify with our primordial roots in nature. Nature is often perceived as material whose sole potential involves exploitation. Transgression has become the norm. Inner reflections about our origins, indeed nature's origins, raise existential questions about the great divide between humanity and nature. Are we participating in a process of development and change decided by a mindset established centuries ago?

hdv one of the originators of that mindset was rené descartes (1596–1650), who laid the foundations for mechanistic philosophy that so strongly influenced the developing science. it is still being worked out in our times. descarte's line *cogito ergo sum* (i think therefore i am) was opposed by his contemporary gassendi (1592–1655) who lived in digne, a town close to roche rousse, with the comment *ambulo ergo sum* (i walk therefore i am). people walking up the footpath to the sanctuaire de la nature de la roche rousse will find beside the path this gassendi quote cut into the surface of a rock that once fell from a ridge. the idea of sanctuaries and bois sacré (sacred forests) is of a place for reflection, revelation, and contemplation amid nature's manifestations. a new sanctuary near zeewolde in the netherlands was completed recently. a circular earth wall, densely covered with wild roses surrounds it. the hortus liberatus in merzig, germany, and our "meadow" near our village of eschenau that we will give back to nature also have to do with these ideas.

JG Does part of the problematic have to do with the structure of language itself? I am thinking of *the bundles* (1972–1989), a simple shelf structure with a series of labled and bundled newspapers (information rendered as object) that have dried leaves hidden inside them (another kind of "information"), or *the earth museum* (1998) with its seven thousand samples of earth from around the world, each wrapped in plastic and presented in sample boxes, exhibited at the Rijksmuseum in Holland. Each looks the same inside their container, yet they collectively represent such a diversity of immediate experience.

hdv immediate experience is the right expression. language divides the world in parts, but they still belong together.

JG You have actually been involved in redesigning a section of land into a nature reserve in the freshwater wetlands and marsh area called Weeribben, in the northwest Dutch province of Overijssel. This project again evidences the artists capacity to move into areas of process that are usually reserved for "professionals" from other fields such as landscape design, architecture, and urban planning. Some areas of this preserve will have areas for contemplation. In other areas the water level has been raised closer to its natural levels. . . .

Here is a very real example of how artists can transform reality, actually make a difference in the real world.

hdv the transformation of six square kilometers of agricultural land below sea level into wetland nature was, of course, not possible without biological, historical, and hydrological research. plant sociology and the succession of plant associations i have studied are particularly important to integrating a successful variable transition between the two existing nature reserves there. i think this is a good example of a fusion between art and science.

when completed, the region will be accesible only by canoe and footpath. it is not intended to be a place that encourages mass tourism. it is for those people who want to experience deep nature in holland, a densely populated country. some parts of the region will be reserved for nature itself. no visitors will be allowed entrance, not even scientists. this area will be seen only from the outside.

JG In your installation titled *from earth; from around swabisch hall* (1998), you did not represent the landscape surrounds of this place in a traditional way. Your placement of 35 earth samples of various colors, hues, and textures, selected out of the original 129 you took, into a large tableau of rubbings is direct experience. Not only is geological history part of your process here, but equally human history. You exhibited earth rubbings from the Biel/Bienne region at the base of the Jura mountains in Switzerland, adjacent to the tableau. Like your "comparative landscape studies," as you call them, you included samples from other places—Scotland, Sicily, Greece, and Germany. They build a visual relation between specific sites. These environmental traces become a global expression. Some would call this approach scientific, or at least systematic. Including samples from Buchenwald, Tchernobyl, and Australia (a region inhabited by the original Australians with cave drawings and wall paintings that have survived millennia) in the same show, you reestablish the locus of humanity's evolution and heredity in the landscape. Buchenwald and Tchernobyl are presented as heaps of earth on display. They are designated differently—Tchernobyl states the radioactive level of this contaminated soil and Buchenwald simply as KZ Buchenwald, Barrack 15.

hdv a handful of earth, or "dirt" as some people call it, can be a rich source for reflection and contemplation. our history is in the earth. everything that has been is returned to this original substance. amid the earth at barrack 15 in the kz buchenwald, a place used by the nazis for so-called "experiments" on humans, i found a small button. this tiny button touched me more than any memorial monument can do. the tchernobyl sample presented evidence of the danger of some human activities: the sample had a radiation of 568 bequerel.

bringing together earth from various regions and countries in the world, these works enable us to see their differences and similarities. none of the seventy-two hundred samples in my earth museum are in fact the same. like

233

the faces of men, the forms of the leaves of one tree, any earth sample is a new form. every happening, every new chance to realize form, reveals a new one. i added a mirror to underline the fact that they may look identical but still be different, they can look different but are still identical. nature doesn't repeat itself. its always new, all ways. to be all ways to be all to be ways to be to be.

a systematic approach is one possible way artists can work. i learned this discipline from science, but science on its own cannot provide us with a complete understanding of the world and our life. art and science can be complementary. by fusing both, the two main creative streams of our culture in relation to our life space can be integrated. it is one possibility. there are many definitions of art. mine is that art is a discipline that contributes to consciousness or becoming conscious, but art should not be limited to my definition. in our culture it is very important that art remains a free and open domain. art is a free domain.

JG Poetry has always been an integral part of your art as well.

hdv poetry is an attitude. without it, my world would not exist:

> my poetry is the world
> i write it every day
> i rewrite it every day
> i see it every day
> i read it every day
> i eat it every day
> i sleep it every day
>
> the world is my chance
> it changes me every day
> my chance is my poetry

NOTE

1. example: on a 24 × 24 cm. page, using a cm grid and ten rectangular elements, there are 6,579,329,566,975,974,127,670,720,595,328,889,430, 137,295,077,376 possible forms and positions. that's an overastronomical number of chances.

21
THE HEART OF THE MATTER
Chris Drury

Chris Drury has developed a unique and inimitable approach to working in the environment. Born in Ceylon (Sri Lanka) and educated at Camberwell School of Art in London, Chris Drury has, over the past twenty years produced an incredible range of works. For his large scale sculptural integrations Drury builds two distinct structural forms: cairns or shelters. The choice of location plays a role in the conception of the work, and the locations have varied greatly from New Mexico to Sussex, England. He has exhibited his work widely. Chris Drury's most recent exhibitions include *Heart of Stone* in early 2004 at Oriel Mostyn Gallery, Llandudno, Wales and at Stephen Lacey Gallery, London. *Hut of the Shadow* won him a commendation from the Association for the Protection of Rural Scotland in 2002. Commissioned site specific works include *Cloud Chamber for the Trees and Sky* (2003) for the North Carolina Museum of Art, *Heart of Reeds* (2000), a reedbed biodiversity initiative that is taking place at the Lewes Railway Land Reserve in Lewes, Sussex, *Tree Vortex* (1998) at Dragsholm Castle in Odsherred, Denmark and *Cedar Log Sky Chamber* (1996) in Kochi, Japan.

JG A civilization's artistic expression can give us indicators as to the degree of depth and intelligence of a given culture at a period in history. It also carries traces of geospecificity, of climate, of landforms, animal species, flora and fauna. Are your structures a cultural embodiment or expression of parallel relations between human history and natural history?

CD I don't know, these structures are made instinctively—acting from a hunch, a feeling in the pit of the stomach. One can think about reasons, etc., after and that is a process of becoming conscious. Structure is part of the process. If you want to build a big structure from flimsy sticks, the structure has to obey certain laws. I like that. The structure is both practical and beautiful. There is structure in process and process enters into my work at all levels.

JG Do you believe culture can play a role in heightening awareness of nature's place in our lives?

235

CD Nature is an idea created by culture, and nature is an idea embedded in language. Its very term presupposes that we are outside of it and therefore is anthropocentric. We are nature and nature "is." Our lives are a process of nature.

JG Satish Kumar has said that we have to develop a new declaration of dependence as opposed to independence in recognizing that we should perceive our place on earth in mutualist terms.

CD Yes of course that is correct.

JG Does the way you make art express a relation between human culture and that of nature?

CD Human culture is part of the process of nature. The problem is that we are divided. There is a perpetual duality. This is so deeply ingrained in the human psyche that we will never change our self-destructive habits until we understand that division. Only in this understanding will our actions change. Without this we will always act with disregard.

JG Your recent *Cloud Chamber* (2003), created for the North Carolina Museum of Art, includes an aperture that projects the image of trees upside down inside the structure on the walls and floor. This is an artwork that references architecture, but an architecture sensitive to a culture of permanence where ecology and nature are a presence.

CD I am aware of all the ecological debates, but these are not the primary source of my work, although they may obliquely reference it. In the first instance, I make my work on a hunch, or by instinct. Usually this is from a direct experience in or with the outer world. A visceral connection is made. I feel that modern man is disconnected and divided and that in part is what is causing many of the problems. Later, usually after the art event, I am able to make conscious connections. I may even make use of this "joining of the circle" to push those emerging ideas further in subsequent works.

Some of the works I build outside are indeed architectural. They enclose a space and you can enter them as you would a building. All of these works play on the idea of inside/outside, inner/outer. From the outside they are an object, structure, or hut that exists as an object in space and fits with the surrounding landscape. Seen this way they neither dominate nor are they overly discreet. Seen from inside, however, they become an experience that no photograph can adequately describe. In some way, the outside is brought within and changed. The viewer is obliged to wonder about the nature of the relationship of inside to outside. In a sense such works give the viewer a very physical, gut experience. They experience it first and then, if they will, continue to wonder about it.

JG At times what people have called environmental art can lose its relation to actual site, ironically even in so-called environmental art. Such artworks were created in outdoor nature settings, and the intention is to emphasize the ephemeral quality of life itself, but there is a disregard for site nevertheless. Where would you place your cairn work and bundles in this?

CD My cairns are built very fast and photographed to say, "Look at this place now, at this moment." They are not about balancing stones. The bundles are like notes from a place, or souvenirs. As time has passed since I made them, I find them to be a bit fetishistic but they work well enough. The last one I made was probably in 1993. I still make cairns occasionally, but I am growing increasingly reluctant to make any interventions in "wild" landscape. I tend now to use such "wild nature" experiences in more indirect ways, by working with maps, with earth, and straight photographs. I allow these experiences of landscapes to enter into my work at a deeper level.

JG Do your cairns have some ritualistic aspect to them? In particular, I make reference to the *Driftwood Cairn*, for instance, that you made in Kvaloya Island, Norway, or the *Seven Sisters Cairns* (1995) on the Sussex coastline of England.

CD The *Driftwood Cairn* was part of a number of works I made that involved an exchange of objects between mountain and sea. In that sense, yes, this work is a kind of ritual, but one that is only intended to make a very physical connection between Mountain and Sea. *Seven Sisters Cairns* involved building seven chalk cairns for the seven undulating cliffs of that name. I made the latter cairn fast on a wild January day, in this magnificent landscape. The tide washed them away just fifteen minutes later.

JG When did you come up with the stove structures? Was it by intuition, and what do these ministructures represent?

CD They are really an extension of the cairns. The cairns mark a remarkable place in a moment in time. A fire inside a cairn talks of: heat in a cold place, light and dark, fire and water—all opposites.

JG Cultural survival relies as much on how we maintain our environment as each environment carries codes that facilitate us in the perpetuation of knowledge of nature in a particular response to a specific environment. Your *Medicine Wheel* (1983) series of works on paper integrate actual living plant and mushroom species from an environment and develop a dialogue with nature within the creative process. . . . I believe this was a cyclical, seasonal project that evolved over the seasons.

CD The idea for the *Medicine Wheel* occurred as I bent down to pick up two lapwing feathers off the fields in August. I realized it would be a marvelous thing to do just that every day for a year—pick up a natural object. By this simple system, chance and my life and the natural world would be interwoven. So that's what I did!

JG Your *Earth Wave Drawing* involved actually printing with black ink using earth as a medium, and recalls some of Belgian artist Bob Verschueren's assemblages and vegetal artworks.

CD The *Earth Wave* prints are a part of a whole swathe of works to do with movement/water/blood—microcosm/macrocosm. They are also an extension of the woven map works in that in those works maps of two places which have

237

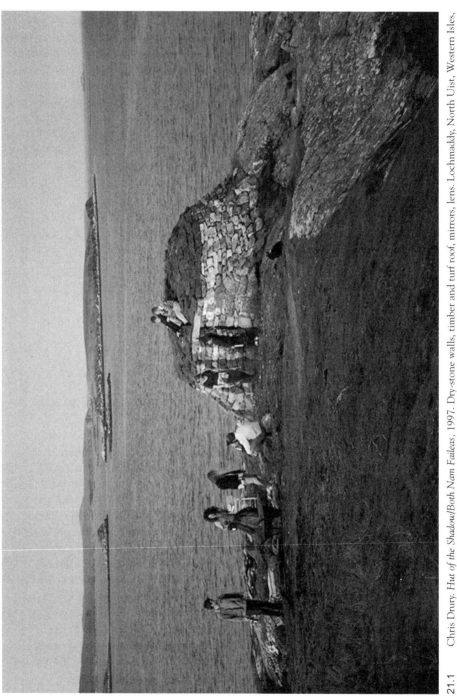

21.1 Chris Drury. *Hut of the Shadow/Both Nam Faileas*, 1997. Dry-stone walls, timber and turf roof, mirrors, lens. Lochmaddy, North Uist, Western Isles, Scotland. Photo courtesy of the artist.

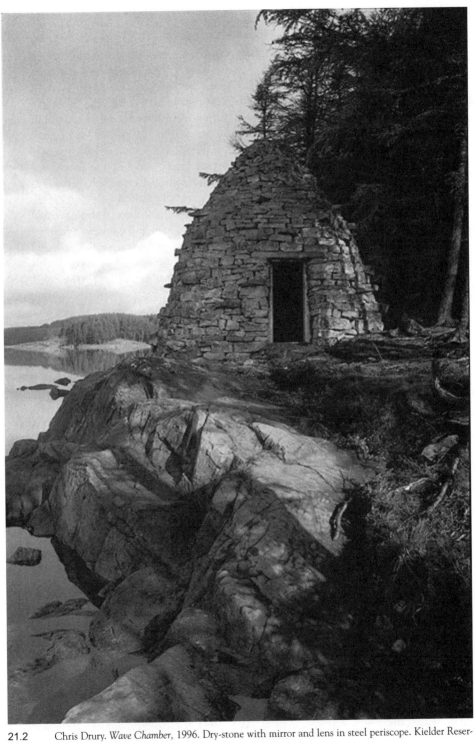

21.2 Chris Drury. *Wave Chamber*, 1996. Dry-stone with mirror and lens in steel periscope. Kielder Reservoir, Northumberland, England. Photo courtesy of the artist.

239

something in common or are polar opposites are cut into strips and woven together. In the *Earth Wave* works, soil from both places are printed together. Early works were monoprints from a released Xerox print over soil pigment. In later works, soil from one place is rubbed dry or washed wet into the paper in a circular ground. A wave pattern screen print is overprinted using sieved soil in a print medium. I have a library of soil pigments from everywhere I have been in the world. In my travels I notice that plants, for instance, look vaguely familiar to some plants back home. As they are growing in different conditions and in different climates they have adapted differently. Everywhere things are the same but different—goes for animals and people as well.

JG The *Adharc drawings* and the cast bronze works that followed also assemble elements and thus develop a rapport with place, time, and memory. I believe the Adharc was a three-piece horn used some two thousand years ago found preserved in a peat bog in Denmark. . . . Some of your works play on and with the notion that memory can be something that exists even beyond the era it originated in.

CD I guess memory plays a huge part in our lives. Without memory we can't speak or walk or feed ourselves. Without memory we are like newborn babies. We see and act in the world through memory. We are conditioned by it. Some things, objects even, can spark archaic memories (memories from the human race), or move us in ways we can't explain. I think that ancient Irish horn does that. It speaks of Earth and other times, hence the ram's horns cast in peat. The dead ram found on the beach in West Cork went by the name of Cyril—the farmer called all his rams by the names of foppish Englishmen!

JG And what do you think of cell memory?

CD I guess homeopathy works as a faint trace memory and the active ingredient must be present in something smaller than cells. Genetic coding is memory.

JG The South Carolina Botanical Garden is a living laboratory where environmental sculpture and site specific installations are allowed to decay, to enter into the process of life from which the materials originally derive. *Time Capsule* (2002) with its two domes of braided wood and over sixty serviceberry plants placed around it is eclectic. There is a rammed earth core in the larger dome with a time capsule buried in it. The monolithic inner form has tree branches braided around it that reinforce it. A passage unites the two structures. The path within and between the two domes resembles an an infinity symbol. I believe you integrated living trees in the actual braided structure. As things decay they will also grow.

CD Yes, this idea of building growth into my work came when I saw other works were slowly decaying. In their decay they began to look decrepit. I felt that if the decay was designed to be very much part of the work, together with living, growing elements, things might go better. So, yes, the work decays and grows at the same time. The Earth was rammed into a mold of woven sticks in which there were four living trees. As a result, the basket mold will leave its

imprint on the rammed earth as it decays, and the four living trees will grow up and fuse themselves around the rammed earth. The two outer domes will also rot and drop away. They will gradually be replaced by a grafted figure of eight, a double ring of trees that will actually be intertwined to be one tree. This would eventually make a very different shape that that of the original domes. Chaos and uncertainty is built into the process. . . . That's how nature works. It is not predictable and ultimately out of our control.

JG Yes. Humanity will never be master of nature, and this myth of mastery over nature is a potentially dangerous one. I was wondering if you have ever been accused of being purist for using nature-based materials? Of course all materials—even synthetics—ultimately derive from nature, but I was wondering . . .

CD I don't think I have ever been accused of being a purist—rather the opposite. Someone once asked me a long time ago what the difference between myself and Andy Goldsworthy was, and I jokingly said "Glue."

JG I believe you once said the cairns you make like *Lost Coast Cairn* in California develop out of walks in nature. The cairns remain as markings of a special place and time . . . rather like the Inuit in the Arctic made cairns as signposts of a kind. You do not see the cairns as sculptures per se, more something outside of the self that are temporary . . .

CD The cairns are not at all self-referential. In fact, they point to something else outside the closed circuit of the self, something in flux and ever changing.

JG Most interesting are the innovative structures you build that are instinctive and imaginative responses to specificity of species and locale. The *Reed Chamber* is a case in point, completed as with many of your works in collaboration—in this case with Chris Tomkins, a thatcher. Using locally available materials, you make us aware of how environmental awareness can make us realize that resources are everywhere and local materials, if used, can integrate with a greater environmental harmony than imported or standard product materials. Local materials may actually adapt better than imported in the building of structures.

CD Yes this is certainly true, but it is only the industrialized and alienated countries that have had to rediscover this. Most of the rest of the world uses local materials out of common sense and necessity. However in the case of *Reed Chamber*, because of agricultural pollutants in the water and because reeds take up these pollutants (these reeds rot very fast, so reed for thatching is mostly imported from unpolluted wetlands in Turkey—which is a mad situation). I was not able to use the reeds on site. Thatching is indeed a fine art and only straight unpolluted reeds, taken from reedbeds which are harvested on a yearly basis will do. At Arundel, their reedbeds are habitat reserves for wildlife and cannot be harvested. So the reeds came from Turkey!

JG The "land drawings" you make like *Heart of Reeds* (1998) created on the Lewes Railway Land Reserve has an overall configuration that looks like the

double vortex whorl shape of human heart tissue. With a six meter earth mound and ribbons of land and boardwalk representing the left and right ventricles of the heart, *Heart of Reeds* embodies the parallels that exist between macrocosmic and microcosmic patterns in nature, and all living elements, ourselves included. Your *Heart of Reeds* formation and more recent *Heart of Stone* (2003), which was made using Welsh slate stone, evoke similar forms. These notions of the microcosm and macrocosm were written of by Theodore Schwenk in his groundbreaking book *Sensitive Chaos*. I find your *Heart of Reeds* and *Heart of Stone* projects express Schwenk's notions of organic waves and shape variables in an artwork. Your art directs us to consider the greater cosmic forces, and the way water content in solid organic living matter reflects these forces, whether in microcosm or macrocosm. . . . Theodore Schwenk believes these forces and resultant forms likewise receive formative impulses from the spiritual world. How do you feel about this? Can art play a role in guiding people towards deeper spiritual and ecological questions?

CD Yes definitely. I have Theodore Schwenk's book and of course that is where the diagram from the cross section of the apex of the human heart came from, also the whirlpool image, and sand ripple marks, which I have continued to use over the years. The original meaning of *Spirit* is Breath which denotes life. It is the life force of which gives the Earth its Spirit. So in a sense the spiritual is a connection to "life force" and life force is in all animate things (in the native Algonquin language stones are animate). First there has to be the connection, and art can help to establish this connection as well as communicate it.

JG The *Cloud Chambers* you build with stone walls and wooden roofs, I am told, actually capture clouds of steam within them. Is this rather like a native sweat lodge in principle? The first cloud chamber came into being in 1990 made of tarpaulin with an opening rather like a native Amerindian tent structure and you have since built around ten of them. Evoking a principle of timelessness, they are said to evoke clouds or waves, ephemeral fluxlike forms within their structures. . . . Can you explain?

CD No, the *Cloud Chambers* have no steam and are not related to the sweat lodge or Viking sauna. My *Cloud Chambers* operate like a camera obscura or giant pin hole camera. With a small aperture or lens, an image from outside can be projected onto a white screen in the dark interior. The outer shell of the chamber fits with its surroundings and is an object or building in space. Within the chamber, one can experience ghostly images of clouds as they drift across the floor.

If the site is unprotected I use an aperture two centimeters in diameter in steel because it cannot be vandalized. It works well but it takes time for your eyes to adjust to the low light. Usually the images are in black and white as the light level is so low, but the advantage is that you get a projection on the walls as well as across the floor. With a lens you have to have a fixed focus (say

infinity) so things nearer are a little blurred. However with a lens you get a bigger hole and more light, so you get color, but the image is only a certain size.

With the *Wave Chamber*, I built into the top of the chamber a small mirror with a periscope angled to view the lake. The mirror picks up the image of the waves. They then pass through a small cheap lens and project onto the interior floor.

JG What role does publishing your projects play alongside your art, or is it part of the art?

CD Most people know of my art through publications, so obviously this has to be an important aspect of the work, and you have to do it right, but photographs will always be limited in what they can do and I always advise people to get to see the work if they can. If the work is a photograph, that is another matter.

JG You have done some drawings based on hill life in old Ceylon (Sri Lanka) where your family lived in old colonial ways that sound fascinating. In a similar way, Ladakh, Hebrides/Manhattan, and the Jura/Alps have inspired you. Travel and memory involve a process of layering just as you layer aspects of nature like mushroom spores onto old maps, thereby interspersing immediate nature-based points of reference and linear or rational elements such as maps for counterpoint. The end result, however, is a purely visual effect that reflects principles of entropy and the ontological process and cycle of life. In a word these works are beautiful evocations of humanity's relation to and within nature, of which we are a part. It must be exciting working on these paper pieces, though they are the end result of the artistic experience and process.

CD Yes, I think that is right what you say about these works, they are about layers of perception (in fact most of my works have layers of meaning which one can peel back). Discovering these layers is an ongoing part of the cycle of work. Intuition, fabrication, and growing consciousness as to what has taken place are endemic to process.

Another part of these works is the repetitive task. I repeat an action in weaving maps, writing repeated words (as I did with *Destroying Angel* for a period of three months). Repeating an action is close to chanting a mantra or being in a perpetual meditative state. I really like this, but I also need heavy physical work outside, building with stone or weaving sticks, to contrast the meditative action. Repetitive internalized tasks are very much like the state of mind one has when walking for a week or more in out of the way places. . . .

JG Which do you prefer, working out of doors or on site specific installations indoors?

CD I like both. The gallery is always like a temple space for you to fill, or work with. Outside you have to create that temple space so that it is not segregated from what is around it, so that it becomes part of the surroundings. The gallery is a closed off space so that the focus is within, but works made inside such

243

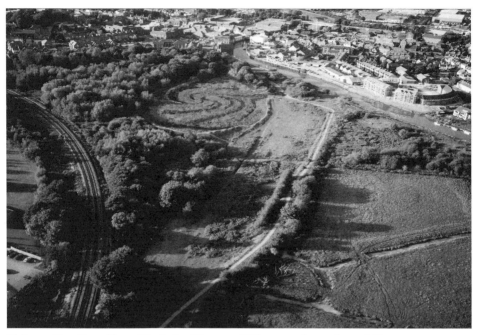

21.3 Chris Drury. *Heart of Reeds*. Land Drawing, 2000–present. Lewes, Sussex. UK.

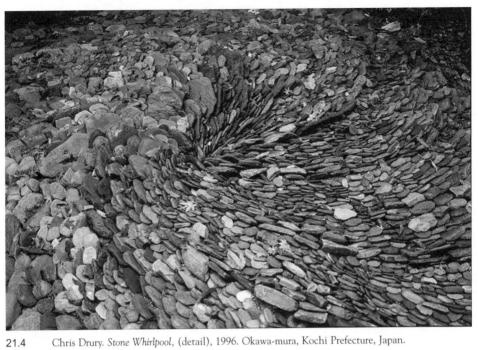

21.4 Chris Drury. *Stone Whirlpool*, (detail), 1996. Okawa-mura, Kochi Prefecture, Japan.

spaces may speak of the outside. Works outside have to be integrated into the landscape, but are at the same time works you can enter. The interior experience has within it changed aspects of the outside (via lens or through open weave). This movement from one to the other is central to the connections I try to make between inner and outer nature.

RECOMMENDED READING

David Abram. *The Spell of the Sensuous*. New York: Vintage, 1997.

Malcolm Andrews. *Landscape and Western Art*. New York: Oxford U. Press, 1999.

José Arguelles. *The Transformative Vision: Reflections on the Nature and History of Human Expression*. Boulder: Shambhala, 1975.

John Beardsley, *Earthworks and Beyond*. New York: Abbeville, 1998.

Walter Benjamin. *Illuminations*. New York: Schocken, 1968.

Maurice Berger, ed. *The Crisis of Criticism*. New York: New Press, 1998.

Thomas Berry. *The Dream of the Earth*. San Francisco: Sierra Club, 1990.

Suzanne Boettger, *Earthworks Art and the Landscape of the Sixties*. Berkeley and Los Angeles: U. of California Press, 2002.

Murray Bookchin. *The Ecology of Freedom*. Montreal: Black Rose, 1991.

David Bourdon. *Designing the Earth: The Human Impulse to Shape Nature*. New York: Abrams, 1995.

F. H. Bradley: *Appearance and Reality*. Oxford: Clarendon, 1930.

Marilyn Bridges, *Sacred Landscapes from the Air*, New York: Aperture Foundation, 1986.

Paul Cooper. *Livingsculpture*. London: Mitchell Beazley, 2001.

Suzi Gablik. *The Reenchantment of Art*. London: Thames & Hudson, 1991.

James George. *Asking for the Earth; Waking up to the Spiritual/Ecological Crisis*. Rockport, Mass.: Element, 1995.

John Grande. *Balance: Art and Nature*. Montreal: Black Rose, 2004.

———. *Intertwining: Landscape, Technology, Issues, Artists*. Montreal: Black Rose, 1998.

Paul Hawken. *The Ecology of Commerce: A Declaration of Sustainability*. New York: Harper Collins, 1993.

Jane Jacobs. *Systems of Survival: A Dialogue on the Moral Foundations of Commerce & Politics*. New York: Vintage, 1994.

Salim Kemal and Ivan Gaskell, eds. *Landscape, Natural Beauty and the Arts*. Cambridge: Cambridge U. Press, 1993.

Lucy Lippard. *The Lure of the Local; Senses of Place in a Multicentered Society*. New York: New Press, 1997.

Barbara C. Matilsky. *Fragile Ecologies; Contemporary Artists' Interpretations and Solutions*. New York: Rizzoli with the Queens Museum of Art, 1992.

Marshall McLuhan and Bruce R. Powers. *The Global Village; Transformations in World Life and Media in the Twenty-first Century*. Oxford: Oxford U. Press, 1989.

B. L. Molyneaux and Piers Vitebsky. *Sacred Earth, Sacred Stones*. San Diego: Laurel Glen, 2001.

E. F. Schumacher. *Small Is Beautiful; Economics as if People Mattered*. New York: Harper Perennial, 1989.

Michael Tucker. *Dreaming with Open Eyes: The Shamanic Spirit in Twentieth-Century Art and Culture*. San Francisco: Aquarian Harper, 1992.

Alexander Wilson. *The Culture of Nature: North American Landscape from Disney to the Exxon Valdez*. Toronto: Between the Lines, 1991.

INDEX